Watercolor Painting

STEP-BY-STEP

Watercolor Painting
STEP-BY-STEP

By Arthur L. Guptill

EDITED BY SUSAN E. MEYER

Watson-Guptill Publications

New York

Published by Watson-Guptill Publications, 165 West 46 Street,
New York, New York 10036. *Copyright in Japan, 1967* by Watson-Guptill
Publications. *All Rights Reserved*. No part of the contents of this
book may be reproduced without the written consent of the publishers.
First Edition, 1957
Second Edition, 1967
Library of Congress catalog card number 66-19738

CONTENTS

Publisher's Note, 10

Author's Note, 11

Part One: FUNDAMENTALS OF WATERCOLOR PAINTING

1. CHOOSING YOUR PIGMENTS 17
*Watercolor Paints, 17 • Painting Sets, 18 • Cakes, Pans, or Tubes?, 18
Brand of Colors, 19 • Sizes, 21 • Permanence of Colors, 21 • Number of
Colors, 21 • Spectrum Colors, 22 • Recommended Lists, 22*

2. ADDITIONAL ITEMS OF EQUIPMENT 26
*Color Box, 26 • Palettes, 28 • Color Cups, 28 • Water Containers, 29
"Setting" the Palette, 29 • Brushes, 30 • Red Sable Brushes, 30 • Bristle
Brushes, 31 • Care of Brushes, 31 • Easel or Drawing Table, 31 • Cabinet, 33
Sketching Stools, 33 • Pencils, 34 • Erasers and Erasing Shield, 34
Knives and Paper Cutters, 35 • Daylight Lamp, 35 • Blotters and Dust
Brush, 35 • Sponge, 35 • Rags, 36 • Clothespins and Such, 36
Hair Dryer, 36 • When Tube Caps Stick, 36 • Artists' Umbrella and
Sunglasses, 37*

3. PAPER 38
*Imported Papers, 38 • Surfaces, 39 • Sizes, 39 • Weight, 39 • Choosing a
Sheet, 41 • Which Side Up?, 41 • Mounted Paper, 41 • Machine-made
Paper, 41 • Watercolor Blocks, 42 • Odd Materials, 42*

4. MOUNTING AND STRETCHING PAPER 43

Mounting, 43 • Stretching Paper Onto a Frame, 43 • Stretching Paper Onto a Board, 44 • The Board, 45 • The Pan Method, 45 • An Alternate Method, 46 • Further Pointers, 46 • Buckling Paper, 47 • A Word of Caution, 47 • Cutting off the Stretch, 47 • Removing the Glued Edges, 47 A Glueless Method, 48 • Stretching Frames, 48 • Working Over Glass, 49 Why Bother?, 49

5. GETTING UNDER WAY 50

"Transparent" Painting, 50 • Methods of Application, 51 • Exercise 1: Line work, 51 • Exercise 2: Dry-Brush Work, 51 • Exercise 3: Dabs and Stipple, 52 • Spatter and Spray, 53 • Mingling, 53 • Exercise 4: Wash Work, 53 • Applying the Flat Wash, 54 • Stopping the Wash, 55 Graded Washes, Light to Dark, 56 • Graded Washes, Dark to Light, 56 Sediment Washes, 56 • Exercise 5: French Method, 57 • Exercise 6: Overlapped Grades, 57 • Exercise 7: Two Stroke Grades, 57 • Exercise 8: Superposed Grades, 57 • Exercise 9: Simultaneous Washes, 59

6. GETTING ACQUAINTED WITH YOUR WATERCOLORS 60

Exercise 10: Comparative Washes, 60 • Exercise 11: Superposition of Color, 61 • Exercise 12: Water-Resistance Test, 64 • Exercise 13: Opacity of Color, 64 • Exercise 14: Test for Fading, 64

7. COLOR QUALITIES: VALUES AND THEIR MEASUREMENT 65

Mixing and Matching Colors, 65 • First, Some Definitions, 66 • Hue, 66 Brilliance or Value, 67 • Saturation, Chroma, or Intensity, 67 • Normal Colors, Tints, and Shades, 67 • Tone, 68 • Obtaining Tints and Shades, 68 Exercise 15: Value Comparisons, 68 • Analysis, 69 • Exercise 16: Value Scales, 70 • Matching Nature's Tones, 71

8. COLOR MIXING AND MATCHING: COLOR CHARTS 72

Some Color Theories, 72 • Exercise 17: Be a Good Mixer, 73 • A Fascinating Discovery, 76 • A Color Wheel, 76 • Exercise 18: Making a Color Wheel, 76 Primary Colors, 77 • Secondary Colors, 77 • Tertiary Colors, 77 Analogous Colors, 78 • Complementary Colors, 78 • Triads, 78 • A Strange Paradox, 80 • A Practical Application, 80 • Another Chart Application, 80 Exercise 19: Matching Nature's Hues, 80 • Exercise 20: "Copying" Color Areas, 81 • Color Schemes, 81 • A Successful Scheme, 81 • But Be Careful!, 82 • Neutralized Colors, 82 • Timidity, 83 • Exercise 21: Try for Yourself, 83 • Importance of Color Area and Relative Position, 83 Exercise 22: Experiments in Area, 83 • Exercise 23: An Area Phenomenon, 83 • Where Does This Leave Us?, 84

9. COLOR ARRANGEMENTS, ILLUSION, ACTIVITY 85

Exercise 24: Color Arrangements, 85 • Color Activity, 86 • Warm and Cool Colors, 88 • Advancing and Retreating Colors, 88 • Exercise 25: Further Color Experiments, 90

10. COLOR SCHEMES YOU CAN USE 91

There are No Rules, 91 • Using Color Schemes, 92 • One Color with White, Gray, or Black, 93 • The Monochromatic Scheme, 93 • The Modified Monochromatic Scheme, 93 • Analogous Schemes, 94 • With Dominant Hue, 95 • With Complementary Accents, 95 • Complementary Schemes, 95 Exercise 26: After-Images, 96 • Near and Split Complementaries, 96 Triads, 97 • A Play-Safe Method, 97 • It's Very Complicated, 98 Exercise 27: Color Schemes 98

11. PROFITING FROM THE PHOTOGRAPH 99

Advantages of the Photograph, 99 • Selecting the Photograph, 100 Limiting the Subject, 100 • Sketching the Subject, 100 • The Pigment, 100 Analyzing Your Subject, 100 • Advancing the Work, 101 • Apparent Carelessness, 101 • Center of Interest, 102 • Vignetting, 102 • Pattern Interest, 102 • Examples, 104 • Indication, 105 • Simplification, 106 • Trial Studies, 108 • Thumbnail Sketches, 108 • Exercise 28: Sketching from Photographs, 108

12. LEARNING FROM THE MASTERS 109

Which is Best?, 109 • Four Paintings, 112 • Lessons from the Masters, 113 Suggestions, 114 • Paintings in Other Media, 114 • Advancing the Work, 114 Portions of Subjects, 115 • Copies Plus Photographs, 115 • The Works of Early Painters, 116 • Exercises, 116

13. STILL LIFE: PAINTING THE SINGLE OBJECT 117

The Value of Still Life, 117 • Equipment, 118 • Lighting, 118 • Choice of Subject, 119 • Vary Your Subjects, 120 • The Single Object, Step-by-step, 120 Exercise 29: Still Life in Wash, 122 • Exercise 30: Speed Work, 122 Exercise 31: Memory Work, 123

14. STILL LIFE: COMPOSITION AND LIGHT 124

Object Rest or Shadow Box, 124 • Composing the Still Life, 125• Composing with the View Finder, 125 • Lighting and Composition, 126 • Reflectors, 126 Exercise 32: Experiment with Lighting, 127 • Lighting Affects Surface, 128 Reflected Light, 128 • Seeing Values with the View Finder, 128 • Quality of Edge, 129 • Exercise 33: Trial Sketch, 129 • The Final Sketch, 129 Exercise 34: Outdoor Subjects, 130 • Exercise 35: Rounded Objects, 130 Exercise 36: Varied Objects, 131 • Exercise 37: Colored Objects in Wash, 131

15. STILL LIFE: PAINTING THE PICTURE 132

Picture Proportion, 132 • Paper, 133 • Drawing, 133 • Analysis of Subject, 133 • Preliminary Sketches and Full-Size Studies, 133 Artistic License, 134 • Oil Versus Watercolor, 134 • Direct Method, 134 Indirect Method, 135 • Sandpapering, 135 • Scrub Method, 135 • Combined Methods, 136 • Highlights, 136 • Exercise 38: Still Life, 137 • Still Life in Color, 137 • Exercise 39: Full Color, 137 • Your Approach to Color, 137 Textures, 139 • Exercise 40: Texture Representation, 139 • Exercise 41: Subjects Outdoors and Indoors, 140 • Simple Outdoor Sketches, 141

16. NOW LET'S PAINT OUTDOORS 142

*Outdoor Equipment, 143 • Paper, 144 • Outdoor Easel, 144 • View Finder
and Reducing Glass, 144 • Selecting the Subject, 145 • Point of View, 146
Lighting, 146 • Comfort, 146 • Analyzing the Subject: Construction, 147
Preliminary Sketches, 148 • Recomposition, 149 • Center of Interest, 150
Procedure, 150 • White Paper, 151 • Turning the Paper, 151 • Drying, 151
Two at Once, 152 • "Dry" Painting, 152 • Speed, 152 • Color Judgment, 153
Color Distribution, 153 • Purple Shadows, 153 • Squinting, 154 • Shadow
Shapes and Edges, 154 • A Color Matching Tip, 154 • Incomplete Work:
Notes, 155 • Analysis, 155 • Repairs, 155 • Know When to Quit, 155
Matting Sketches, 155 • Exercise 42: Comparative Work, 156
Special Matters, 156*

17. ALTERATIONS AND CORRECTIONS 157

*Scrubbing, 157 • Sandpaper, 158 • The Eraser, 158 • The Knife and
Razor, 159 • Alterations by Addition, 159 • Repairing Fans, 159 • Mending
Edges, 160 • Patching, 160 • Opaque Color, 160 • Burnishing, 161*

18. TREES AND OTHER LANDSCAPE FEATURES 162

*Learn About Trees, 162 • Field Trips: Anatomy, 163 • Exercise 43:
Skeletons, 165 • Silhouettes, 165 • Exercise 44: Silhouettes, 166
Values, 166 • Hue, 167 • Exercise 45: Planes, 167 • Holes Through
Foliage, 169 • Trunks and Branches, 169 • Exercise 46: Branches and
Holes, 170 • Exercise 47: Tree Shadows, 170 • Ellipses Caused by Tree
Shape, 170 • Ellipses Caused by Diffraction, 171 • Shadows Expressing
Form, 172 • Shadow Edges, 173 • Common Errors, 173 • Exercise 48:
Bushes, 174 • Exercise 49: Hedges, 175 • Foliage Methods, 175
Exercise 50: Foliage Methods, 178 • Flowers, 178 • Grass, 178 • Exercise, 179
Summary, 179*

19. PAINTING BUILDINGS 182

*Large Buildings, 182 • Building Details, 183 • Stonework, 183
Brickwork, 183 • Concrete and Stucco, 186 • Clapboards and Shingles
(Walls), 186 • Other Building Materials, 187 • Chimneys, 187 • Roofs, 187
Windows, 187 • Doorways, 190 • Shadows, 191 • Shadow Values and
Shapes, 191 • Reflected Light, 191 • Exercise 51: Representing Buildings, 191*

20. SKIES AND CLOUDS 193

*Cloudless Skies, 194 • Texture, 194 • Exercise 52: Sky Textures, 194
Exercise 53: Cloudy Skies, 195 • Minglings on Minglings, 195 • Glycerine
and Alcohol, 195 • Exercise 54: Erased Clouds, 195 • Direct Handling, 195
Exercise 55: Direct Handling, 197 • Exercise 56: Stippling, 197
Exercise 57: Opaque Effects, 197 • Composition, 197 • Sunsets and
Sunrises, 199*

21. STIPPLE, SPATTER, AND SPRAY 201

*Stipple, 201 • Exercise 58: Stipple, 202 • Spray, 202 • The Air Brush, 202
Atomizer, 203 • Mask or Stencil, 203 • Rubber Cement, 204*

The Pigment, 204 • The Spraying, 205 • Clouds, 205 • Spatter, 207
Exercise 59: Spatter and Spray, 207

22. THE TREATMENT OF REFLECTIONS 208

Horizontal Planes, 208 • Exercise 60: Laws of Reflection, 209 • Reflective
Surfaces, not Plane, 210 • Exercise 61: Reflective Surfaces, 211
Spherical Reflections, 211 • Exercise 62: Varied Surfaces, 212
Interiors, 212 • The Wet Street, 212 • Vertical Planes, 212 • Exercise 63:
Two-Way Reflectors, 214 • Three Reflectors, 214 • Exercise 64: Three-Way
Reflectors, 214 • Move the Vertical Planes, 214 • Exercise 65: Vertical
Planes, 215 • Tipped Planes, 215 • Curved or Irregular Planes, 216
Color, 216 • Exercise 66: Colors in Reflection, 216 • Reflections in Water, 217

23. SOME TIPS ON COMPOSITION 218

Composing with Contrasts, 218 • Exercise 67: Value Representation, 222
Tracing Paper, 222 • Contrasts of Hue, 223 • Composition Terms, 224
Preliminary Sketches, 224 • Composing by "Addition," 225 • Composing
with Cutouts, 226

24. EMPHASIS, DISTANCE, DETACHMENT 227

Emphasis Through Value Contrasts, 227 • Emphasis Through Color
Contrasts, 228 • Emphasis Through Detail, 228 • Size, Shape, Texture, 229
Emphasis Through Location and Motion, 229 • The Surprise Element, 230
Distance, 230 • Detachment, 231 • Graded Tones, 231

25. UNUSUAL METHODS AND MATERIALS 233

Opaque Watercolors, 233 • Method, 236 • Watercolor and Charcoal, 237
Opaque Color on Colored Paper, 237 • Colored Pencils, 237 • Watercolor
and Ink, 237 • Colored Ink Work, 237

Part Two: DEMONSTRATIONS BY PROFESSIONALS

HOW TO STRETCH WATERCOLOR PAPER: JOHN ROGERS 241

PAINTING A LANDSCAPE: NORMAN KENT 246

PAINTING A WATERCOLOR: TED KAUTZKY 250

PAINTING STILL LIFE: RALPH AVERY 255

PAINTING OUTDOORS: HERB OLSEN 260

CREATIVE METHODS: SAMUEL KAMEN 264

Index, 267

Publisher's Introduction

ONE OF THE LATE Arthur L. Guptill's admirers—a famous watercolorist and teacher—put it this way: "Arthur's greatest virtue was that he put in everything, absolutely everything; he was never ashamed to say the obvious, so he never left anything out."

In the years since its original publication in 1957, *Watercolor Painting Step-by-Step* has become one of the most popular watercolor books ever published for the beginner. Judging by the fan mail, readers agree that the author "put in everything, absolutely everything" that the beginning watercolorist should know.

How, then, should a publisher have the audacity to put forth a revised and enlarged edition of a famous book which, despite its slim size, has seemed *complete* to thousands of readers?

The concept of a new, revised, greatly enlarged edition was suggested, indirectly, by the readers themselves

One of Arthur L. Guptill's earliest books was a colossal effort titled *Color in Sketching and Rendering*. Long since out of print, this massive book is now virtually a collectors' item. Professional book hunters receive a steady stream of requests: "Can you track this book down? Price is no object." Readers have had painfully little success in their hunt for this forgotten "classic" of art instruction, perhaps because those who own the rare original edition, published by Reinhold in 1935, are understandably hesitant to part with it.

Ever since the original edition disappeared from the bookstores, readers have written us, asking whether there might be some way of making this material available once again. The new edition of *Watercolor Painting Step-by-Step* is an attempt to do just that.

With the permission of the heirs to the Arthur L. Guptill estate, we have methodically gone through the watercolor sections of *Color in Sketching and Rendering* and excerpted all the relevant passages which are not covered in the previous edition of *Watercolor Painting Step-by-Step*. Thus, the new edition of *Watercolor Painting Step-by-Step* is virtually doubled in size, incorporating the best of two art instruction "classics."

The result is a watercolor handbook that begins on the most elementary level and carries the reader through to the advanced problems of the professional watercolorist. In short, the new, revised and enlarged edition of *Watercolor Painting Step-by-Step*—incorporating the watercolor sections of *Color in Sketching and Rendering*—is the most comprehensive watercolor text now available.

The Editors

Author's Note

WATERCOLOR HAS LONG been my favorite medium of pictorial representation—at least so far as my own painting is concerned—so whenever I have taught it, or have had the opportunity to write about it, I have been able to do so with unusual enthusiasm.

Why do I like watercolor so well? Partly because it always seems to me such a *joyous* medium. Good watercolor paintings are customarily so crisp and clean-cut, so spontaneous, so alive. Watercolor also seems to me a *miraculous* medium, permitting maximum results with a minimum of time and effort. The skilled practitioner can grab a big brush, dash it a few times across the sky, puddle some large areas with fascinating colors (often delightfully intermingled) onto other features, draw a bit with the edge of his brush, give the whole a dozen deft dabs and a couple of pats, and, there before you, in an hour's time or less, has developed a highly individual and amazingly expressive and attractive result—a spirited creation imprisoning for all to see a rare instant of time, an ephemeral mood of nature, a record of a mental conception.

This mere exhibition of the watercolorist's virtuosity is sometimes enough to take one's breath away. Facility, spontaneity, crispness, directness, color opulence—these are the words which come to mind when you watch a good man at work or view his results.

But there is an additional reason why I like watercolor. It is a *convenient* medium, always on instant call. I can keep a stretched paper behind the door and a color box in my desk. I may not use it for a month. But if that autumn foliage, with its reflection in the pond, urges me to action I am under way in a jiffy. If a fresh snowfall intrigues me, out comes my equipment again. In the meantime, it has been no care and it has not deteriorated. And all of this equipment is light in weight, easy to transport and easy to store. And it is available everywhere at a very modest price. Even the finished paintings are no problem. A year's output of the most prolific producer can be stored, unframed, in a single drawer or portfolio.

I could go on and on extolling the virtues of the medium, but I want to set one thing straight. Don't think for a minute that the virtuosity I was just talking about—the manual dexterity and the mental competence behind it—can be quickly acquired. Despite what I have said of facility and speed, it's not easy to paint a good watercolor even when you possess skill, and it's harder yet to gain that skill.

You may, to be sure, start with beginner's luck. I have seen occasional students produce results of near-professional quality at their very first

attempts. And you may, as you go on, have a fair share of what have so aptly been called "happy accidents," at times producing far better work, either in whole or in part, than you deserve.

Yet obviously you can't rely on either beginner's luck or happy accidents. You must *master* your art. You must start at the very beginning and learn the tools of your trade and what they will and will not do. You must stretch paper, draw lines and run washes with your brushes, learn to avoid "mud," to scrub off faulty areas, and a thousand such things.

And take nature, one's normal source of subject matter. You'll gradually have to learn what each of her subjects really looks like. You may think that you already know, but, unless you have painted before, you don't. Only when you try to play the game of approximating, with the limited facilities at your command, nature's multitudinous and diversified forms, tones, colors, and textures, will you realize how blind have been your eyes, how uncomprehending your mind, how deficient your technical means.

This getting to know nature and learning the fundamentals of watercolor representation won't all be fun, for you will have your trials and disappointments. Many things, though, will be simply fascinating. With a few hues you will create others. With a dozen strokes of a "split-hair" brush you will successfully catch the repetitive undulations of a plowed field. You will touch a flat brush into two or more colors on your palette and, in a single stroke on your paper, effectively render a tree trunk. You will swish a brush up and down and cause a mass of tangled grass or shrubbery to appear. You will drag a somewhat dry brush over your paper and instantly create the roughness, the weight, the immobility of a ledge or boulder. You will stick your finger into a paint puddle and manipulate the not-yet-dry color into a telling semblance of water reflection. You will discover the trick of leading the spectator's eye where you wish—into the foreground or background, to the right or to the left. You will develop the magic of shrinking a huge oak to a space an inch high or of pushing it a mile away. You will veil a subject in smoke or fog. You will catch a mood of loneliness, of tranquillity, of excitement, of mystery or romance. These are but indicative of the many treats in store for you. Every step forward will give a thrill.

But can this book tell you how to master all of this? Not exactly, and not entirely. But it's been my privilege to teach hundreds of watercolor students. I have learned their strengths and their weaknesses, their successes and their failures; these all run much the same year after year. And from this broad experience, I have discovered the basic and encouraging truth that *practically anyone, sincerely and persistently trying, can, before too long, turn out acceptable watercolors.* And the course which I gave these

students, revising it again and again as new needs suggested themselves, is, so far as is possible in print, what I'm offering on the following pages. But I can't do your work for you, nor can anyone else. You'll have to hold your own brush and perform your own exercises—preferably in the order of those which I prescribe.

However gratifying your progress, don't rest too soon on your laurels. You may not even be as good as you think, so if possible obtain at least occasional criticism from some qualified person. And as you proceed, keep before you always the goal of turning out some day supremely fine work. You may, or you may not, reach that goal. No one, least of all yourself, can as yet judge your capacity. But let me again assure you that, whatever your ultimate achievement—and I wish you every success—once you are well under way with the work recommended here, you'll enjoy rich rewards: satisfaction in the mere doing, and gratification over your finished results. And you won't be alone in your pleasure—painting and paintings are things to be shared with others.

Arthur L. Guptill

Part One

FUNDAMENTALS OF WATERCOLOR PAINTING

Chapter 1

CHOOSING
YOUR PIGMENTS

THE STUDENT ENTERING any new medium of pictorial expression for the first time should get to know something of the customary materials—the tools of his new "trade"—before he rushes into premature attempts at picture making. Since the scope of this volume is so great and the requirements of our readers so diversified, I think it would be most appropriate to discuss the selection, preparation, and care of watercolor equipment. After describing the materials, I recommend that you follow the exercises to familiarize yourself with the nature of the medium.

WATERCOLOR PAINTS

Watercolor paints fall into two different categories, generally termed *transparent* and *opaque*. For typical watercolor painting, the former are employed. We speak of transparent paints merely as *watercolors*. Opaque pigments are known under such names as *opaque watercolors, poster colors, show card colors, mat colors, body colors, tempera,* and *gouache.*

Since so many watercolor paintings are done with transparent pigment, it will be our main consideration in this book. More will be said about opaque pigments in the last chapter, "Unusual Methods and Materials."

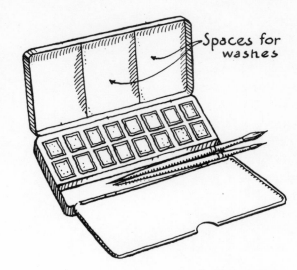

Spaces for washes

Figure 1
STANDARD'S SET *This is practical for the beginner: a set including box and brushes with hues well chosen.*

Whole Pan

Half Pan

Figure 2
PANS *These are enclosed in glass, porcelain, or metal, and come in many student watercolor sets.*

PAINTING SETS

The beginner often purchases his colors as part of a student's painting set which includes box and brushes. If of good quality, and if the hues are well chosen, these sets are satisfactory. Figure 1 shows a typical student's outfit. Sets with approximately twelve colors are popular. Refills are available.

Although there are similar fitted boxes of better quality, the advanced student or professional usually prefers to select individual pigments.

CAKES, PANS, OR TUBES?

Watercolor paints are available in several forms. First come the hard or semisoft types sold in pans (Figure 2) and cakes (Figure 3). This is the form which appears in many of the student watercolor sets. These must be softened with water each time they are used. Then we have the moist types of watercolor paints put up in tubes (Figure 4); these are preferred by most watercolor artists and are what we recommend. Considerably less familiar are powdered colors, "sticks" from which color can be rubbed, concentrated liquid watercolors, papers coated with soluble pigments, etc. Each type has its champions, though some of these last kinds of watercolors are used only for special purposes—for photo coloring, for example. Then there are jars of color, both dry and moist, most of them intended primarily for the poster artist or show card writer.

Of these pigments, cakes, pans, and tubes are the most common. Cake and pan colors are satisfactory if sufficiently soluble. Cakes and pans are at their best if you paint only occasionally or use little pigment at a time. A drawback is that they are often too hard. Again, they become daubed or saturated with other hues.

18

A great advantage of tube colors over those in cakes and pans is that each color comes from its tube clean and fresh. Tube colors also permit the quick preparation of amounts of color sufficient to coat large paper areas. (It is discouragingly slow, by way of contrast, to have to soften enough color from pans or buttons to cover only the smaller areas of your work.) Whatever your decision as to kind of paint, almost invariably considerable water must be added, the quantity depending on the depth of tone required. For dark or brilliant hues, relatively little water is needed. For most light tints, the color is greatly diluted.

BRAND OF COLORS

Practically every painter ultimately develops a personal preference for brand. In today's stiff competition, it seems safe to assume that any of the well-known brands will give satisfaction. Your choice may depend on what your dealer has to offer, though most dealers carry several lines. Or perhaps some teacher or artist friend will be the one to determine your choice. The main thing is to realize that, whatever the make, you get just about what you pay for, so the cheaper colors—sometimes known as "students' colors"—cannot be expected to be as satisfactory in the long run as those made for professional use. Professionals employ the students' colors to some extent, however, and many of them are capable of perfectly satisfactory work. Yet this work may be more likely to fade or otherwise deteriorate with time than that done with the better grades.

Eventually you may want to experiment for yourself with different makes and grades in order to determine the ones best suited to you. On the whole, though, it will prove safer to stick to one brand once you are familiar with it, for you will gradually learn exactly what to expect from every color of that particular make. Artists often learn with surprise and regret that a given color of one brand may be quite different in hue or consistency from some other manufacturer's product bearing the same or similar name. In other words, if an artist were forced to paint without his own familiar colors, he would find himself considerably handicapped.

Figure 3
CAKES *These are similar to pans because they both must be softened with water as they are used.*

Whole Cake

Half Cake

Whole Tube

Half Tube

Figure 4
TUBES *These are most satisfactory when you need a good amount of pigment and you want it clean and fresh.*

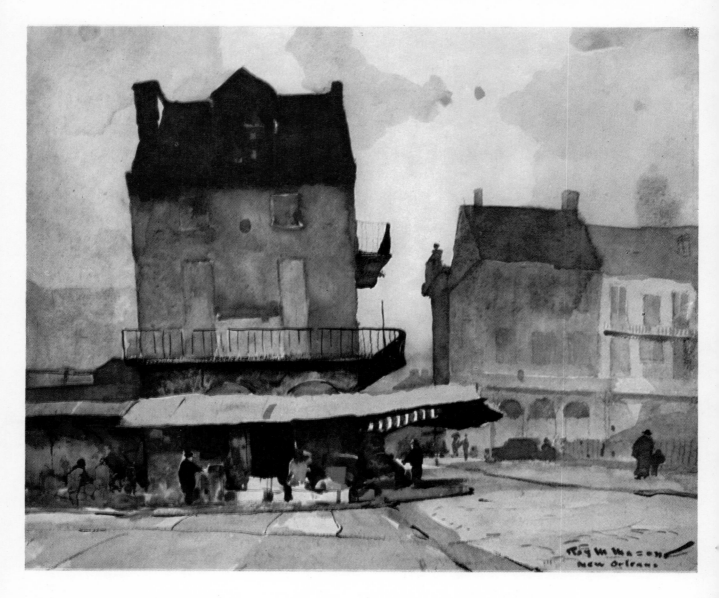

Roy M. Mason

FRENCH MARKET, NEW ORLEANS *In this very subtle watercolor, the range of color is surprisingly rich. Study the soft, violet-browns of the architecture, the delicate blues of the sky (which are placed with care to focus the composition), the warmer notes of the architecture and the street in diffused sunlight, and the brilliant accents of red, blue, and yellow beneath the awning. More color is here than it seems at first. (Collection, Norman Kent)*

Cakes, pans, and tubes are available in different sizes. Many companies provide large "studio" tubes, a size which is economical in the long run. There is enough variety in size for you to choose quantities suited to your needs.

PERMANENCE OF COLORS

Regardless of brand or cost, not all watercolor paints are permanent. Some will fade badly on long exposure to light, some very little, and some to no perceptible degree. Several manufacturers very wisely list their colors accordingly, so the artist has something to guide him. The more fugitive colors may be suitable for work of a temporary nature, though their use at any time is questionable, for the painter never knows how long he may wish to preserve even the most casual sketch or color note. (Later we shall offer simple means by which the artist can test his own colors for fading.)

Perhaps I should point out that certain colors, when mixed with one another, set up harmful chemical reactions. Apparently, few painters worry about this, or take the trouble to learn dangerous combinations, but the mere knowledge of this incompatibility will at least help to explain why some color areas in one's painting change greatly with the passage of time.

While the day has not yet arrived when we consider all watercolor paints permanent, there has nevertheless been a great improvement over the years. Watercolor paintings done today have a far greater chance of surviving unfaded than did those of not too long ago. When you realize that artists' paints come from all sorts of sources from all over the world, some animal, some vegetable, and some mineral, it is not hard to see what a variety of problems face the manufacturer. Today, greater and greater reliance is placed on the synthetic product created in the chemist's laboratory. Aside from all other considerations, several of these new colors are different in appearance from any previously available, some being extremely beautiful.

NUMBER OF COLORS

The manufacturer frequently lists a hundred or more colors. This is bewildering, so we offer definite selections or "palettes" below to guide you until you develop your own preferences. These palettes vary greatly in number of colors. It is surprising how much you can accomplish with only three or four colors. Nearly every color normally found in nature can be

approximated, if not precisely matched, through mixtures of three basic colors: red, yellow, and blue. These three colors are, therefore, frequently referred to as "primary" colors. (These must not be confused with the *light* primaries of the physicist, red, green, and blue-violet.) This holds true for all such color media as oils, watercolors, dyes, and inks. (All of the color work in this book, for instance, was printed with red, yellow, and blue inks, plus black for greater depth of tone.) Though beautiful paintings can be made with merely the three primaries, red, yellow, and blue, these are usually supplemented (even in student sets) with the secondaries, orange, green, and violet, plus brown and perhaps black and white. I urge the mature student, whether a beginner or not, to go beyond this total of nine, buying at least twelve or fifteen hues; for many purposes, twenty or more are better.

Varied color is not the only consideration. The artist seeks to represent not only the *hues* of the objects depicted, but such *textural* characteristics such as smoothness and roughness. He tries also to interpret vague things like the scintillation of sunshine and the vibration of atmosphere. He therefore chooses his colors accordingly. Some pigments contain sediment which produces a granular quality. Some pigments dye the paper in such a way that interesting effects are obtainable through scrubbing. Some, in mixture with others, tend to separate, giving unique results. Such peculiarities help the artist express the endless variety and complexity of nature: with too limited a palette he is handicapped.

SPECTRUM COLORS

Several makers offer sets of extremely brilliant pigments, usually graded or arranged to simulate the solar spectrum. Although these bright, clear colors are ideal for certain purposes—as in making color charts or painting vivid flowers or sunset effects—the student should employ them, if at all, only to supplement his regular colors. Spectrum colors should not be substituted for your regular colors because they have only limited use in most representational painting, where your normal task is to portray the somewhat neutral tones of everyday objects. Since most colors in nature are not garish, therefore, they can best be interpreted with paints which are to an extent already neutralized by the manufacturer. Spectrum colors also lack the desirable sediment already mentioned.

RECOMMENDED LISTS

Artists seldom agree on precisely which colors should constitute the palette. Henry Gasser, who not only is an outstanding painter but has for years

taught and demonstrated watercolor, says: "My palette varies according to the subject, but I generally use from eight to twelve colors. They are:

Cadmium yellow, light and deep	Indian red
Cadmium red, light	French ultramarine (blue)
Yellow ochre	Viridian (green)
Burnt sienna	Payne's gray
Alizarin crimson	Ivory black

"Colors such as cerulean blue, vermilion, Davy's gray and ochre are very helpful in controlling a wash when working on a wet surface."

Dong Kingman, another outstanding watercolorist represented on page 103, offers this:

"I choose about nine tubes of the best-made watercolor. I prefer it in the tube for it keeps fresher that way." The colors are:

Cadmium yellow, light	French ultramarine blue
Cadmium yellow, deep	Hooker's green #2
Cadmium red, light	Burnt sienna
Alizarin crimson	Lamp black
Prussian blue	

Jacob Getlar Smith, whose painting "May," is reproduced on page 235, offers the following, considerably longer lists with the advice, "If you choose at least one from each group there will be at your command a range of colors flexible enough for any desired result. Asterisks (*) indicate suggested palette."

1	2
*Cadmium yellow, pale or lightest	*Cadmium red, light or lightest
*Cadmium yellow, deep	*Cadmium red, deep
*Cadmium orange	Scarlet vermilion
Aureolin	Vermilion
	Rose madder (permanent only when not mixed with earth colors)

3	4
Yellow ochre	*Raw umber
*Raw sienna	Burnt umber
Mars yellow	*Burnt sienna

5	6
Venetian red	*Viridian
*Indian red	Oxide of chromium
Light red	

7	8
*Cerulean blue	Lamp black
Cobalt blue	*Ivory black
*French ultramarine	Mars black
Prussian blue	

Below is a brief description of some of the most popular colors; remember, not all manufacturers sell precisely the same hues under the same names. Perhaps I should repeat that artists occasionally buy water-color paints not for hue alone but because they contain sediment or possess other peculiarities which can prove extremely useful in producing "granular," "sediment," or "deposit" washes which are invaluable for certain purposes, as will be explained in a later chapter.

REDS

Alizarin crimson: Everyone needs at least one good bright red. This particular color is sometimes employed as a primary in making color charts. It is also especially fine for producing purples or violets in mixture with such hues as French ultramarine and cerulean blue.

Rose madder: A transparent color, somewhat more delicate than alizarin crimson. It is quite a favorite in painting flowers. Also mixes well with the blues.

Cadmium red: This, or cadmium scarlet, is often used today in place of vermilion, which has a tendency to blacken in impure air.

Light red; Indian red: A pair of similar hues with many uses where a slightly neutral red is needed.

Burnt sienna: This is on the border between red and brown. Mixed with French ultramarine, it produces most interesting sediment washes, valuable in texture representation. An extremely versatile color.

YELLOWS

Aureolin: A very bright, transparent color. A common choice as a primary in color mixing.

Cadmium yellow: Another bright yellow, slightly opaque. Also used as a primary. Does not mix well with all colors, however.

Yellow ochre: A great favorite. Not as brilliant as the previous two.

Raw sienna: Similar to burnt sienna as an aid in obtaining sediment washes in mixtures.

Cadmium orange: Bright.

Naples yellow: Very appropriate for certain limited applications. Somewhat opaque.

BLUES

Phthalocyanine blue: A bright color especially helpful in mixing greens. Various manufacturers sell this comparatively new hue under different names. It is gradually superseding Antwerp blue which is less permanent.

French ultramarine: An excellent all-around color.

Cerulean blue; Cobalt blue: Standard colors found on many palettes.

GREENS AND BROWNS

A reasonably adequate range of greens can easily be mixed from blues and yellows. But among the well-liked ready-mixed greens, *phthalocyanine green* has become a popular choice. *Viridian* is also a favorite. Among the browns, common choices are *burnt sienna* (listed above), *sepia, raw umber,* and *burnt umber.*

WHITES AND BLACKS

Chinese white has occasional uses, and one needs a good black or two, such as *ivory black* or *lamp black.*

Chapter 2

ADDITIONAL ITEMS
OF EQUIPMENT

WE HAVE SEEN from the *Author's Note* that a great virtue of watercolor painting is that it calls for only a few materials. These may be purchased almost anywhere; even the best are relatively inexpensive. They are easy to transport and to store; they deteriorate only a little with time (though paints in tubes will gradually harden); they are clean to use. Also, finished paintings, unlike those done in oil, are dry in a matter of minutes, so can be carried and stored without trouble. Nor does watercolor work (at any state of progress) smudge or dust off like that done with many forms of pencils, crayons, charcoal, and pastels. All of which makes watercolor a particularly convenient medium when working outdoors.

COLOR BOX

Though a box for storing your colors is not an absolute essential, it is certainly a convenience. But think twice before choosing yours, for there is a great difference between such boxes, and it is easy to throw your money away. Practically all boxes are of tin, black outside and white inside, but there the resemblance ends.

As I mentioned in the last chapter, the beginner all too often buys a

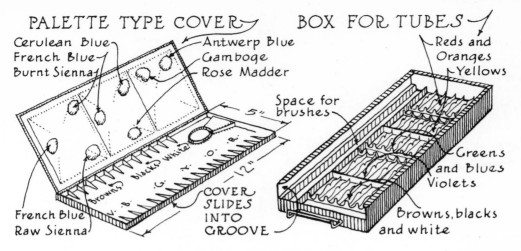

PALETTE TYPE COVER → BOX FOR TUBES →

Cerulean Blue
French Blue
Burnt Sienna
Antwerp Blue
Gamboge
Rose Madder

Space for brushes

French Blue
Raw Sienna

COVER SLIDES INTO GROOVE

Reds and Oranges
Yellows

Greens and Blues
Violets

Browns, blacks and white

Figure 5
AUTHOR'S COLOR BOX
This box holds thirty hues, and is really too large for the beginner.

"fitted box" ("watercolor set") which contains an assortment of cheap colors (cake or tube), and two or three inferior brushes. The cover has several depressions for mixing washes; also, there is often a flat surface on which to mix smaller amounts of color. Even if the box itself is good, these fitted boxes give one no choice as to either colors or brushes.

The more serious student, like the professional, often prefers to buy his box and colors separately. He will want a box large enough to accommodate at least fifteen to twenty tubes. Such a box is often provided with a palette-type cover which slides out to hold in the hand. This cover normally has many small "stalls" (one for each color) into which fresh paint may be squeezed as needed. The tubes remain in the box and so do not weigh down the palette. Both the tubes and the colors in the stalls are usually arranged by the artist in some logical way, perhaps in a "rainbow" or color wheel sequence such as we shall describe in a moment. Although my color box is unnecessarily bulky, the general style—as shown in Figure 5—is a good one. Boxes accommodating eighteen to twenty-four hues are usually better. For half tubes a much smaller size will do. Another palette box is sketched in Figure 6. This makes no provision for storing the tubes. A similar type reverses this arrangement, with stalls in the cover.

For pan colors, Figure 7 shows a suitable box. This, like many palette boxes, is manufactured in both right-hand and left-hand styles.

For outdoor sketching, the same box generally is suitable, though a small one, like that in Figure 79 in Chapter 16, can prove extremely handy, slipping into the pocket.

Figure 7
THUMB HOLE BOX
This is a palette box for pan colors.

Figure 6
THUMB HOLE BOX *This is a palette box which has no room for storage, but provides for mixing tube colors.*

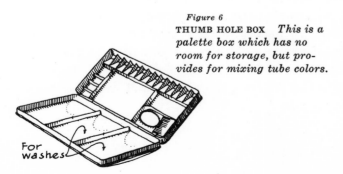

For washes

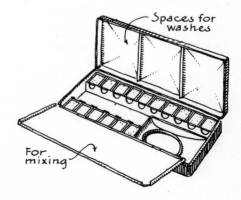

Spaces for washes

For mixing

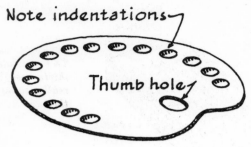

Note indentations

Thumb hole

Figure 8
THUMB HOLE PALETTE *Made of white china or metal, this palette provides ample space for holding and mixing colors.*

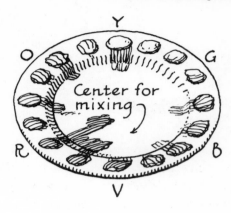

Figure 9
DINNER PLATE PALETTE *Here the artist can place his colors in a spectrum arrangement.*

Center for mixing

PALETTES

One of the greatest faults of the beginning aquarellist is timidity. He uses too little color. The limited accommodations of the typical color box do not encourage him to be as generous with his paint as he should. Therefore, if he can buy a watercolorist's palette (Figure 8) made with ample depressions to contain all of his colors, plus sufficient space for mixing all but large quantities of color, it can prove not only a great convenience but a definite factor toward the improvement of his work.

Sometimes, however, an artist feels that small depressions in a palette are more of a nuisance than none. He chooses, therefore, a flat palette or some sort of round dish—perhaps a dinner plate, as pictured in Figure 9. Such a palette or circular utensil has an outstanding advantage: it permits the arrangement of most hues more or less according to the spectrum, which makes it especially convenient when preparing the color charts or "wheels" often made when studying color mixing, matching, etc.

Figure 10
NEST OF SAUCERS *These are handy for mixing colors.*

China

COLOR CUPS

There are many kinds of vessels (in addition to color boxes and palettes) in which pigment is mixed. Among the most useful are the china saucers ("godets," as the French call them) pictured in Figure 10. They take little room, and can be "nested" with washes in them, preventing evaporation. Figure 11 pictures a type of tin cup which is inexpensive and practical; its width is approximately three inches. For small amounts of wash, the regular artists' tiles and slabs (Figure 12) do very well, many of them

Figure 11
COLOR CUP *This is an inexpensive and practical item for color mixing.*

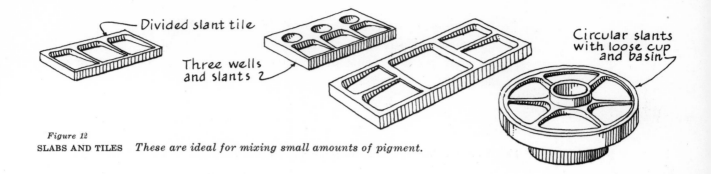

Figure 12
SLABS AND TILES *These are ideal for mixing small amounts of pigment.*

contain more "wells" than our sketches show. Muffin tins, as in Figure 13, are extremely popular, both for mixing large washes and as water containers. For mixing large washes, they are improved by lacquering with white, permitting true color judgment. Regular cups, sauce dishes, or bowls are ideal for the same purpose.

WATER CONTAINERS

For storing a supply of water in the studio, a white bowl, tin pail, drinking glass, muffin tin, or other suitable vessel is essential. Outdoors, a container of water, preferably provided with a cover or stopper to prevent spilling, must be taken along unless you are certain to be near a supply. Some painters like a thermos bottle, because this can hold enough water for both painting and drinking. (See Figure 82 in Chapter 16.)

Figure 13
MUFFIN TIN *This is a handy water container.*

"SETTING" THE PALETTE

Your pigments, whether they are in the form of a pan or tube, should be systematically arranged both in box and palette. The main thing is to decide before too long on a good arrangement and then stick to it, because you can save a great deal of time if you get into the habit of organizing your colors in the same way every time.

A common arrangement is based on the spectrum. The reds come first, then the oranges and yellows, next the greens, blues, and violets, and finally the browns, blacks, and whites. As you gain experience you may choose to group colors which you frequently use in combination; note the palette cover, Figure 5. For instance, you may like to mix French blue and burnt sienna, or alizarin crimson and cerulean blue. It will, therefore, be logical for you to have such pairs side by side on your palette for easy manipulation, so if you use one plate for a wheel-like arrangement, you may eventually have a similar supplementary plate for these associated pairs.

Figure 14
WATER CONTAINERS *A variety of household objects make ideal items for storing water.*

In another scheme, two major groups are arranged; the first consisting of colors which insure smooth, clear washes, and the other the heavy, deposing ones. As tube white dries quickly, it is best to squeeze it out only as needed.

BRUSHES

Brushes are particularly important. Cheap brushes usually prove a waste of money, so buy only the best; they will be a wise investment. You won't need many, and, given reasonable care, they will last a long time. Talk the whole thing over with your dealer, who can compare the different items in his stock for you. Of the several types commonly offered, artists differ as to preference. As we shall see later, your choice will vary with your method of working.

RED SABLE BRUSHES

Brushes of red sable are popular for many kinds of work. Of these, the round, sharply pointed ones (such as we picture at actual size in Figure 15) are perhaps the most useful; some painters employ nothing else. A good sable brush of the round type should, by the way, be uniformly round, and should keep a sharp point at all times. Unlike the cheaper camel's hair brush, which is flabby and fails to hold a point well, the red sable brush should be springy and resilient.

Sable brushes come in many sizes; manufacturers vary in their methods of designating such sizes. You will need at least three: small, medium, and large. As a safe rule, you should always use the largest brush possible for any particular piece of work. Except for fine detail, small brushes require too frequent dipping and are likely to lead into finicky techniques. For all-around work, a fairly large brush is good.

For quick, bold sketching, and for laying big washes (as on skies or backgrounds), a huge brush (Figure 16) is extremely useful, but costs so much in sable that one often feels forced to substitute something less expensive—camel's hair or squirrel's hair.

There are special needs when flat, square-pointed sable brushes are even better than the round-pointed type. They are great timesavers, for instance, when it comes to the representation of buildings or similar subject matter where squarish forms predominate. A single stroke can represent a window shutter, the side of a chimney, or even a large roof area. Three or four of these are, therefore, well worth having; they could vary from $\frac{1}{8}''$ to $\frac{3}{4}''$ in width. See Figure 17.

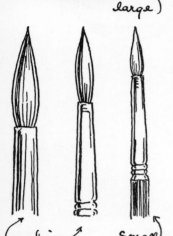

Figure 15
ROUND SABLE BRUSHES *Use the largest brush you can when you paint. The small one is good for very minute details.*

Figure 16
CAMEL'S HAIR DABBER *This is a reasonably priced brush which is indispensable when you do large washes.*

30

BRISTLE BRUSHES

For certain techniques, and particularly for scrubbing out highlights or correcting faulty passages, bristle brushes such as are commonly used in oil painting—much stiffer than sable brushes but otherwise quite similar in form—are just the thing. The flat ones appear to be generally preferred, though everything depends on purpose.

Whether the brush is round or flat, test each brush before you buy it. Wet it thoroughly. Shake it. Slat it. Does it look well made? Does it hold its point even with most of the water jarred out? Does it seem springy and responsive as you draw it across the paper, or is it dead and flabby? If it's not right, reject it.

CARE OF BRUSHES

As already mentioned, good brushes will give many years of service—but only if they receive proper care. Rinse them frequently as you use them. For maximum service, wash them thoroughly with mild soap and warm water when you put them away. Shake each one out—don't squeeze it—so that it assumes a natural form. Don't let brushes stand on their hairs for long, or dry in cramped positions. Don't try to soften hardened watercolor paint on your palette or color box by scrubbing it vigorously with your best brush. And moths, by the way, are all too fond of expensive sable brushes. Unless a new brush has been injured (as by moths) the hairs should be firmly embedded. If an old brush starts "molting," it can sometimes be cured by hammering the ferrule.

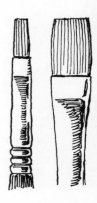

Figure 17
FLAT SABLE BRUSHES
Use this kind when you paint forms with straight edges.

EASEL OR DRAWING TABLE

Customarily, the artist—especially when working indoors—uses a suitable easel or table to support the stretcher frame or board on which his paper has been mounted or stretched. Don't make the mistake of buying the type of easel which holds a painting only in a vertical (or nearly vertical) position; that is, don't buy an easel designed for oil painting exclusively. Although occasional watercolorists can use this upright type of easel to advantage because they work rather "dry" (*drawing* their picture with brush strokes rather than *painting* it), most watercolorists work "wet" at least part of the time, applying their color in a liquid or semiliquid form. Such application calls for a support which is slanted only enough to permit "washes" of color to flow down the paper gradually, always under control of the brush. For this purpose, an incline of only five or ten degrees from the horizontal is usually ample.

For indoor work, you can manage very well with almost any available stand or table. Merely lay your board, stretcher, or block of paper upon the table top, raising the far edge by means of some support such as a book or two. Still more convenient is a draftsman's adjustable drawing table, such as we show in Figure 18, for this can easily be raised or lowered to any desired height and set at a convenient slope. Figure 19 illustrates a somewhat larger but less expensive type. Both can be used standing or seated; both store away in comparatively small space. A fairly satisfactory substitute is an adjustable "table easel," as shown in back view in Figure 20. This is placed on a table top.

For the professional artist who does large work, the combination drafting table and cabinet, Figure 21, is just the thing. The sketch is self-explanatory except at *A*, where a swinging arm with instrument shelf could be added. An adjustable stool is a fitting companion piece. Since this kind of table is bulky and expensive, the renderer often substitutes a large

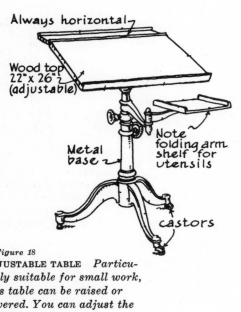

Figure 18
ADJUSTABLE TABLE *Particularly suitable for small work, this table can be raised or lowered. You can adjust the slope as well.*

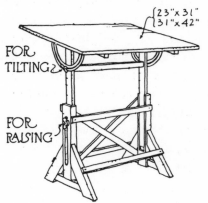
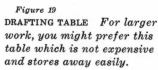

Figure 19
DRAFTING TABLE *For larger work, you might prefer this table which is not expensive and stores away easily.*

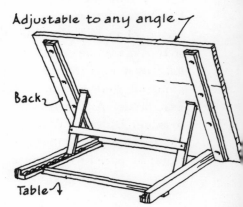

Figure 20
TABLE EASEL *The artist can place this tilt board on a table when he works.*

THE TOP TILTS
TO DESIRED
PITCH

Adjustable

Raising bars

Top 42"x84"

34"

30"
to
34"

A

Removable
partitioned
tray

Drawers
32"x42"x2½"

Raising or
leveling blocks

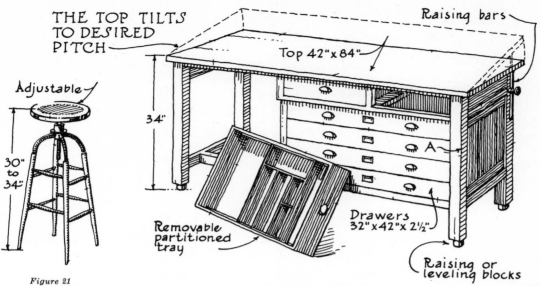

Figure 21

PROFESSIONAL DRAFTING TABLE *For the professional, this arrangement provides good storage space as well as a large working surface area.*

drawing board supported by a pair of horses: note the adjustable type, Figure 22. The board may be pitched slightly, or left flat, in which case the work is done on another board laid on top, blocked up the necessary five or ten degrees.

For painting outdoors, a folding easel, being portable, will usually be selected, but it should be the kind of easel that permits the firm support of the paper in the desired, almost flat position. Figure 23 pictures such an easel. Your dealer can supply you with something of this general nature. An "all-purpose" easel is good for both watercolor and oil, indoors and out. Be sure that the easel you buy is rigid, and that the legs are not only sturdy but adjustable to the irregularities of the ground. Any metal should be rust-resisting.

CABINET

Figure 24 pictures a handy cabinet for materials. Such a cabinet is frequently used in conjunction with a table of the type shown in Figure 18.

SKETCHING STOOLS

If you are to work in comfort, you will find a folding sketching stool of great convenience. These come in several styles, in metal or wood, with the seats usually made of canvas. (A second stool, by the way, can be used in place of an easel to support your paper.) Figure 25 pictures two kinds of sketching stools.

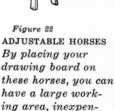

Figure 22
ADJUSTABLE HORSES
By placing your drawing board on these horses, you can have a large working area, inexpensive and easy to store.

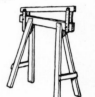

Figure 23
FOLDING EASEL *The field easel, designed particularly for outdoor painting, should be sturdy and rigid.*

Will tilt to any angle

Adjustable
to any
height

Pointed feet

33

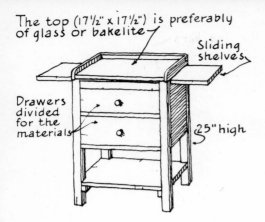

The top (17½" x 17½") is preferably of glass or bakelite

Sliding shelves

Drawers divided for the materials

25" high

Figure 24
ARTIST'S CABINET
Having a cabinet such as this enables you to have all your painting equipment in easy reach.

Figure 25
SKETCHING STOOLS *Either one of these stools would be a comfortable addition to your equipment.*

12" x 14" 7" x 14½"

Wood Steel

PENCILS

Since you will often use pencils for laying-out your subject on your paper, you should keep a small assortment on hand. The degree known as HB, being medium, is good for all-around work, though much depends on whether the paper is smooth or rough, damp or dry. (Don't attempt to draw with a sharp point on paper which is very damp; your pencil may cut right through.) For thumbnail or other preliminary sketches, a softer pencil—3B, for example—is better; it is rapid, and permits very dark values. Some artists prefer charcoal to pencil, both for speed and breadth of effect, and because charcoal work can so easily be altered.

ERASERS AND ERASING SHIELD

The eraser plays an important part in lightening tones and picking out highlights, to say nothing of its use in making corrections and cleaning the sheet. You will need several different types.

Particularly valuable is the erasing shield, because it limits the areas erased. The draftsman's style is best (Figure 26) with its openings of many shapes and sizes.

The erasing knife (Figure 27) or a sharp penknife is another aid worth having. With this tool you can scrape out details.

Thin metal Perforations

Figure 26
ERASING SHIELD *This item prevents you from erasing more than you want.*

Figure 27
ERASING KNIFE *This is a handy article, designed to scratch out small details you want to eliminate.*

PAPER CUTTER *The water-colorist always finds a need for a sharp edge to trim paper, to remove stretches, etc. This is perfect.*

KNIVES AND PAPER CUTTERS

A paper cutter (Figure 28) fills a real need when it comes to removing stretches from the board, trimming drawings, etc. A knife may be substituted, of course. Scissors, too, are handy.

A sturdy knife (Figure 29) for cutting mounted paper or heavy mat stock is helpful, too, as well as some of the devices which make use of discarded razor blades.

DAYLIGHT LAMP

Your work must be well illuminated at all times. Daylight is best when it comes from the north, being relatively clear and steady. Light from the left prevents disturbing shadows falling from hands and instruments. For work after dark, a "daylight" lamp should be placed to simulate the day lighting. The author has several of the type shown in Figure 30: a single one does quite well for most purposes. They cost very little.

Figure 29
KNIVES *You will find a good knife useful. Here are three types.*

BLOTTERS AND DUST BRUSH

Have plenty of blotters within reach. Set your color cups on them: keep one under your hand to protect the paper: touch your overcharged brush to them until just right; grab them in emergencies.

Dust your paper frequently. Particles of dirt, especially if of sooty or linty type, can cause real trouble. See Figure 31 for a handy style of brush.

SPONGE

A sponge is essential—not only for mounting paper, but for lightening tone, removing offending areas, and, on occasion, for applying pigment. Sponge brushes (Figure 32) are also used occasionally for applying pig-

Figure 30
DAYLIGHT LAMP *A lamp such as this one is the best substitute for day lighting, essential when you want to paint in the evening. Hang it from a bracket or cord.*

35

Figure 31
DUST BRUSH *Use this to help remove foreign particles from your paper. But use it only for these purposes!*

ment, or for scrubbing out highlights. They can scarcely be classed as essentials.

RAGS

Paint cloths (cheesecloth is good) are employed by some artists as much as blotters are by others. In the type of work where pigment is dampened and "wiped out" to form lights, the cloth often becomes an important instrument.

CLOTHESPINS AND SUCH

If you use unmounted or unstretched paper, you will probably tape it (at several points) or thumbtack it to a drawing board of suitable size— plywood or one of the stiffer types of wallboard may be substituted. Some artists use the portfolio in which they keep their paper as a backing, temporarily fastening the paper to it with clothespins or heavy spring clips.

HAIR DRYER

When painting indoors, the impatient artist can speed up the drying of his work by means of an electric hair dryer, with its flow of either warm or cool air. A small fan is a good substitute.

WHEN TUBE CAPS STICK

Dipping an obstinate cap in water (preferably hot) for a moment will generally loosen it from the tube. Heating the cap with a match will do the same thing even more effectively. Pliers are sometimes of help, but don't break your tubes open! Keeping screw threads clean will help prevent this nuisance from happening.

Wooden handle

Nickelled ferrule

Quill

Figure 32
SPONGE BRUSHES *For pigment application or for picking out highlights, you may find these useful.*

Whether you prefer, for outdoor work, to sit in the shade, or to create your own shade by taking along an umbrella, is of course a matter of choice. Don't use a brightly-colored umbrella; if you do, the light coming through it may be so modified that it will affect the hues of your painting, tricking you into errors. A white umbrella will do; one which is neutral gray or opaque is better. See Figure 33.

A wide-brimmed hat can prove invaluable, or, if you use dark eyeglasses, be sure that the lenses are neutral, not colored. For suggestions about additional equipment for painting outdoors, see Chapter 16.

These, then, are the principal items of equipment. You may not need them all, yet remember that you will have handicaps enough in your work without the added one of trying to get along with too few, or too poor, materials.

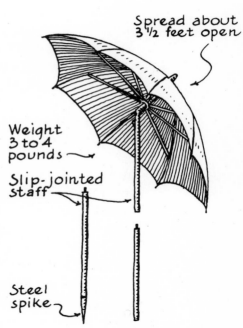

Figure 33
ARTIST'S UMBRELLA *When you sketch outdoors you may be glad you brought this along. It protects you from the sun and prevents the direct sunlight from distorting the pigments on your paper. Gray is a good color for the umbrella.*

Spread about 3½ feet open

Weight 3 to 4 pounds

Slip-jointed staff

Steel spike

Chapter 3

PAPER

UNLIKE OIL PAINTINGS, which are normally done on canvas, watercolor pictures are customarily painted on paper. This paper is manufactured especially for the purpose, and must be of exceptional quality. The papers generally used for watercolor painting differ from each other in many important respects. They are white or colored; rough or smooth; absorbent or non-absorbent; light or heavy in weight; handmade or machine-made. They are of pure rag stock, and so will prove durable, or of cheap stock which will cause them to discolor or otherwise deteriorate.

Paper not meant for the artist or paper which is primarily intended for other media is sometimes employed for watercolor work, particularly colored paper. Naturally, its quality varies greatly. The use of paper which is far off the white should be postponed until you have fair mastery over the white. I shall emphasize the customary white papers in this chapter.

IMPORTED PAPERS

Although there are a number of good American papers on the market (of a machine-made variety), a majority of discriminating watercolorists prefer—at least for their best work—almost any of the well-known imported papers, notably those from England, France, and Italy.

In what ways do imported papers excel? Being handmade of the very best rag stock, following methods passed down from father to son for

hundreds of years (and apparently not practical in this country), they have properties of toughness, long life, surface texture, etc., which apparently cannot be matched in America's machine-made products. Therefore, get acquainted with some of these imported papers. They will at least give you a standard for judging others.

SURFACES

The surface known as "cold pressed" or "C. P." (or in England "not pressed") is perhaps the best for all-around work. It has considerable roughness or inequality of surface (grain), yet not enough to prove troublesome. You can draw on it easily.

Where extremely fine brushwork is concerned, the smoother surface known as "hot pressed" or "H. P." is popular, though perhaps less sympathetic to larger washes. Hot pressed paper seems to show erasures or surface injuries more plainly than the cold pressed.

A third surface called "rough" or "R" is splendid for bold effects. Being heavily grained, it is ideal for the "dry-brush" technique. It is in demand for outdoor sketching.

SIZES

Watercolor papers vary in size, weight (thickness), and surface. As to size, the "imperial" sheet is a common one; this measures approximately 22″ x 30″. A slightly smaller sheet, the "royal," is about 19″ x 24″. The "double-elephant" is 27″ x 40″, while the "antiquarian" is 31″ x 53″. These are often halved or quartered by the artist or dealer to bring them to suitable picture size, though many paintings are made to the 22″ x 30″ dimension.

WEIGHT

Sheets vary from a rather flimsy 72 lb. weight to an extremely thick and heavy 300 lb. The lighter papers are of course the cheaper ones; not only are they more likely to become punctured or torn, but, in their natural state, they afford a less rigid surface which buckles annoyingly whenever water is applied. This makes mounting or stretching almost necessary, following methods which we shall investigate in the next chapter. Even the 72 lb. papers will stand considerable abuse if properly stretched or mounted.

Unscrupulous dealers sometimes sell the light paper (which is naturally relatively cheap) for the heavy. Beware of bargains! If you want to save money, it would be better to select "second" or "retree" sheets of fair weight than the first quality of thinner grades.

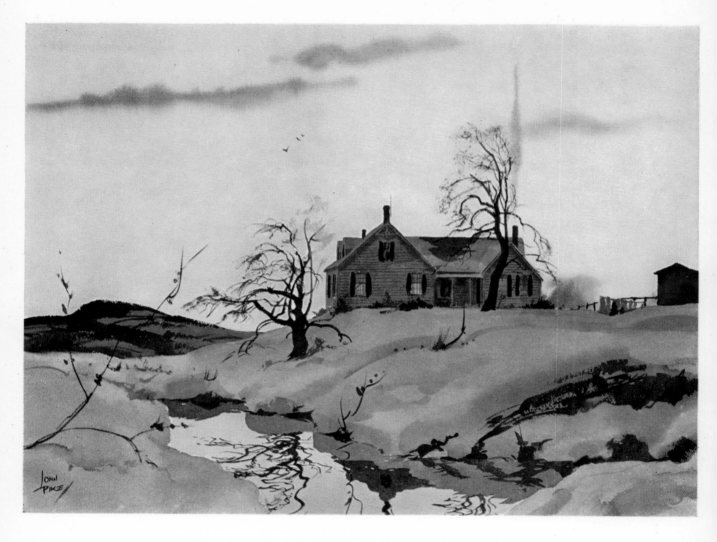

John Pike

WINTER EVENING *Note the ragged brush strokes of the dark accents in the foreground and the dark hill in the distance. In this semidry-brush technique, the artist exploits the texture of his paper by manipulating the brush so that the color sometimes strikes only the "ridges" and, at other times, settles into the valleys. The wispy clouds and chimney smoke were painted into a wet sky wash, which accounts for the blurred edges of these forms.*

CHOOSING A SHEET

Since all handmade paper varies in perfection, pick it with care if you want a fine sheet. Feel it for weight; examine it for equality of grain; inspect it (hold it to the light) for the watermark which proves it to be genuine, and search for specks, thin spots, lumps, or other defects.

WHICH SIDE UP?

Is there a right and wrong side to handmade paper? Strictly speaking, yes. If you hold a sheet to the light and can discover a watermark (usually the name of the paper) reading in the natural way—that is, from left to right —the top (working surface) of the paper is facing you. So far as general use is concerned, it apparently makes little difference which side of a handmade sheet you paint on, but some machine-made papers reveal a noticeable difference between front and back, the former being far superior to the latter.

MOUNTED PAPER

Since these "flat" papers must all be mounted or "stretched" by the artist before they can be used to best advantage (see the coming chapter), some papers can be purchased already mounted. Once you have decided on a brand, you merely ask for it in mounted form. Such mounted paper has two great advantages: it remains flat throughout the entire painting process, and is relatively easy to mat or frame. It is quite expensive, however, and, unless you place a high value on your time, it is cheaper to mount your own.

Professionals often fasten mounted sheets to their wooden drawing boards by means of small nails around the edges. This holds them straight and true and tends to make them dry perfectly flat.

Don't confuse mounted paper with "illustration boards" which tend to have smooth, unsympathetic surfaces. There is an inexpensive board known as "eggshell" which makes possible very interesting results, particularly if a fresh, direct technique is employed, as in quick sketching. It will not stand abuse.

MACHINE-MADE PAPER

Though machine-made paper is usually less satisfactory than handmade, it does have the advantage of availability in a greater range of sizes. Keuffel and Esser's "Paragon," for example (a drafting paper), comes not only in sheets of many sizes but in large rolls up to 72″ in width. From the

latter it can generally be purchased by the yard. This Paragon paper can be highly recommended, incidentally, as a heavy, hard sized paper of 100% rag stock which insures it against the brittleness and discoloration to which many inferior papers are subject. It takes pencil, ink, and watercolor well, and stands erasing far better than do many other machine-made papers.

Some inexpensive papers are so pleasing in texture that the artist selects them for temporary uses without worrying about durability. One such paper, popular for its rough texture, is known as "Morilla Board #1059" (distributed by the Morilla Company of New York).

WATERCOLOR BLOCKS

Many painters who don't mount or stretch their watercolor paper rely instead on prepared blocks, each consisting of quite a number of sheets (24 is common) glued by the manufacturer at all four edges. The artist of course paints first on the top sheet and then cuts this away, exposing the next, and so on. If the paper is sufficiently heavy, not too large, and securely fastened all around, the sheets may not buckle badly. Surely such blocks save the artist a lot of time, and are very compact and convenient, especially for work outdoors. They come in many sizes and several surfaces.

ODD MATERIALS

The beginner is urged to avoid at first such odd materials as window shade cloth, canvas, wood, mounted tracing paper, etc. These are all interesting and can do no harm at the proper time, but the common materials present problems enough for the moment, as you will soon discover.

Chapter 4
MOUNTING AND
STRETCHING PAPER

WE ARE NOW READY for some definite instructions on the methods of both hand mounting and "stretching" papers. Since most mounted papers are costly and limited in size, some artists prefer to mount their own.

MOUNTING

Here is a typical method of mounting: the selected paper is moistened until limp, with a sponge or by soaking in water; then it is pasted evenly all over the back with some water soluble adhesive, such as drawing board paste, bookbinders' paste, or diluted glue. The paper is then laid paste-side-down on heavy mounting board, previously dampened. Next, with a protective sheet of paper over the paper, it is rolled, scraped, or brushed vigorously enough to force all air from between paper and mount and to promote uniform adhesion. The paper is then weighted down (perhaps between two drawing boards loaded with books) where it can dry flat.

This often takes several hours. The mount will buckle if removed before thoroughly dry.

STRETCHING PAPER ONTO A FRAME

Despite the popularity of these mounted papers, the old-fashioned "stretch" is in even greater use, serving the same purpose. It is so economical and

practical that every student should master the art of making it. In stretching, only the *edges* of the paper are fastened down. There are several methods of going about this and every painter should master at least one method. Study the methods below. Try each method for practice.

In what is perhaps the simplest of these, the initial move is to assemble a wooden frame of the desired size, using for the purpose four of the stretcher strips sold for stretching canvas. This frame should be at least two inches smaller than the paper in both length and width. The next move is to saturate the paper until it has absorbed all the water it can hold. It is then laid flat on some clean, level surface and the frame placed upon it, centered to leave a uniform margin of paper all around. Working one edge at a time, this paper margin can now be turned up at right angles to the main surface of the paper and thumbtacked to the edges of the wooden frame, using tacks every two or three inches. Any extra paper can be trimmed away or folded onto the back of the frame and tacked. (When the paper is large enough in relation to the frame, it is sometimes folded to the back of the frame all around and thumbtacked there instead of along the edges. This practice insures a stronger job and is almost imperative when stretching large sheets, because they exert such a tension when drying that they may otherwise split or work loose or pull the stretcher frame out of shape, thus slacking the paper.)

As the paper dries, it gradually shrinks to drumhead smoothness. It is then ready for the artist. It will buckle to some extent each time he wets it (depending on its thickness) but will go flat again when dry. The finished painting should not be cut from the frame until it has dried for several hours, or it may wrinkle badly.

STRETCHING PAPER ONTO A BOARD

In another stretching method, favored by many artists, the thoroughly wet paper is first laid face up on a drawing board or sheet of heavy plywood. Heavy gummed tape is then used to fasten the paper to the board. The tape must run around the entire perimeter of the paper, equally overlapping both paper and board. The tape may be doubled or tripled for greater strength, especially if the paper is of sufficient size to indicate the possibility of developing excessive pull. As the sheet shrinks, watch the tape to make sure that it doesn't work loose. Rub it down repeatedly and reinforce it with thumbtacks if you think this advisable.

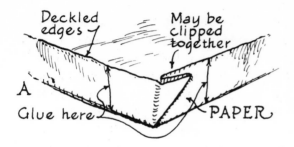

Deckled edges

May be clipped together

A

Glue here

PAPER

B

C

Figure 34
THE PAN METHOD
Here is how you turn up the edges when you stretch paper according to the pan method.

THE BOARD

The dampness involved in stretching paper onto a board is none too easy on the drawing board. A second-rate board will do, but it must be strong, clean, fairly smooth, and large enough to accommodate the paper when swollen to maximum size. For the beginner, a 16″ x 23″ board is ideal, accommodating a half-imperial sheet of paper, large enough for a big sketch or several small sketches.

For outdoor sketching, stretches are sometimes made on thin boards or even on wall board; in this case it is best to have a stretch on each side, both for convenience and to prevent warping.

Paper for stretching must be of good quality and fair weight or it may pull apart or split as it dries.

THE PAN METHOD

Sometimes—especially for large paper—still another stretching method is followed: the paper (in its original dry state) is first placed face up on a drawing board. Turn up three-quarters of an inch or so of each edge, creasing it until it stands erect. Figure 34 shows ways of folding the corners to complete a paper "pan." Next, with a clean sponge, wet the inside (bottom) of this pan—the working face of the paper—with clear water, keeping the inner faces of the upturned edges dry. After the sheet has received several spongings, the turned-up edges are coated evenly on the outside with glue or other powerful adhesive (library paste seldom has the necessary strength). Don't let the glue spread beneath the paper! Sponge the superfluous water from the paper pan, at the same time dampening the heretofore dry inner faces of the upturned edges. (Don't soak the edges *too* much on either the inside or the outside or they may fail to adhere.) Be sure the paper is placed straight and true; then press these edges down until they adhere to the board. As you do this, gently pull the entire paper surface as smooth as you can. It is soft in its saturated state, so don't pull too hard and tear it. If it does not come practically flat it is

too dry; dampen it again; allow a minute for the water to penetrate and try once more. When reasonably flat (shrinkage in drying will remove all minor wrinkles), rub the edges to the board with a knife handle to insure a firm bond. Thumbtacks are sometimes used to help hold the paper in place until the glue has set. This is all: as the paper dries it should shrink tight as a drumhead.

Such a stretch customarily needs no further attention until your work is completed; remember, in working, that the glued edges must be sacrificed when the paper is finally cut free. When the painting is eventually completed and thoroughly dry, the paper is cut through (with a sharp razor blade) about an inch from the edge and lifted free, perfectly flat and smooth, ready for matting or framing. (The glued paper strips which remain on the board can later be soaked in water until they come loose, when they may be easily removed. Glue on the board can now be sponged away, leaving the board smooth and ready for the next stretch.)

AN ALTERNATE METHOD

Lay your paper flat, face down, and dampen it to within an inch or so of each edge (don't turn up the edges). When it is well saturated, sop up the standing water, moistening the previously dry edges slightly at the same operation. Apply adhesive to these edges as a smoothly spread band three-quarters of an inch or so in width. The paper should now be quite flat: if not, dampen it some more, sponge up the surplus water, pick up the paper by the four corners (an assistant is valuable), invert it, and lower it carefully to the desired place on the board, being sure that no glue gets beneath the working surface. Proceed to strain and rub down as in the previous method.

In both these methods there is sometimes danger of the dry board sucking the moisture from the paper before the glue has set. To avert this, dampen the board before you place the paper on it, if you wish, and keep the paper moist for a while after it is in position.

FURTHER POINTERS

In still another method, the adhesive is applied directly to the drawing board in just the right position to receive the paper, previously dampened.

Again, stretches are made with gummed paper tape as a practical substitute for the glue. That about two inches wide, lapping well onto both paper and board, is best. Several thicknesses are sometimes employed in order to withstand the strain of the shrinking paper. Even when glue

is used, the tape proves a convenient reinforcement, which, covering as it does the rough deckling common to the edges of handmade papers, permits the T-square to glide over them easily.

BUCKLING PAPER

Whatever method of stretching you follow, your paper will quite likely hump somewhat after large or frequent washes are applied. Unless the paper is unusually thin or insufficiently strained, however, this buckling should prove negligible, and you can rest assured the surface will come absolutely flat again when dry. At the worst, the buckling will be less than with unstretched paper.

A WORD OF CAUTION

Stretches, especially when large, sometimes work loose, due to lack of glue, or buckle exceedingly because the paper was not stretched enough. On the other hand, it is possible, as we have already hinted, to stretch paper so tightly that it splits or tears, particularly if thin or of poor quality. Exposure to the heat of a radiator or to extreme cold is enough to shrink or contract paper to the breaking point. This all suggests reasonable care in both the preparation and use of stretches.

CUTTING OFF THE STRETCH

When you have finished a painting, leave ample time for it to dry before cutting it from the board. Stretched paper is very deceptive; though it may feel dry to the hand it may still contain enough moisture to cause it to cockle badly when released. After your last pigment is laid, let your paper stand an hour: all night is better. And don't cut it off on an extremely damp day unless you dry it artificially first.

The cutting may be done with knife, razor blade, or cutter (Figure 28 in Chapter 2). Don't cut one end and then the other, thus setting up a tension which may tear the paper, but follow around the sheet continuously, starting with a long side.

REMOVING THE GLUED EDGES

Don't scratch and scrape at the glued strips remaining on your board as so many beginners do. This is unnecessary. Tear away whatever paper comes freely; then soak the remainder thoroughly with water, going about some-

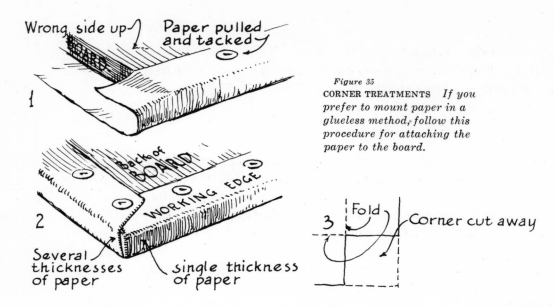

Wrong side up — Paper pulled and tacked —

1

Back of BOARD

WORKING EDGE

2

Several thicknesses of paper

single thickness of paper

3 Fold — Corner cut away

Figure 35
CORNER TREATMENTS *If you prefer to mount paper in a glueless method, follow this procedure for attaching the paper to the board.*

thing else for a few minutes while they soften. Wet rags laid on them will hasten this action. Soon they can be stripped away; wash the glue from the board and you are through.

A GLUELESS METHOD

If you particularly dislike the somewhat messy use of glue which our previous stretching methods involve, you may prefer another way. Select a board small enough to permit the paper to overlap it by about an inch and a half all around. Thoroughly saturate the entire paper; lay it on the board (or, if you wish, lay your board on the paper) and thumbtack these overlapping edges to the back. See Figure 35. As you do this, gently but firmly strain the paper. Tack it first at opposite centers, working gradually toward the corners. With heavy papers, cut out squares at the corners if you wish to prevent humps such as might interfere with the working of the T-square. Stretches of this sort are sometimes made over the frames (stretchers) used for supporting artists' canvas. The wedges at the back can be employed to force the paper quite tight; shrinkage will do the rest.

STRETCHING FRAMES

Theoretically, stretching "frames" (such as the one illustrated in Figure 36) should save the artist a great deal of time and trouble, for the paper is merely dampened, laid over the frame, and clamped in position by means of strips held in place by clips. The ones I have tried were disappointing, proving insufficiently rigid and permitting the paper to slip.

There is still another method of preparing paper for painting, occasionally referred to as the "Dutch" method because of its popularity at one time among certain Dutch artists. Wet blotting paper or a wet blanket is laid upon a sheet of glass placed horizontally. The paper, also wet or extremely damp, is laid on top, the subject having been previously sketched in pencil with the paper dry. The larger washes are applied to the paper while it is still damp; they merge and spread with many interesting accidental effects. As the paper gradually dries, the finer detail is added. All the colors must be used in greater strength than in other methods, as they seem less vivid when dry.

There are several variations on all these mounting and stretching procedures, one of which is fully demonstrated by John Rogers in Part Two. With a little experience you will discover a method that works well for you, permitting you to stretch your paper tightly so that buckling is minimized as you paint and the paper becomes absolutely smooth when dry.

WHY BOTHER?

Is all this effort absolutely needed? Must the artist so laboriously stretch his paper? No! Some artists—including prominent ones—never take the trouble. Yet, unless they choose a very heavy paper or employ what is known as a "dry" technique, using a minimum of water, they work under quite a handicap which takes a lot of knowledge to overcome. As their wet paint produces wrinkles on their unstretched paper, for instance, the pigment particles tend to float off the hills into the valleys. Unless these particles are redistributed by the brush or removed, they will dry there and, in the finished work, may reveal a definite trace of the original location of each wrinkle. In other words, the wrinkles not only have to be fought constantly as the work proceeds, but they may unpleasantly affect the appearance of the completed painting. This is only one of several negative factors involved when painting on "loose" paper, but enough to indicate the advisability of preparing in advance (at least for any effort of more than minor importance) the best possible working surface: the mount or stretch.

Figure 36
STRETCHING FRAME *This is a device which clamps the paper into place right onto the frame.*

SECTION A-A

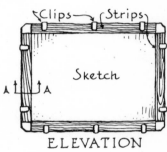

ELEVATION

Chapter 5

GETTING
UNDER WAY

NOW COMES THE FUN of our first painting exercises! Our immediate problem is to learn the common methods of applying pigment to paper. There are several methods: we can "run" or "lay" it on in the form of *washes;* drop it onto dampened surfaces, letting it spread or *mingle* with the water or other pigments; *stipple, dab,* or print it on with brush strokes usually laid side by side; *draw* it on by employing the brush in a linear manner; *roll* it on by rotating the brush; *spatter* or *spray* it on, etc. Sometimes watercolor is applied by means of a sponge, a bit of cloth or cotton, or even the fingers.

Before launching into painting, you would be wise to spend some time becoming acquainted with your materials. While there is no one best way of doing this, the following exercises, long tested through classroom use, afford a sound guide.

"TRANSPARENT" PAINTING

First, it should be clear that the type of watercolor painting which will receive most of our attention throughout this volume is the orthodox, traditional type often loosely referred to as "transparent" painting, in contrast to other types commonly called "opaque." (This latter term refers to the use of such opaque colors as gouache, tempera, casein, and show card

paint or regular watercolor thickened with opaque white. These are discussed in Chapter 25.)

It is self-evident, however, that no watercolor work is truly transparent. If that were the case, we would constantly see the white of the paper plainly through the color; we know that often the paper is hidden entirely. Keep in mind, therefore, that the term "transparent" is used by artists only for lack of a better one, and is relative. Perhaps "translucent" or "semi-opaque" would be more suitable. Only when paints such as we deal with here are greatly diluted with water do they approach true transparency; when less diluted, they are translucent; when employed full strength, they are opaque (or nearly so). One of your first experiments is designed to test your different paints in order to learn how nearly transparent each one is.

METHODS OF APPLICATION

As a preliminary to this, however, let's examine the several common ways in which the artist applies his watercolor paints to his paper. This is a basic matter which should be fully understood from the start, so the reader should carry out exercises of his own to test all of the procedures here presented.

Exercise 1: Line Work
First, the artist often lays his color on in what might be called a linear manner. In other words, he "draws" his color into place using strokes of his brush. These strokes may vary in width from a hair line (*A*, Figure 37) to an inch or more (*B*). They may also vary greatly in length and direction, some long, some short; some straight, some curved; some wavy or irregular (*C* and *D*). Similarly, some lines may be sharp (*C*), some soft (*E*), some uniform, some graded (*F*), some broken (*I* and *J*). They may differ in color and in value. Such lines will also show contrasts of texture, these being determined very often by the surfaces of the papers used. Try many such lines, working for variety.

Exercise 2: Dry-Brush Work
If, in such linear work, the brush is dipped frequently into paint which is thin and liquid, the strokes will be quite sharp and clean-cut (*G*)—unless, of course, the paint is extremely pale. If, however, the brush begins to run out of paint, or if the paint was originally thick, the brush strokes will be ragged and broken (*K*), particularly if the paper is rough. Experiment in this direction.

These latter strokes, or paintings developed mainly through their use,

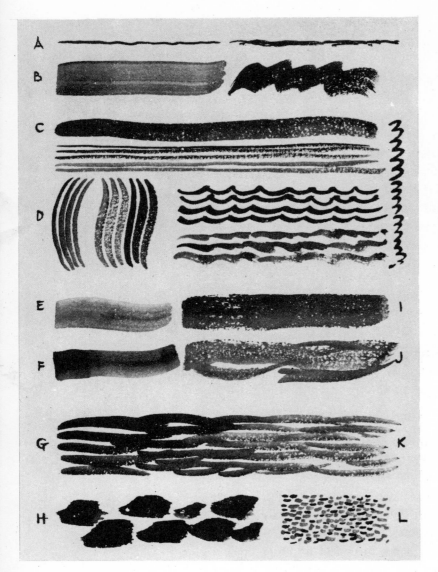

Figure 37
LINE AND DRY-BRUSH WORK
Strokes A *to* J *illustrate various kinds of lines. Line G-K shows what effects are produced when the brush runs dry.* H *and* L *are produced by dabs and stipple respectively.*

are designated as "dry-brush" work. Though relatively few watercolorists paint entirely in dry-brush, many use it occasionally, particularly for the development of textures of such things as rough building materials, the bark of trees, and coarse cloth. Foliage can often be represented to advantage through this dry-brush technique.

Exercise 3: Dabs and Stipple
As a variation of the linear approach, the artist may "dab" his color in place, merely touching his paint-laden brush to the paper again and again

(*H*). By varying his kind and size of brush, and his brush position or pressure, he can produce an amazing variety of brush marks.

Occasionally artists paint some passages through the use of hundreds of tiny brush marks placed side by side in close proximity. This type of work (*L*) is called "stipple" or "stippling." By contrasting these juxtaposed colors, following much the system used by the French Impressionists, and known as "pointillism," painters are able to set up a sort of vibration or scintillation sometimes useful in obtaining atmospheric effects, appearances of distance, or suggestions of movement as in foliage. (More will be said about stipple in Chapter 21.) Try these dabs and dots for yourself.

SPATTER AND SPRAY

Now and then the artist may spray color onto either the whole of a painting or a part of it. He may use for this a mouth or bulb atomizer, or the mechanical device known as the airbrush. Or he may spatter paint onto certain areas. These are but occasional expedients, not to concern you at this early stage, but I will discuss them again in Chapter 21.

MINGLING

To achieve a variety of hues, values, and intensities (terms which will be discussed in following chapters), you can mingle the pigments—mix the colors on your paper. This is done by dropping two or more colors from your brush onto the paper, permitting the colors to flow into one another. You control the flow of pigment with your brush or by tilting the board, allowing some areas to mix more thoroughly than others. In some areas the colors may be full strength, in other areas mixed only slightly, or diluted heavily with water.

Exercise 4: Wash Work

Aside from these various kinds of lines, dabs or dots, which together make possible one basic type of watercolor painting—a "drawn" or linear type— we have another wholly different yet equally basic "painted" or "wash" type. In this, the brush—usually of considerable size—is employed to convey quite a puddle of liquid paint to the paper, this "wash" then being brushed (or allowed to flow under control of the brush) over quite a large area of the paper. The paint is added a brushful at a time as needed, or reduced (picked up by a partly dry brush and wiped off on a rag or blotter) as the limits of the area are reached. Such washes, when applied and dried, may be either "flat"—that is, uniform throughout (*A*, Figure 38)—or "graded"

A B

(Fig. *B*). If the latter, the gradation may be from light to dark, from dark to light, or from one color to another.

It is something of a trick—and a very valuable one—to learn to "run" or "lay" a wash efficiently, especially when the paper area to be covered is large or irregular in contour. At the very beginning you should spend several hours getting a start at mastering this art—one at which even professionals are sometimes not too proficient.

Some paints, whether alone or in mixture, are much easier to handle in the form of washes than others. The coarser the pigment particles, or the greater their tendency to separate or to settle to the bottom of the prepared wash, the more difficult one may find it to run the wash. Never forget, in doing wash work, to stir, stir, stir your paint.

APPLYING THE FLAT WASH

As a preliminary to laying a flat wash, mix enough color ahead of time to cover the desired area completely. Next pitch the board at an incline just sufficient to permit the wash to flow slowly without danger of running out of bounds or off the paper. The area to be filled with wash is customarily outlined in pencil. The artist's aim is to coat this area precisely with a tone uniform throughout. As a preliminary to this, it is sometimes well to wet the area with clear water, brushed exactly to the boundary line. (This preliminary wetting is not always done; it proves most valuable when one seeks nearly perfect results.) As soon as the shine has died down, but while the paper is still damp, the wash can be started.

Dipping a large and sharply pointed brush, give it a shake or two (over your color cup) so as to get rid of surplus paint and thus prevent the brush from dripping on your paper. If it still seems too wet, you may touch the point to the inside top edge of the cup, or to a rag or blotter. Then put brush to paper lightly and carefully, usually at the upper left-hand corner of the area to be painted (if you are right-handed). Then stroke it deliberately to the right (when you do this, don't get nervous and hurry!), dipping it once or twice—or as often as necessary—to form a wet

"puddle." With a puddle thus formed all the way across the top of the area, re-dip your brush and start once more at the left. With some paints, it is best merely to touch the point of the lower edge of the established puddle, painting another band to the right, allowing the puddle to flow down of its own accord (Figure 39). The brush should be dipped often enough to maintain a good wet puddle at all times.

With other paints—especially those containing pigment particles which tend to settle to the paper surface very quickly—it may prove better for you to work back into the lower part—but only the lower part—of the area first painted, using, perhaps, a round-and-round stirring movement of the brush just as though you were painting small circles. (An up-and-down motion is sometimes substituted.) As you gradually proceed from left to right in this way, the puddle should flow down uniformly to re-form at the bottom. Never forget that in order to maintain an adequate puddle you may need to dip your brush again and again; you *must* keep the puddle wet. The main thing to avoid is the drying out of part of the area too soon.

Now return once more to the left and proceed as before, gradually supplying just enough paint to keep the puddle wet as you paint this third band across. (The upper areas which were first painted will soon begin to dry. Don't go back into them once they start to set—and lose their shine—or you will be in trouble.) This entire procedure should be repeated as necessary until the designated area has been nearly filled.

STOPPING THE WASH

As you approach the lower boundary line, your job (aside from painting exactly to the pencil boundary—a thing which it is good practice to try to do at all times) is to take up any surplus paint which may flow down to make the puddle too wet along the lower edge. As has already been hinted, you do this by drying your brush slightly—touching it to blotting paper or a rag—after which it will absorb the surplus paint. In this, you should

Figure 39
APPLYING THE FLAT WASH
You control the flow of the puddle with the tip of your brush.

work with an especially light hand, trying not to disturb any pigment particles which may have set. And don't "lift" *too much* paint, or the lower edge of the washed area will dry too soon and paint from above may streak down across it, preventing a uniform result. Yet if you fail to absorb the surplus moisture, the area above the puddle will become dry, and the puddle may creep back over it to form a blemish.

When you start this practice for yourself, if your first wash doesn't dry out uniformly, you simply haven't acquired the proper knack. But don't let it annoy you. Try again and again. With practice you will soon develop this extremely valuable skill of running a uniform wash. Much will depend, however, on the size of your predetermined area. It is an easy thing to run a satisfactory wash a few inches in size and quite another to cover successfully a large area—an entire sky, for instance.

GRADED WASHES, LIGHT TO DARK

Graded washes are even more difficult, though much the same general procedure is followed. For a large graded wash—a sky, again, or a large area of lake or sea—the artist sometimes mixes a number of color cups of wash, each a little darker than the previous one. He builds his puddle with the lightest wash, then shifts to the next and so on. With practice, he can learn to create in this way a gradual transition from light to dark (or from one color to another).

GRADED WASHES, DARK TO LIGHT

Some prefer to work from dark to light. If so, they should of course reverse the order of using this premixed color. Not infrequently, they grade dark to light and back again, or the reverse. In the case of color, they similarly grade from one hue to another, then to a third, and so on.

If an area is comparatively small, it is seldom necessary to prepare the cups of color in advance. If you have learned always to keep your wash wet, you can probably master in a few attempts the trick of increasing or decreasing any given color in order to secure uniform gradation. Often you can add paint or water from time to time to your pool or puddle on your palette, thus reloading your brush with paint of the right hue and value.

SEDIMENT WASHES

We have already mentioned that some of your watercolors possess more sediment in the pigments than others. These granular colors—which you

will discover as you get acquainted with your pigments—can sometimes produce desirable qualities in the washes. Unlike the clear wash, the sediment wash is speckled with pigment, a marvelous effect when you desire it. Furthermore, these sediment washes can be laid one on top of another to produce even more interesting effects. However, you must be well acquainted with your colors to use these washes effectively.

Exercise 5: French Method

It is extremely hard, even when working in monochromatic (one color) wash, to carry a sudden grade across the narrow dimension of a long rectangle or similar form. In one method, sometimes called the "French" method, true gradation is simulated by superposing a series of flat washes, each a little narrower than the previous one. Very faint parallel pencil lines are sometimes first ruled as a guide. This method is particularly well suited to many architectural purposes, as in cornice shadows where lines of moldings can be utilized to bound the various washes. Practice this method, both in monochrome and color.

Exercise 6: Overlapped Grades

In narrow areas where you desire to grade from one color to another across the narrow dimension, your problem is often simplified if you utilize a pair of overlapped graded washes. You can start a yellowish or orange wash (for reflected light) at the top of a cornice shadow, for instance, and grade quickly to pure water. Or, with the board reversed, you can run the wash from water to yellow. When dry, a wash of the second color—perhaps blue-gray—can be laid in the opposite direction in the same manner, the final effect being yellowish at the top grading to bluish at the bottom. Experiment sooner or later with this sort of gradation.

Exercise 7: Two Stroke Grades

Occasionally on these long, narrow spaces which are to be graded crosswise, you can simply draw your brush, laden with some selected pigment, quickly but steadily the whole length of the area to be toned, covering about half the width of it, immediately following this (before the wash has set) with an overlapping stroke of the second pigment, covering the rest of the area. With practice, a good grade can be produced. Why not try your hand at this?

Exercise 8: Superposed Grades

You have attempted running fairly large, flat washes, one on top of another. Do the same thing now with grades. Remember to wait for the first to dry thoroughly before adding the next, and work fast and lightly. You will

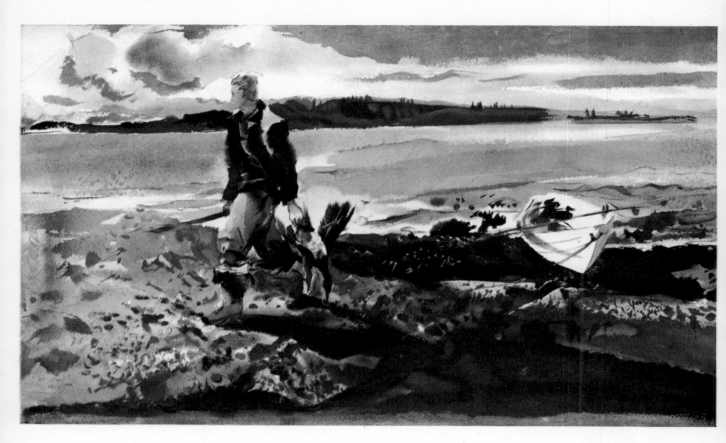

Andrew Wyeth

COOT HUNTER *In recent years, Andrew Wyeth has won his greatest reputation for meticulous paintings in tempera. However, he first gained public notice for lively, richly textured watercolors. The spontaneous brushwork of the foreground is a particularly interesting blend of long, fluid strokes and dabs of dry-brush. The sky combines strokes on dry paper with wet-in-wet effects. The boat is bare, white paper with just a few touches of dark, deftly applied.*

Figure 40
DOUBLE WASH *This is one way to achieve a light-to-dark gradation. The pair of washes at A-A have been graded equally and brought together at B, perfectly blended.*

WRONG·SIDE·UP

discover that whereas some beautiful tones can be built up through superposition of wash on wash, certain pigments do not accept graciously this sort of treatment. For most purposes, direct effects are considered better than those obtained through superposition, but there are many exceptions.

Exercise 9: Simultaneous Washes

It frequently happens that pigment must be applied to an area so broken in shape that it is necessary to run two or more like washes simultaneously. If you are painting a building with a dome or tower, for example, and you invert your paper in order to grade a sky from light at the horizon to dark at the zenith, you will probably find it advisable to start a pair of washes, one on each side, as indicated in Figure 40, *A-A*, grading them so equally that when brought together, they will blend perfectly. The usual method is as follows. Try it. Advance one wash an inch or so; then the other. Next, darken your saucer of pigment a bit and advance both washes. Continue this alternation, using darker and darker pigment, until the two washes meet to form one, and proceed from this point in the customary manner. If the dome or tower profile is complex, a small supplementary brush is handy in bringing the washes exactly to it.

If your sky is to be flat rather than graded, you can substitute one wash for the two, turning the board as indicated in Figure 41. Begin the wash, as at 1 (*A*), gradually rotating the board, advancing the wash to *B;* the arrows show the approximate direction of flow. Finally swing the board to position 3, completing the wash at *C:* the portion at *A* must be dry by this time or there is danger of runbacks.

Let me stress once more that this matter of wash laying is very important. Stick to it (even if it takes a week) until you can lay a wash of any size and kind. Many painters are needlessly handicapped for half a lifetime because of failure to acquire this knack of laying flat and graded washes.

Figure 41
ROTATION OF BOARD
This is one way to do a flat wash: turn the wash from A to the board, advancing B to C.

1

2

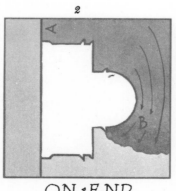

3

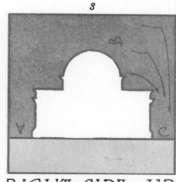

WRONG ·SIDE · UP ON ·END RIGHT· SIDE ·UP

Chapter 6

GETTING
ACQUAINTED WITH
YOUR WATERCOLORS

AS YOU EXPERIMENT with your different paints, you will discover that each has highly individual characteristics, not only of hue but of texture, amenability to mixture with other colors, etc. Before you undertake actual paintings, it is logical for you to play around with each paint in turn, carrying out exercises on the order of those which follow. In this way, you will discover how each color looks in its full strength, as diluted with varying amounts of water, or as darkened with black. You will learn how each color mixes with every other color. You will find out which of your colors are absolutely clear and which possess sediment, producing a granular quality which, for certain purposes, is highly desirable and, for others, distressing. You will observe that some paints so dye the paper that they cannot be removed easily, while others are so soluble that, following application, they can be wet with water and blotted or wiped away with little effort.

Inasmuch as various brands of paint differ from one another in all these characteristics, we can give you only general suggestions. You must learn through experimenting with your own paints.

Exercise 10: Comparative Washes
Choose a fairly large sheet of watercolor paper—half-imperial (15″ x 22″) will do nicely. On this, draw as many small rectangles as you have colors in

your palette. (See the First Pigment Practice Sheet, reproduced in color on page 62.) Then fill each rectangle with a wash, graduating from almost pure water at the top to the strongest color of which the pigment is capable. For ease in comparison, group your reds, yellows, blues, greens, and browns. You will learn a lot from merely making the chart, and when it is finished it will be a valuable reference from which you can discover, at any time at a glance, the hue and intensity of each of your colors in full strength and as diluted. From this, study the colors to see which seem compatible with each other, which seem more granular, etc.

Exercise 11: Superposition of Color
In making watercolor paintings, it often becomes necessary to paint one color over another. Not only are many new hues thus created, but textures of various types are developed, some of them pleasing and others offensive. Not all colors work equally well when thus superimposed; sometimes the foundation color is dissolved by the superimposing color and a muddy effect results. Some colors are so opaque that they tend to hide any color beneath. For this reason, we suggest that you make a test with every color in your palette by applying it as a narrow band and then crossing it with every other color. This will give you a dozen or more bands not unlike those in the Second Practice Pigment Sheet, page 63.

From such a test, a number of things can be learned. For example, it will be noted that the order of superposition is important. In Figure 42 a band of yellow ochre was first applied (1). French blue was next washed over it (2). When dry, a band of yellow ochre was washed over the French blue (3). Although the blue flowed over the yellow with little damage, the yellow, when passed over the blue, dissolved and streaked it.

Artists troubled with getting muddy or otherwise disappointing color in their paintings should experiment extensively along these lines, for here may lie the key to their difficulty. They will find that when several colors are applied one on top of another, "mud" often results because the first applications are dissolved by, and merged unpleasantly with, the subsequent work. This shows us that in making finished paintings we should work as freshly and directly as possible, avoiding a build-up of layer on layer of paint. Or we should use for foundation washes only those paints which we know to be resistant to later overpainting.

Figure 42
ORDER OF SUPERPOSITION *Both stripes, 1 and 3, were painted with yellow ochre. The yellow did not streak when French blue (2) was washed over it. But the yellow did streak when it was washed over the blue.*

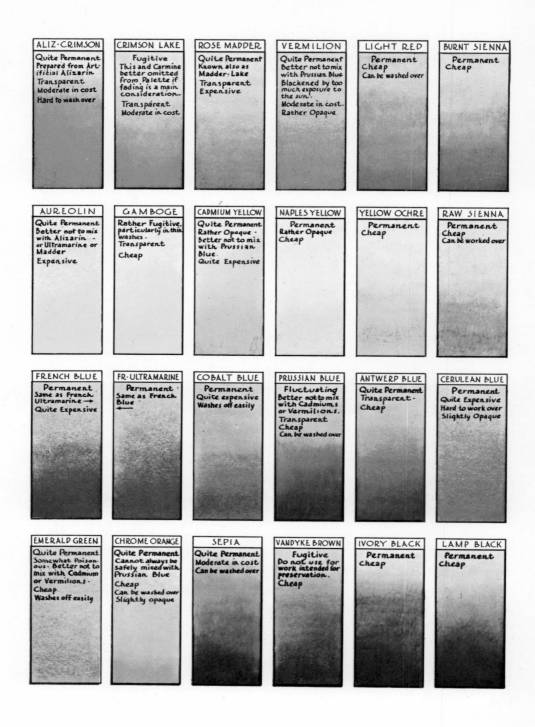

ALIZ·CRIMSON	CRIMSON LAKE	ROSE MADDER	VERMILION	LIGHT RED	BURNT SIENNA
Quite Permanent Prepared from Artificial Alizarin Transparent Moderate in cost Hard to wash over	Fugitive This and Carmine better omitted from Palette if fading is a main consideration. Transparent Moderate in cost	Quite Permanent Known also as Madder-Lake Transparent Expensive	Quite Permanent Better not to mix with Prussian Blue Blackened by too much exposure to the sun. Moderate in cost. Rather Opaque	Permanent Cheap Can be washed over	Permanent Cheap

AUREOLIN	GAMBOGE	CADMIUM YELLOW	NAPLES YELLOW	YELLOW OCHRE	RAW SIENNA
Quite Permanent Better not to mix with Alizarin - or Ultramarine or Madder Expensive	Rather Fugitive, particularly in thin washes. Transparent Cheap	Quite Permanent Rather Opaque - Better not to mix with Prussian Blue. Quite Expensive	Permanent Rather Opaque Cheap	Permanent Cheap	Permanent Cheap Can be worked over

FRENCH BLUE	FR·ULTRAMARINE	COBALT BLUE	PRUSSIAN BLUE	ANTWERP BLUE	CERULEAN BLUE
Permanent Same as French Ultramarine → Quite Expensive	Permanent Same as French Blue ←	Permanent Quite expensive Washes off easily	Fluctuating Better not to mix with Cadmiums or Vermilions. Transparent Cheap Can be washed over	Quite Permanent Transparent - Cheap	Permanent Quite Expensive Hard to work over Slightly Opaque

EMERALD GREEN	CHROME ORANGE	SEPIA	VANDYKE BROWN	IVORY BLACK	LAMP BLACK
Quite Permanent Somewhat Poisonous- Better not to mix with Cadmium or Vermilions - Cheap Washes off easily	Quite Permanent Cannot always be safely mixed with Prussian Blue Cheap Can be washed over Slightly opaque	Quite Permanent Moderate in cost Can be washed over	Fugitive Do not use for work intended for preservation. Cheap	Permanent Cheap	Permanent Cheap

FIRST PIGMENT PRACTICE SHEET *Make a graded wash with each of your colors and make notations about their characteristics. Keep your chart nearby for handy reference.*

62

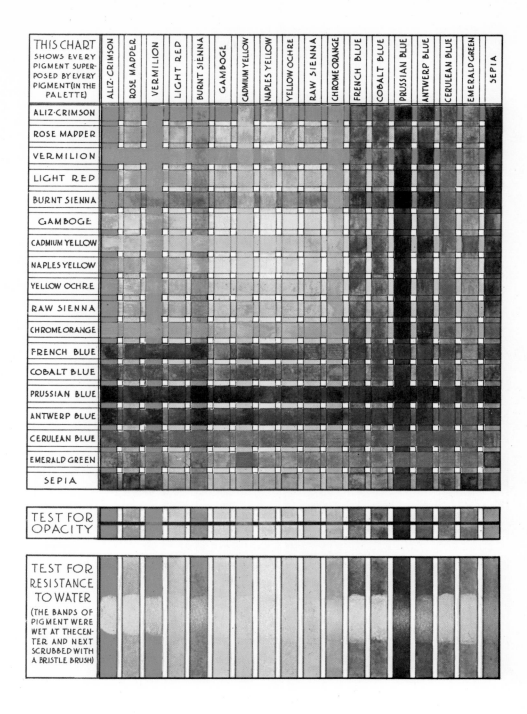

THIS CHART SHOWS EVERY PIGMENT SUPERPOSED BY EVERY PIGMENT (IN THE PALETTE)	ALIZ-CRIMSON	ROSE MADDER	VERMILION	LIGHT RED	BURNT SIENNA	GAMBOGE	CADMIUM YELLOW	NAPLES YELLOW	YELLOW OCHRE	RAW SIENNA	CHROME ORANGE	FRENCH BLUE	COBALT BLUE	PRUSSIAN BLUE	ANTWERP BLUE	CERULEAN BLUE	EMERALD GREEN	SEPIA
ALIZ-CRIMSON																		
ROSE MADDER																		
VERMILION																		
LIGHT RED																		
BURNT SIENNA																		
GAMBOGE																		
CADMIUM YELLOW																		
NAPLES YELLOW																		
YELLOW OCHRE																		
RAW SIENNA																		
CHROME ORANGE																		
FRENCH BLUE																		
COBALT BLUE																		
PRUSSIAN BLUE																		
ANTWERP BLUE																		
CERULEAN BLUE																		
EMERALD GREEN																		
SEPIA																		

TEST FOR OPACITY

TEST FOR RESISTANCE TO WATER (THE BANDS OF PIGMENT WERE WET AT THE CENTER AND NEXT SCRUBBED WITH A BRISTLE BRUSH)

SECOND PIGMENT PRACTICE SHEET *This chart is a systematic method of superposing every pigment in the palette to test their reactions to each other.*

63

Exercise 12: Water-Resistance Test

The last line in the Second Pigment Practice Sheet carries this thought still further. Parallel bands of all the colors of the palette were first applied and allowed to dry. Then water was carried across them with a stiff bristle brush, using a scrubbing motion. Some colors immediately dissolved and were almost entirely washed away. Other colors resisted the water. Try this for yourself. These latter colors would obviously be the best ones for foundation washes in a painting—the first to be applied—while the others might better be reserved for subsequent application.

Exercise 13: Opacity of Color

In the line of the Second Practice Pigment Sheet marked "test for opacity," a line of black waterproof ink was painted across the paper. This was then superimposed with various colors. Some of these—cadmium yellow and emerald green, for instance—nearly hid the line. Such opaque colors can be very valuable when you wish to hide or disguise unpleasant passages but should not be used in full strength when you want an underlying color or detail to show through. Test your colors in a similar manner.

Exercise 14: Test for Fading

Many good watercolor paintings have been injured—some of them ruined—through long exposure to strong light. Certain colors resist light well; others fade badly. Here is an easy test of your own colors; make it now and by the time you are ready to start your "masterpieces" you should know a lot about every color's permanence.

Paint a vertical band (a half-inch or so wide) of each of your colors in full intensity all the way down a sheet of paper so that you finally have a dozen or more parallel bands. Then cut this paper horizontally in several strips; each strip will thus contain a sample of each color. Write the names of the colors on at least one of the strips—preferably all—and add the date.

Place one strip permanently in bright sunlight—at a window perhaps; another in bright light but away from the sun; a third in a darker part of the room; and a fourth in a drawer or elsewhere, where no light can penetrate. Every few weeks, lay these strips side by side for comparison. If any colors prove to be too fugitive by this test they can be rejected from your palette—at least for any serious work. For all-around practice, however, you will probably find that each of your colors is sufficiently light-proof.

Chapter 7

COLOR QUALITIES:
VALUES AND THEIR
MEASUREMENT

EXPERIMENTS TO THIS POINT need not be performed at any particular time or in any particular way. They offer you no panacea—no guarantee of success. Their purpose is only to give you, before you paint pictures, at least a basic understanding of the leading qualities and characteristics of your paints, and an increased knowledge of how to manage them. If you prefer to pitch right into painting pictures without devoting time to such preliminaries, your impatience is understandable, and I admit that no amount of such advance practice can prepare you to cope successfully with the many problems of painting a picture. You must wrestle with each as it comes. But isn't this all the more reason for first trying these exercises?

MIXING AND MATCHING COLORS

There is one sort of preliminary exercise which under no condition should be neglected, as it is worth far more than the time it takes. This exercise has to do with mixing and matching colors.

Let us suppose that you have selected a palette of a dozen or fifteen paints. In nature there are literally thousands upon thousands of hues, some bright, some dull, some light, some dark. How, with your few paints, can you represent them all?

Frankly, you can't hope to match each one perfectly, especially if it is viewed in brilliant sunshine. It is by no means necessary for you to

do so. In fact, the most satisfactory pictures are often painted with a somewhat limited palette, nature's colors being greatly simplified and conventionalized. It is important, however, for you to be able, when you wish, to approximate nature's hues quickly and without conscious effort.

As an aid to this, you should at once learn certain qualities or characteristics of your different colors, along with basic principles of color mixture.

FIRST, SOME DEFINITIONS

Before venturing into this new field, it seems best to stop for a few general definitions without which it is hard for the writer and reader to find a meeting ground.

Unfortunately, the terms common to the field of color can prove very confusing. The physicist dealing with color in the form of light, utilizes a highly scientific vocabulary. The psychologist, concerned with visual and mental impressions of color, has another terminology equally erudite. The painter prefers his own language, somewhat more simple yet scarcely less strange to the layman's ears. And even the painter is not always consistent. Many of his words, such as "shade," "tint," "tone," and "value," have a variety of meanings.

It would be bad enough if these variations were confined to terminology, but the student of painting is confronted with more vital differences. Referring again to the physicist, you will recall that his "primary" or basic colors from which all other colors can be created—remember he is dealing with light—are red, green, and blue (blue-violet). To the psychologist, the primaries are red, yellow, green, blue, black, and white. The painter's primaries—*our* primaries as we work with color in the form of paint—are often stated as red, yellow, and blue. You will remember that these are the printer's primaries, too; together with black, all the color work of this book was printed with these three. We should perhaps point out, however, that some systems of color notation—the Munsell, for instance—use, as their principal hues (in place of our three primaries), red, yellow, green, blue, and purple. Still others use red, yellow, green, and blue.

So the terms that I shall employ may or may not be the ones to which you are accustomed, although most of them have general acceptance in the field of painting.

HUE

Color possesses three qualities or attributes of which the most outstanding is perhaps hue. Webster defines "hue" as "that attribute in respect to which

66

colors may be described as red, yellow, green, or blue, or as an intermediate between two of these . . ." In the layman's language, the word "hue" relates to the *name* of the color. An apple is red; red is the hue of that apple. We can alter the hue of a color by mixing another color with it. If we mix red paint with yellow paint we produce orange paint. That is a change in hue.

BRILLIANCE OR VALUE

Webster defines "brilliance" as "that one of the three attributes of a color . . . in respect to which it may be classed as equivalent to some member of the series of grays ranging from black to white; roughly the degree of resemblance to white or difference from black."

Many artists prefer, in place of the term "brilliance," the word "value." It is by brilliance or value that we are able to discriminate between light red and dark red. By mixing a color with something lighter or darker than itself we change its value.

SATURATION, CHROMA, OR INTENSITY

Coming to our third color quality, and again quoting Webster, "saturation is that attribute in respect to which colors may be differentiated as being higher or lower in degree of vividness of hue; that is, as differing in degree from gray." As "saturation" refers to vividness or distinctness of hue, the more gray we mix in a color the less saturated it becomes.

Some artists substitute the word "chroma" for "saturation." (Webster tells us that "chroma" characterizes a color qualitatively without reference to its brilliance [value], thus embracing both hue and saturation.)

Still more in use by the artist in this connection is the word "intensity." Therefore, that is the term we shall employ in the coming chapters, despite the fact that many authorities don't recognize "intensity" as a color term. Simply stated, some colors are strong and some weak; the quality by which we distinguish between them is called "intensity." We can change the intensity of a color by mixing it with something which tends to dull or gray it. We can change intensity without changing value or hue by adding neutral gray of equal value.

NORMAL COLORS, TINTS, AND SHADES

A color in its full, natural strength may be called a "normal color," or a "color of normal value." If lighter, we call it a "tint"; if darker, a "shade." In this sense, it is wrong to refer to a "light shade" or a "dark tint" of a color. Remember that *all tints are light, all shades are dark.*

TONE

The word "tone" is another of varied and complex meaning. Webster offers this for "tone": "Color quality or value; any tint or shade of color; any modification of a chromatic or achromatic color with respect to brilliance or saturation; also, the color which appreciably modifies a hue or white or black; as, a bright dark or light *tone* of blue; the gray walls took on a greenish *tone;* the soft *tones* of the old marble." As to painting, Webster adds this thought on the word "tone": "The general effect due to the combination of light and shade, together with color; commonly implying harmony; as, this picture has *tone.*"

Complicated? Don't let it worry you. Some of our leading artists—excellent colorists—know little or nothing of such definitions.

For your present purpose of making tests, each of your watercolor paints—at least the more brilliant ones—might be considered a "normal" color, that term sometimes being loosely applied to your more intense colors just as they come from the tube. Some painting will be done with your colors in this natural form. Often, however, it will be necessary to lighten, darken, intermix or otherwise modify them to create a greater variety of hues to approximate the myriad colors of nature.

OBTAINING TINTS AND SHADES

There are several ways in which you can obtain, on your white paper, tints of each of your colors: (1) You can dilute the paint with water; obviously, the more water you add, the lighter the tint will be. This is the best method for the watercolorist to create tints, and by far the most common. (2) You can add white paint. (This method is usually reserved for painting an occasional highlight, or for making minor corrections, or for work generally opaque in nature—see Chapter 14.) (3) You can brush the paint on so very dry that it "breaks" to let the white paper show through in places. (The rougher the paper, the more easily this method can be used.) (4) You can cover an area of your paper with small separated dots of color. The eye will blend these dots with the surrounding white, through this optical admixture, gaining the effect of a tint. (5) You can also lighten a color by mixing it with some other color of lighter value, though this will, of course, change the hue as well as the value.

The common way to obtain true shades of a color is to darken it with gray or black. It can also be mixed with some other color (or colors) darker than itself, though this again changes both value and hue.

Exercise 15: Value Comparisons
Paint a row of squares (each an inch or so in size) horizontally across the

middle of a sheet of paper, one for each of your colors just as it comes from the tube. Group your reds; also, the yellows, blues, greens, and browns. Above this row of squares, paint a second row in which every color is somewhat lightened by the addition of water, giving you a series of tints. Above this, add another row in which the colors are still further diluted (as uniformly as possible), creating even lighter tints. Still above this add, if you wish, another row or two, with your paints so greatly diluted as to result in very pale tints of all of your colors.

As to shades, follow the same general procedure, painting several rows below your normal colors, adding more and more black to each new row.

ANALYSIS

You will now begin to see what a variety of colors you can obtain through even this simple mixture of water or black to each of your normal colors. Some interesting comparisons will also be evident. If you study your two series showing normal colors and tints, and normal colors and shades, you will observe, among other things, that normal colors vary greatly in tone, some being quite light and others quite dark. For example, yellow in its normal form is very light in tone—really a tint in relation to most other normal colors. Therefore, as you add the water to yellow to create a series of yellowish tints, these will vary only slightly in value from one another. On the contrary, in the case of a paint which is normally dark, deep blue or violet, for instance—as you add the water to create tints, you will discover a very noticeable difference from area to area. Whereas a light tint of yellow will look quite similar in value to the normal yellow paint, a light tint of deep blue or violet will look very different from the normal deep blue or violet.

Now study your areas of shade. Here the yellow will change very rapidly in tone as the black is added to make it darker. The chances are that a dark shade of yellow will have an appearance which, if seen as an isolated spot, you would scarcely recognize as yellow; yet, strictly speaking, it is. In the case of your deep blue or violet, there will be far less difference in your shade squares. Try to get all these differences in mind by forcing yourself to make such comparisons as the above, so that if you later wish to represent a certain tint or shade when working from nature you will know just what paint will give it to you through the addition of water or black only.

I wish I could sufficiently impress upon you the importance of trying to memorize the fundamental appearances of these tints and shades which you can obtain by the simple addition of water or black to each of your colors.

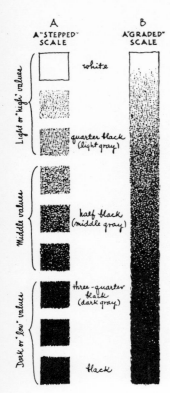

A
A "STEPPED" SCALE

B
A "GRADED" SCALE

white

quarter black
(light gray)

half black
(middle gray)

three-quarter
black
(dark gray)

black

Light or "high" values

Middle values

Dark or "low" values

Figure 43
VALUE SCALES *This
is an excellent way
to understand the
values of light and
dark. Practice doing
stepped and graded
scales. Values are as
important as colors!*

In painting these first comparative squares of Exercise 15, it is improbable that you will succeed in "stepping" your colors as gradually as you would like from the palest of tints to the darkest of shades. You will *try*, however, to add water (or black) to your paint in exactly the right quantity for each square so that your gradation will be as uniform as possible. But don't worry if you fall short of your goal. It doesn't matter much. Whatever your success or lack of it, you won't be wasting your time, for, through all this manipulation, you are certain to familiarize yourself quite thoroughly with each of your individual hues while at the same time automatically developing considerable control of mixing and painting procedures. These are the things that count.

Exercise 16: Value Scales
Considering that one of your main jobs in representational painting will often be to match nature's tones as well as you can, not only in hue but in value, it's not a bad idea, while you are on the subject, to make a few additional—and more accurate—value scales to supplement those described for Exercise 15. Start with such typical colors as your most dominant red, yellow, blue, and green. Later, go as far as you choose.

You are likely to be more successful in this effort if you take a few minutes first to make at least one or two carefully executed black-and-white scales. They will prove of use in more than one way. In our accompanying illustration (Figure 43) we show, as a guide, a pair of such scales. (The original drawing was done in pen and ink, rather than watercolor, in order to insure more faithful reproduction.)

This drawing—which you will of course interpret with your watercolor paints—is practically self-explanatory. For a "stepped" scale, as at *A*, first pencil on your paper a vertical row of nine squares, each an inch or so in size. (Any number of squares may be used; the scale is a purely conventional and arbitrary thing. Nine, as shown, are convenient.) The first of these squares, at the top, you will leave bare—plain white paper. The bottom square you will paint solid black. Halfway between, you will apply a "half black" or "middle gray," formed by diluting your black paint with water until it satisfies your eye as being a neutral gray. (As all watercolor paints seem to lighten as they dry, you may have to go over the area more than once to build it to the desired value.) Adding still more water, paint next a "quarter black" or "light gray" tone as indicated in the third square from the top. Now add black and paint the "three-quarter black" or "dark gray" tone as indicated in the third square from the bottom. Next paint four carefully adjusted intermediate steps.

(The above procedure, which keeps you alternately lightening and darkening your color, is usually more accurate, though slower, than the

70

mere addition of a bit of water for each step from the black to the white. Try both methods if you wish; it's all excellent practice.)

Nature's values from light to dark of course seldom follow such a definite scheme of graduated steps as this arbitrary scale records. Nature shows us every possible nuance from bright light (far "whiter" than our whitest paper) to the blackest of black. We therefore come a bit closer to her myriad tones when we draw or paint, instead of a stepped scale, a graded scale like that at *B*. In making your painted interpretation of this, you will preferably start with a puddle of pure water, adding black by degrees. (This is quite a knack which you may not acquire for some time. Therefore, you may have to paint over this—or parts of it—more than once in order to obtain the desired uniformity of gradation.)

MATCHING NATURE'S TONES

When you have finished these black-and-white scales, try putting them to use. Look around your room—at some particular area of white plaster, perhaps, or a white door. Hold up your scale in good light and compare it with the tone you have picked. With a little experience, your scale, used in this manner, will prove a sort of yardstick for "measuring" the value of any tone in nature. Compared with your scale, is the tone in question (as it appears to the eye, not as you know it to be) quarter black, half black, three-quarter black—or what? Study a white house outdoors, again "measuring" its various values by comparing each with your scale. This practice will help you become more aware of values and their subtle differences. This will be of great help when you start to paint actual pictures, for the value of a color is often as important as its hue—sometimes more so.

Now at last you are ready to make some reasonably accurate value scales using some of your typical colors each lightened with water and darkened with black as necessary. Paint a number of these, following either the stepped or the graded white-to-black form, or both. Then use these scales, one at a time, in an attempt to "measure" some of the colors you see in nature. Hold up each scale in turn for comparison with areas of similar hue, just as you did your black-and-white scales.

Another revealing test, in this connection, is to cut or punch a small opening in a sheet of white cardboard—a half inch or an inch will do—and then peek through this opening at some limited area of one of nature's colors. By isolating a single area in this way, it will be far easier to judge it than when it is surrounded by a lot of other hues. Another way of learning values and hues through comparison is to cut or punch small holes through all the areas of a stepped value scale, then by peeking through each hole in turn, try to find values and hues in nature which match those of your scale.

Chapter 8

COLOR MIXING
AND MATCHING:
COLOR CHARTS

YOU HAVE NOW MIXED each of your watercolor paints with water and with black to obtain a full gamut of values. You have also made value scales in black-and-white, as well as in color, and have practiced "measuring" nature's tones by comparing them with these scales. All of these exercises, even if they served no other purpose, could (1) strengthen your realization that areas of color as seen in nature vary not merely in hue but in degree of light and dark, and (2) sharpen your faculties of observation and discrimination between one hue or value and another.

At last comes the excitement of turning magician, for your next move is to create an endless variety of colors of your own by mixing together, in pairs (and perhaps later in groups of three or more), your various paints just as you squeeze them from the tube.

SOME COLOR THEORIES

Before beginning a series of color exercises in this chapter and in the next two, I should explain a bit about basic color theory.

For the purposes of the artist, there are three *primary* colors from which all other colors can be mixed: red, yellow, blue. Actually, physicists, who see color as light rather than paint, recognize a different set of primaries: red, green, and blue-violet. However, you needn't concern yourself with *light* primaries, which are of interest primarily to the scientist.

Here is how *your* primaries work. The first thing to remember is that any mixture of two primaries will produce a *secondary* or binary. Thus, a mixture of red and yellow will produce orange; yellow and blue will produce green; red and blue will produce violet. These are your secondaries: orange, green, violet. (See the chart called "Primary and Secondary Colors," reproduced in color on page 74.)

By further mixing, you produce *tertiaries*. These are usually mixtures of a primary and a secondary. Thus, red and orange will produce red-orange; yellow and green will produce yellow-green; blue and violet will produce blue-violet; yellow and orange will produce yellow-orange; blue and green will produce blue-green; red and violet will produce red-violet. So then, the six tertiaries are: red-orange, yellow-green, blue-violet, yellow-orange, blue-green, red-violet. (See the chart called "Tertiary Colors" on page 75.)

Exercise 17: Be a Good Mixer

When it comes to mixing one color with another in order to discover what the two will yield, there is no one best way; any experiments which you perform will help you. Yet it goes without saying that the more systematic your procedure, the more you will profit. Whatever method you use, your final purpose is to learn how to obtain from your dozen or so paints the numerous colors needed when you wish to interpret any of nature's multitudinous hues in your pictures.

Figure 44 suggests one logical procedure: first, squeeze out a small amount of color (*a*) and, two or three inches away, a like amount of any second color (*b*). Then, using a brush and a minimum amount of water (so

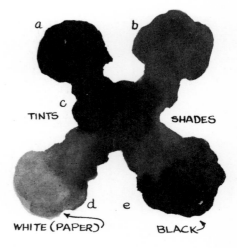

Figure 44
MIXING EXERCISE *This exercise will show you what happens when you mix any two colors. It will show what third color results from the mixture and the full range of values that color yields, depending on how much it is diluted with water.*

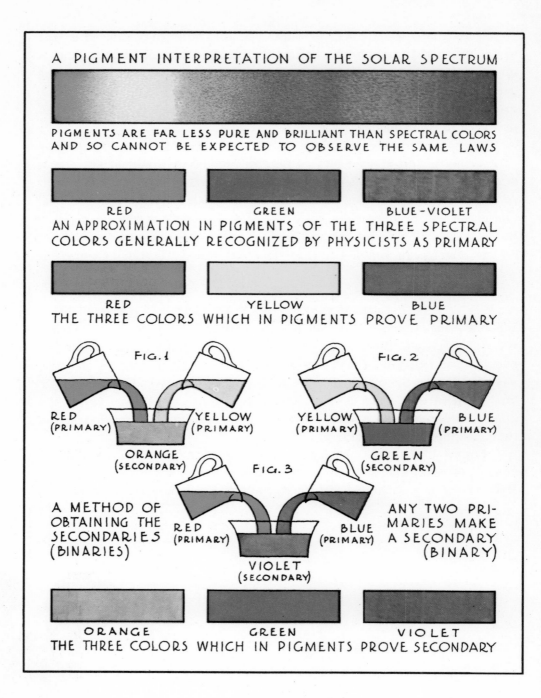

A PIGMENT INTERPRETATION OF THE SOLAR SPECTRUM

PIGMENTS ARE FAR LESS PURE AND BRILLIANT THAN SPECTRAL COLORS
AND SO CANNOT BE EXPECTED TO OBSERVE THE SAME LAWS

RED GREEN BLUE-VIOLET

AN APPROXIMATION IN PIGMENTS OF THE THREE SPECTRAL
COLORS GENERALLY RECOGNIZED BY PHYSICISTS AS PRIMARY

RED YELLOW BLUE

THE THREE COLORS WHICH IN PIGMENTS PROVE PRIMARY

FIG. 1

RED (PRIMARY) YELLOW (PRIMARY)

ORANGE (SECONDARY)

FIG. 2

YELLOW (PRIMARY) BLUE (PRIMARY)

GREEN (SECONDARY)

FIG. 3

RED (PRIMARY) BLUE (PRIMARY)

VIOLET (SECONDARY)

A METHOD OF OBTAINING THE SECONDARIES (BINARIES)

ANY TWO PRIMARIES MAKE A SECONDARY (BINARY)

ORANGE GREEN VIOLET

THE THREE COLORS WHICH IN PIGMENTS PROVE SECONDARY

PRIMARY AND SECONDARY COLORS *Study this chart to understand how primary and secondary colors are derived.*

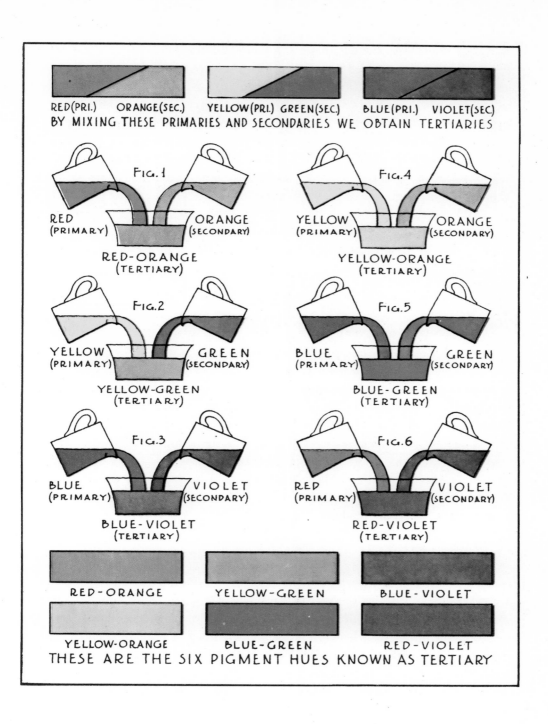

RED(PRI.) ORANGE(SEC.) YELLOW(PRI.) GREEN(SEC.) BLUE(PRI.) VIOLET(SEC.)
BY MIXING THESE PRIMARIES AND SECONDARIES WE OBTAIN TERTIARIES

FIG.1
RED (PRIMARY) — ORANGE (SECONDARY)
RED-ORANGE (TERTIARY)

FIG.4
YELLOW (PRIMARY) — ORANGE (SECONDARY)
YELLOW-ORANGE (TERTIARY)

FIG.2
YELLOW (PRIMARY) — GREEN (SECONDARY)
YELLOW-GREEN (TERTIARY)

FIG.5
BLUE (PRIMARY) — GREEN (SECONDARY)
BLUE-GREEN (TERTIARY)

FIG.3
BLUE (PRIMARY) — VIOLET (SECONDARY)
BLUE-VIOLET (TERTIARY)

FIG.6
RED (PRIMARY) — VIOLET (SECONDARY)
RED-VIOLET (TERTIARY)

RED-ORANGE YELLOW-GREEN BLUE-VIOLET

YELLOW-ORANGE BLUE-GREEN RED-VIOLET

THESE ARE THE SIX PIGMENT HUES KNOWN AS TERTIARY

TERTIARY COLORS *Study this chart to understand how tertiary or interme-diate colors are obtained.*

as not to overdilute them), bring the two together (*c*) and intermix them thoroughly to form a puddle of paint. To extend your experiment further, add more water gradually to your mixture (*c*), extending it on your paper to create a series of tints approaching pure water (white) as at (*d*). Next squeeze out a bit of black (*e*) and add it gradually to the color just created (*c*). Thus you will not only see what the two colors through admixture will yield in the way of a third color, but you will discover how this third color will appear in a full gamut of values ranging from light tints to dark shades. Repeat this exercise with many pairs of paints.

You should save the results and study them again and again, memorizing the appearance of each hue and its component parts. Thus, when you wish to represent some specific hue seen in nature, and you don't have a ready-mixed paint of the right color, you will know precisely how to produce it.

A FASCINATING DISCOVERY

This mixing of colors can prove as entertaining as it is informative. By a sort of magic you will create from your limited number of original hues a large number of new hues; we have seen that in theory, if not in practice, all colors can be mixed from the three primaries, red, yellow, and blue, plus black and white.

You will note interesting things about these mixtures. For example, one pair of bright colors (such as red and yellow) will mix together to produce a third bright color (orange), while another pair of equally bright colors (such as red and green) will, on the contrary, intermix to produce a dull color (gray or drab brown). Why?

A COLOR WHEEL

Such differences can perhaps best be noted, understood, and memorized by referring to (or, better yet, by making) a highly convenient and clever gadget known as a color wheel. (See Figure 45.) Different authorities recommend different wheels; unless you go more deeply into color study it matters little which you make. Every wheel is an artificial thing roughly representing the portion of the solar spectrum visible to the human eye. Bringing together, purely for convenience, the ends of that visible portion to form a circle has no counterpart in nature.

Exercise 18: Making a Color Wheel
Since you can learn so much from a color wheel, why not make one? First, on your paper rough out in pencil a circle six or seven inches wide or any convenient size.

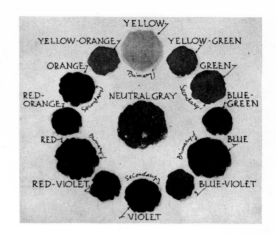

Figure 45

COLOR WHEEL *A color wheel is a clever gadget for studying the relationship of colors to each other. It will help you understand the nature of primary, secondary, intermediate, analogous, and complementary colors.*

PRIMARY COLORS

Start by applying, in the positions indicated by our diagram, small areas of three primary colors: red, yellow, and blue. You may not have a red as clear and bright as could be desired, but choose your "reddest" red—one which is inclined toward neither orange nor violet. Paint at the left of your circle an area of this red, full strength. Next, choose your purest yellow, and add an area of that, as indicated by our diagram. Do the same with blue. (Some manufacturers offer paints especially made up as primaries, secondaries, etc.)

SECONDARY COLORS

As we have already shown, secondary colors are formed by mixing two primaries: red and yellow will give you orange; primary yellow and primary blue will give green, and primary blue and primary red will give violet. Apply them in the positions indicated on the wheel.

TERTIARY COLORS

Similarly, by mixing the primaries and secondaries as shown, you can obtain "intermediate" or "tertiary" hues (but a tertiary, according to Webster, is made by mixing two secondaries. Yet you needn't be unduly concerned with these names; in themselves they mean very little. The thing which counts is that when the colors are arranged around an arbitrary circle such as we have in our diagram, they give us—to repeat—a very useful instrument.)

ANALOGOUS COLORS

Colors which are adjoining or adjacent to any one of the primaries on the color wheel are obviously somewhat similar in nature or of one family. We refer to these as "analogous" or "related" colors. Red, red-orange, and red-violet are analogous, as they all contain red. So are blue, blue-green, and blue-violet; they all contain blue. Because of their common factor, analogous colors of any one family usually harmonize esthetically among themselves and so can be employed together safely.

COMPLEMENTARY COLORS

Colors which lie directly opposite each other on our arbitrary wheel (typical pairs are red and green, yellow and violet, blue and orange) are, on the other hand, dissimilar in character—to an extent inharmonious, at least in their natural state. They do not belong to the same family. Such opposite colors are called "complements" or "complementary colors."

These opposite colors are the ones which tend to annihilate each other when mixed together. We have seen that red mixed with green produces gray or brownish-gray. Similarly, yellow mixed with violet tends to give us a dull hue. If we mix blue with its complementary orange, these once more try to neutralize each other. And so it is with any opposite pair on our chart, such as blue-violet and yellow-orange, red-orange and blue-green, red-violet, and yellow-green. The chart called "Complementary Colors" on the facing page may help you understand this phenomenon more clearly.

TRIADS

Colors which are so positioned on our chart as to form equilateral triangles —i.e. (1) our three primaries, (2) our three secondaries, (3) our two trios of intermediates—are sometimes known as "triads." Just as complementary colors form dull grayish or brownish hues when intermixed, so do triads. (This should be obvious, for if you mix together red, yellow, and blue, it is the same as if you mixed red and green, for what is green but a combination of yellow and blue?) It naturally follows that if you intermix a lot of miscellaneous colors, the resultant color is almost sure to be a dull gray or brown—sometimes a gray-green. (The reader can learn a valuable lesson from this simple fact. If he wishes any area in a painting to be colorful, he must hold to clean, clear colors; the more hues he intermixes, or applies in such small dots that the eye automatically intermixes them, the more neutral his area will become.)

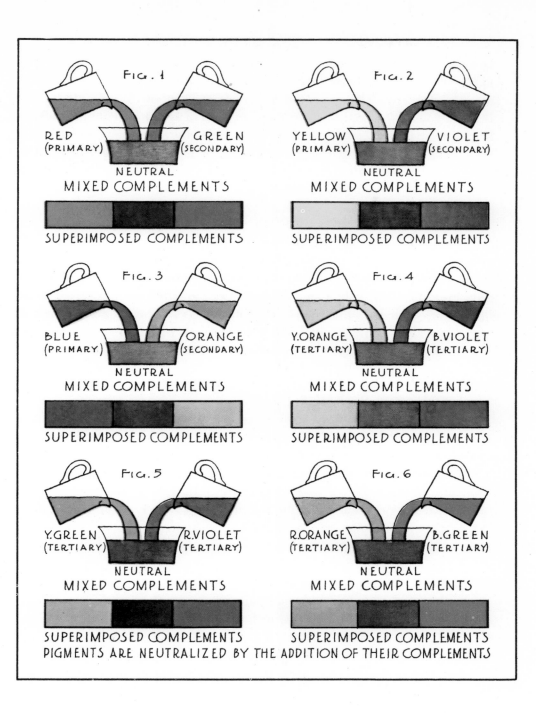

COMPLEMENTARY COLORS *Mixing complementary colors produces a variety of results. Study these results and learn to use them to advantage.*

One of the most amazing and fascinating things about color is this: we have seen that complementary colors, in mixture, tend to annihilate each other. Contrarily, when placed side by side each intensifies the other. Test this for yourself. If you wish to make an area of bright orange look all the brighter, surround it with an area of bright blue; the blue, through contrast, will definitely increase the apparent brightness of the orange. Also the blue will seem brighter.

A PRACTICAL APPLICATION

If you are painting a building bathed in the yellows and oranges of sunlight, and you wish to make it look still more sunny, you can use, adjacent to these warm colors, cooler colors such as blue, blue-violet, and blue-green, thus creating (through what is known as "simultaneous contrast") an illusion of brighter light. One reason why artists employ so many blue and purple shadows is that they know that through this complementary contrast they can make their sunny areas more brilliant in effect.

ANOTHER CHART APPLICATION

When it comes to everyday color mixture, you will discover the value of your chart again and again. As a single example of this, let us suppose that you have mixed some red-violet and that it is a little too bright for your purpose. You know from your chart (which you should endeavor to memorize—keep it before you until you do) that by adding yellow-green to your red-violet you will dull it somewhat. (You could also dull it through the addition of gray or black, but more pleasing colors are usually generated through a mixture of more colorful hues.)

Exercise 19: Matching Nature's Hues

We have spoken of holding up your color scales for direct comparison with the hues you see in nature. Sooner or later you will want to test your ability to match some of these hues with your paints. Don't wait until you are making pictures before you do this, but choose one color area after another and see how close you can come to catching its correct color. If you need help, refer to your color wheel and to the painted results of your previous exercises. There is no reason for you to limit yourself to mixtures of two colors—the type which we have stressed. If you have to mix three or more colors in order to gain the desired result, do so. It won't be long before you can quickly come close to almost any hue you find in nature with the exception of those extremely brilliant ones seen at sunset or under other

extreme lighting conditions. We have already pointed out that at best the artist can only approximate some of these.

Exercise 20: "Copying" Color Areas

Nature's colors being so varied and changeable, if you have trouble matching them with your paints you might well turn for a while to an attempt at matching colors as you see them printed in books or magazines. Find a color picture in a magazine—an advertisment will do. In this, select a small area—the size of a dime, for instance—of one definite color. Cover surrounding areas with strips of paper (or with one strip with a hole through it) to mask away other colors. Then try to mix an area of watercolor of the same hue. (You won't always be wholly successful, partly because you are using paint which dries dull on your dull paper in an attempt to match ink which is quite likely to be on shiny paper. But come as close as you can.) Repeat this exercise many times with many colors. Then turn to nature again.

A logical extension of this exercise would be to copy a color reproduction of a watercolor painting (or, for that matter, to copy an original watercolor). While we can't recommend such copying as a general thing, there are times when one can learn valuable lessons from it. (More will be said about copying in Chapter 12.) Your whole aim will be to match each color area as well as you can.

COLOR SCHEMES

In Chapter 10 we shall deal at some length with color schemes, as they are another highly important consideration in which the color wheel can prove very helpful.

To give a specific application, in one type of color scheme the artist very wisely limits his palette so that the larger areas of his paper are covered with analogous hues. Thus he is practically sure of harmony of color. To obtain the desired relief, however, he utilizes small areas of complementary colors. (In an oil landscape by Corot we often find the canvas largely covered with grass and foliage masses of a somewhat neutralized green. To bring relief to this green and enliven the whole, the artist effectively uses a small area of red—perhaps a cow or a boy's cap or coat.)

A SUCCESSFUL SCHEME

Study many paintings and you will discover that in such analogous schemes with complementary accents the artist often selects, for the larger areas of

any given painting, the analogous colors which would be found in approximately one-third or one-quarter of the circumference of our color wheel. He then goes to the opposite side of the wheel for complementary colors to be used in relatively small areas only.

BUT BE CAREFUL!

Although comparatively small complementary areas can thus be effective, the employment of anything like equal areas of two full-strength complementary colors can be highly dangerous; it often creates a chromatic clash. In other words, it is generally best not to cover large adjoining or adjacent areas with opposite or competing colors of any great degree of brilliance unless you are intentionally working for a dazzling, unrestful effect. Usually, when opposites are conspicuously employed, one or the other should dominate either in area or in hue. To give an illustration, if a painting were to be made with roughly one-half of its area bright red (a red barn, perhaps) and one-half of its area bright green (the foliage around the barn) there would be no dominant hue. We would have, instead, an unpleasant clash of opposites, a fighting for supremacy. To prevent such a chromatic battle, the green could be dulled down, leaving the red to dominate, or vice versa. Or the areas might be adjusted in size so that one of the two colors would dominate through mere bulk.

NEUTRALIZED COLORS

Of course very few painters regularly use their more brilliant colors in large areas and full strength—results would be too garish. And the less brilliant your colors are in any given painting, the less the danger of obtaining a chromatically inharmonious result. If, for instance, a little red (or gray) is mixed into almost all of the greens, and a little green (or gray) into almost all of the reds, this common factor will tend to bring these naturally opposing colors into closer harmony, as we mentioned in connection with the red barn. Other complementary pairs could be similarly treated. (We saw earlier that many colors, when purchased, are already neutralized in this way.)

In order to create harmony, artists frequently use complementary colors to neutralize the shade or shadow side of an object. If you are painting a blue bowl, a certain amount of complementary orange can often be used to advantage in the shade side. A yellow bowl might have some violet added in the shade areas, and so on.

Whatever you do, however, don't neutralize *everything*. It is far better at first to risk garishness or stridency through the use of overbright colors than to risk monotony or worse through an attempt to "harmonize" everything.

Exercise 21: *Try for Yourself*

Why not make some little sketches (or paint experimental areas) to illustrate these points? Or you might like to hunt for examples—either actual paintings or reproductions in color.

IMPORTANCE OF COLOR AREA AND RELATIVE POSITION

A little later we shall offer additional hints for obtaining successful color schemes, but right now we wish to stress a most important fact: *no one, no matter how expert, can tell you exactly how to obtain, consistently, successful color schemes in all your paintings—or anywhere else for that matter.* Many have tried, and some actually offer charts, gadgets, etc., which they practically guarantee will insure successful schemes. *Don't be fooled by any excessive claims in this direction.* Some such charts and gadgets or systems can be very useful up to a point—well worth their price—but they will take you only so far.

Among the reasons why no infallible rules for color harmony can be offered, two are outstanding: (1) Colors may be harmonious when employed in areas of a certain size, yet be inharmonious if used in different areas. (2) Colors can deceive the eye because of the way in which they are arranged in relation to one another; in other words, colors which prove pleasing in some arrangements may clash (or at least prove ineffective) in other arrangements.

Exercise 22: *Experiments in Area*

We've already discussed the first point briefly, but let's take a closer look. Select some colored sheets of paper—clippings from booklet covers, for example. From these, pick the most *inharmonious* pair of colors you can find. Then, with your scissors, snip out areas of these same colors varying in size and pair them up. Study each pair by itself. Just as a small area of bright red usually looks effective placed next to a large area of bright green, so one of your small clippings will quite possibly prove pleasing in combination with a larger clipping of the other color. Artists often bring a clashing combination of two or more colors into harmonious relationship by the mere expedient of changing the areas in size.

Exercise 23: An Area Phenomenon

In order to test still further the importance of color areas, paint, side by side, each three or four square inches in extent, an area of bright red and a like area of bright green. Here you have the typical and very lively complementary color combination repeatedly mentioned, each color heightening the other through contrast. Now, using the very same red and green colors, stripe areas with alternating red and green stripes just as narrow as you can make them with your finest brush or a pen. (Don't allow the two colors to intermix or overlap. But don't, for a fair test, leave any more white paper than necessary.) Next, place these various areas, plain and striped, eight or ten feet away. At this distance the first pair of colors—the larger areas—will still look bright. The narrow stripes, however, will run together, merged by the eye into a somewhat neutral tone, much as though the paints themselves were blended together. (Dots will do precisely the same thing.)

In view of this fact that fine brush marks (lines, dashes, dots) of even the brightest colors will be optically blended when viewed from a normal distance, opposing colors fading away amazingly, *don't, when painting, intermingle a lot of little brush marks of bright complementary hues and expect them to exhibit chromatic brilliancy.* You may, however, obtain by such means unusually vibrant tones, and if you juxtapose brush marks of analogous colors you will often create lively, scintillating effects. We mentioned earlier that the "pointillistic" method of the French Impressionists was based on this very use of myriad small spots of varying hues—generally analogous but sometimes complementary—placed in close proximity.

(Incidentally, a main reason why it is next to impossible to print satisfactory color reproductions of some paintings is that areas which are large enough in the original to be effective are so greatly reduced in reproduction that, like the stripes of Exercise 23, they lose their chromatic power. Illustrators have learned that, when painting for reduction, it is necessary to keep color areas large and simple—somewhat poster-like.)

WHERE DOES THIS LEAVE US?

By way of summary, three facts which stand out from all of this recent discussion are that (1) large areas of opposite colors, juxtaposed, tend to intensify each other; (2) myriad small areas of opposite colors, similarly juxtaposed, are blended by the eye into neutral tone, each color tending to annihilate its opposite; and (3) opposite colors when mixed together also tend to neutralize or annihilate each other.

Chapter 9

COLOR ARRANGEMENTS, ILLUSION, ACTIVITY

Figure 46
COLOR ARRANGEMENT
It's hard to believe that the two small squares are exactly the same! Both color and value are affected by adjacent colors.

HOW GOOD ARE YOU at judging colors, matching them one against another? If I were to lay before you a dozen or more squares or circles of colored paper, each an inch or so in size, could you pick out by eye (without changing their relative positions) two or more which are absolutely identical in hue? Could you do this no matter what the hue of their background and regardless of their arrangement on this background? If so, you are exceptional. Few people can correctly judge colors in all arrangements; nature gives us many optical illusions.

Exercise 24: Color Arrangements

But test the thing for yourself. As in Figure 46, place nearby two fairly large sheets of paper (at least five or six inches square), one of them light yellow and the other dark but intense blue. On these, lay two small (one inch) squares—or other conventional shapes—of bright green paper. So arranged, the green against the dark blue will seem lighter than before and slightly yellowish, while the green against the light yellow will appear darker and slightly blue-green. (Lay transparent tissue paper over the whole and the contrast will be even more pronounced; it is sometimes hard to believe that the two green squares are actually of identical hue.) Not only will the two small green areas differ in apparent value and hue, but the yellow, contrasted with the green and blue, may appear slightly

toward orange and blue, contrasted with the yellow and green, a bit purple. In short, a few such experiments will demonstrate clearly that *colors are influenced in hue by adjacent colors, each tinting its neighbors with its own complement.*

The experimenter, using papers of other colors (or areas of paint, if he prefers) will also learn the following things:

• Dark hues on a dark ground which is not complementary will appear weaker than on one which is complementary.

• Light colors on a light ground which is not complementary will seem weaker than on a complementary ground.

• A bright color against a dull color of the same hue will further deaden the dull color.

• When a bright color is used against a dull color the contrast will be strongest when the latter is complementary.

• Light colors on light grounds (not complementary) can be greatly strengthened if bounded by narrow bands of black or complementary colors.

• Dark colors on dark grounds (not complementary) can be strengthened if similarly bounded by white or light colors.

Just how does all this affect the painter when he goes forth to interpret nature's hues? Not much, actually. But because he has learned how tricky nature can be, he realizes the truth of our claim, on an earlier page, that any rules of color harmony—any hope of learning to paint by rote—is out of the question. Also, he will not be surprised by the way in which some of his colors seem to vary in appearance under different conditions. He will understand that not only do colors vary according to their location in relation to other colors, but, as we saw previously, they also vary according to area. We might sum this up by saying that *colors are not always what they seem to be.* A given color in one size and placing may look amazingly different from the identical hue in another size and placing. This is true both in nature and in painting.

COLOR ACTIVITY

Regardless of size or arrangement, areas of color differ greatly in their affective and attentive value. Some colors can best be described as active, lively, restless, insistent, positive, bold, expanding, or advancing; others seem passive, negative, subdued, timid, submissive, reserved, contracting, or retreating. Some suggest warmth and others coolness; some impress us as heavy and inert and others as light and animated. The student should cultivate the habit of sizing up different colors which he sees about him, noting their characteristics and his reactions to them. When it comes to

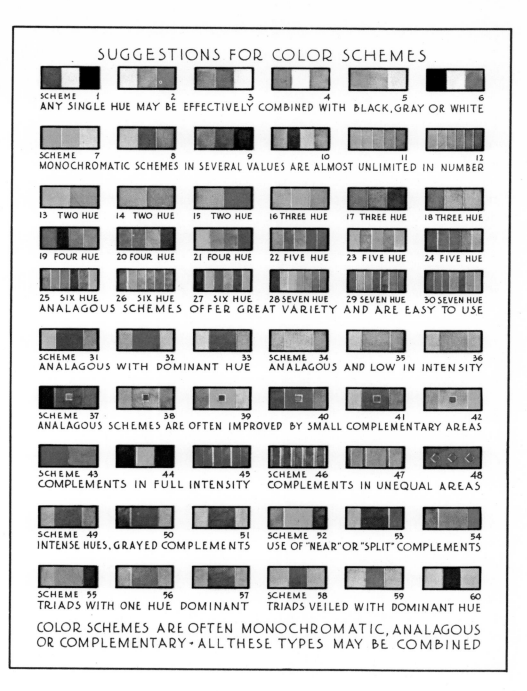

SUGGESTIONS FOR COLOR SCHEMES

SCHEME 1 2 3 4 5 6
ANY SINGLE HUE MAY BE EFFECTIVELY COMBINED WITH BLACK, GRAY OR WHITE

SCHEME 7 8 9 10 11 12
MONOCHROMATIC SCHEMES IN SEVERAL VALUES ARE ALMOST UNLIMITED IN NUMBER

13 TWO HUE 14 TWO HUE 15 TWO HUE 16 THREE HUE 17 THREE HUE 18 THREE HUE
19 FOUR HUE 20 FOUR HUE 21 FOUR HUE 22 FIVE HUE 23 FIVE HUE 24 FIVE HUE
25 SIX HUE 26 SIX HUE 27 SIX HUE 28 SEVEN HUE 29 SEVEN HUE 30 SEVEN HUE
ANALAGOUS SCHEMES OFFER GREAT VARIETY AND ARE EASY TO USE

SCHEME 31 32 33 SCHEME 34 35 36
ANALAGOUS WITH DOMINANT HUE ANALAGOUS AND LOW IN INTENSITY

SCHEME 37 38 39 40 41 42
ANALAGOUS SCHEMES ARE OFTEN IMPROVED BY SMALL COMPLEMENTARY AREAS

SCHEME 43 44 45 SCHEME 46 47 48
COMPLEMENTS IN FULL INTENSITY COMPLEMENTS IN UNEQUAL AREAS

SCHEME 49 50 51 SCHEME 52 53 54
INTENSE HUES, GRAYED COMPLEMENTS USE OF "NEAR" OR "SPLIT" COMPLEMENTS

SCHEME 55 56 57 SCHEME 58 59 60
TRIADS WITH ONE HUE DOMINANT TRIADS VEILED WITH DOMINANT HUE

COLOR SCHEMES ARE OFTEN MONOCHROMATIC, ANALAGOUS
OR COMPLEMENTARY · ALL THESE TYPES MAY BE COMBINED

SUGGESTIONS FOR COLOR SCHEMES *Here are some ways you might combine your colors. Color schemes are often monochromatic, analogous, or complementary. Schemes shown here are designed only to remind you of the elementary types of harmony.*

painting, the discrimination which this practice develops will help him choose the colors best fitted to his mood and purpose—a matter of great importance.

WARM AND COOL COLORS

Of these various characteristics, some seem particularly significant or are sufficiently tangible to be understood easily and put to practical use. That certain colors seem warm and others cool is a thing which you can use easily. Hues of the red, orange, and yellow group are the ones considered warm; they suggest flame, blood, and sunshine, and are especially appropriate when bright, stimulating effects are sought. Hues which are blue, or analogous to blue, are thought of as cool; they bring to mind cool water and ice and the sky of winter and are at their best (there are exceptions, of course) for purposes requiring restraint and subordination.

ADVANCING AND RETREATING COLORS

Cool colors also suggest distance or expansion and are, therefore, often called "retreating" colors, while warm colors, contrarily, are classed as "advancing." If we wish to paint distance or make areas seem spacious we give preference to cool colors; in the foreground, or where we wish attention concentrated, we use warm ones. As warm colors generally are associated with light, so cool colors suggest shadow—another important fact that we apply when painting.

Of the various advancing colors, red and orange, under most conditions, are considered to have the greatest force. Advertisers use them, particularly the red, as a means of gaining maximum attention. The artist employs them particularly to emphasize a portion of his subject when he wishes. Yellow is an exceptionally strong color under some conditions (some give it the highest rating), but usually has less power than red and orange. It carries well and has compelling force against dark or complementary backgrounds (light yellow against black has unusual power to attract) or if bordered or accented with dark, but is relatively weak if contrasted with light tints or white. (Here we are again reminded of the importance of color arrangement.)

Retreating colors, though carrying well as dark spots, often show weakness of hue if viewed from a distance. Greens and violets stand at the halfway point between heat and cold, as they contain both warm and cool colors, and so vary proportionately in their abilities to advance or

recede. Yellow-greens, and violets leaning strongly toward red, tend to advance and have considerable power to attract; blue-greens and blue-violets tend to recede and have less compelling force.

This has given us a strong hint that the carrying or attractive power of colors depends not alone on hue, but also on value and intensity. A gray-red, for example, though it may attract as a dark spot, will have little force compared with the same red when not neutralized. This will be plainly evident if you place slips of paper of these colors across the room.

We have seen that the activity of colors depends to no small extent on background. Distance, too, plays an important part in color strength. If you look down a long city street with brick buildings on either side, you will generally observe that the reds of the brickwork appear more and more dull or indistinct as they go into the distance, particularly if the atmosphere is a bit hazy; a blue or purplish hue will gradually take the place of the red as you approach extreme distance. In other words, *warm tones usually appear cooler in proportion to their distance from the eye.* To some extent this is true of all colors. Cool colors do not always seem to retreat, by the way; certain vivid hues, viewed near-by, appear particularly vigorous and emphatic, especially if against a complementary background. I once noticed, near at hand, a bright blue automobile which, contrasted with brown and red buildings, seemed extremely conspicuous. As it drove into the distance its color softened progressively.

As a practical application of advancing and receding hues, when painting landscapes or marines it is usually better to use your brightest colors in the foreground, and duller and duller colors as you work into the distance. This is not only because bright colors are more advancing than dull colors, but it also relates to the basic rule that all hues in nature, whether dull or bright, tend to be veiled in mist and atmospheric impurities in proportion to their distance from the spectator.

Not only do colors show the activity we have mentioned, but they have the power of stimulating a wide variety of emotional reactions. Such matters have been so ably treated in Sargent's *The Enjoyment and Use of Color* (Dover), and *Color Manual for Artists* (Reinhold), both currently in print, and Weinberg's *Color in Everyday Life* (Dodd, Mead), and Luckiesh's *The Language of Color* (Dodd, Mead), both of which are out of print but available in most art libraries.

The Luckiesh book would be an excellent one for the student to read at this time; it touches on color in mythology, nature, literature, painting, religion, and the theater. There are illuminating chapters on symbolism, explaining the significance of individual hues. There are also chapters on

nomenclature, psychophysiology of color, color preference, the affective and attentive value of colors, etc. Finally come helpful statements on esthetics, harmony, and the like. Sargent's and Weinberg's books, for that matter, go into many of the same things.

Exercise 25: Further Color Experiments

What we have offered here is by no means expected to clarify wholly the entire many-faceted subject of color. It is included mainly to show that color is a complex thing, and to emphasize the need for serious study and experimentation on the part of the earnest student. Read the previous text once more and perform such exercises as occur to you. But don't hope to master the whole thing at one time!

There's one encouraging thing: you can often paint successfully (and many artists do) with little knowledge of the reasons behind such matters as we have been discussing. And many so-called "experts" on color can't paint at all! Don't feel, in other words, that you must devote days and days to color study before trying your hand at actual representative painting. Pitch in and paint. But observe color and think about it often. Gradually, your color knowledge will grow.

Chapter 10

COLOR SCHEMES
YOU CAN USE

PERHAPS WE ARE A BIT PREMATURE in offering the paragraphs below, for you may feel that you will have enough to worry about in making your first paintings without endeavoring to obtain harmonious color effects. So turn at once to Chapter 11, if you feel so inclined. Yet these present suggestions seem so fitting a corollary to what we have already said that we can think of no more logical time to present them. At least they may serve to inspire the beginning painter to observe color more keenly and to think more often along color lines.

THERE ARE NO RULES

From our foregoing discussions—and from your experiments—we hope that you are by now convinced that there can be no rules to guarantee the artist a successful color scheme for a painting. You have learned that such a scheme depends not alone on the *selection* of hues which in themselves are harmonious, but also on the relative *size* of the areas in which they are used, as well as the *arrangement* of these areas.

If no teacher can tell you precisely how to obtain good color schemes— and no teacher can—possibly you have the hope that nature will prove a safe guide. If so, you may be somewhat disappointed. Nature, to be sure, gives you many beautiful schemes to serve as an inspiration and, to some

extent, as a guide. Yet, if you try to copy one by one, as precisely as you can, the hues which nature sets before you so attractively, you will quite possibly produce either discords of hue or, more likely, schemes so dull and common-place that they are uninteresting. This is partly because nature's colors are *living* colors (perhaps bathed in brilliant light or modified by mist, smoke, and the like) while yours are merely pigments, so that no matter how accurately you think you are matching each one of nature's hues as you paint, your final result is almost certain to lack much of the luminosity, the vibration, the subtle nuances, the chromatic richness and unity of the model before you. (Eventually you will learn to go after big *impressions* of natural color, not matching each hue.)

If paintings by the novice fail in any one general chromatic respect, it is that they are so worked over or done with so timid a brush, that they become lifeless and static—too muddy and gray. Or, because the artist senses this fault and endeavors to rectify or avoid it as he works, perhaps by applying pure color just as it comes from the tube, his results may grow too garish and extravagant, one hue clashing with another. Either of these extreme conditions should be avoided.

Yet color is obviously of great importance. An otherwise poor painting which is superior in color often wins acclaim, while an otherwise good painting, poor in color, usually ranks as a failure. Some of the best paint-ings, regardless of size, subject matter or technical handling, appeal to us largely for their color excellence—their esthetically satisfying choice and disposition of hues. Often such colors are close to nature—but often not—and this doesn't seem to matter so long as the spectator finds the result pleasing to his eye.

USING COLOR SCHEMES

But, if there are no man-made rules, and if nature is not an infallible guide, how is the painter to master color to produce satisfactory schemes? This is not easy to answer. Some beginners seldom have trouble with color; they are born with a color sense that others can acquire only after long study—if at all. Most beginners gain mastery gradually, mainly through trial and error.

One way is to "borrow" proven schemes from the paintings of others; there is nothing wrong in this, provided you employ them naturally instead of trying to force them into use. You can also adapt schemes from such things as colored prints, rugs, wallpapers, upholstery and drapery mate-rials. The student is wise who makes notes of attractive color schemes

everywhere he sees them, doing quick color sketches from paintings in the museums and galleries, clipping color reproductions from magazines, experimenting with his paints in an endeavor to find hues which go well together. Often a color scheme, borrowed from nature, can later be adapted to different subject matter, also from nature. A group of flowers, for instance, might provide the color scheme for an entire landscape painting. In short, the artist considers it his right to rearrange or otherwise alter nature's coloring if it suits his purpose or fancy.

ONE COLOR WITH WHITE, GRAY, OR BLACK

The simplest scheme makes use of a single color of only one value and intensity in conjunction with white, gray, or black (and, sometimes, with silver or gold). Such a scheme is seldom used by the painter; it is more commonly found in decoration or design. A typical illustration is the booklet printed with black ink on white paper, with initials or decorations of one tone of some other hue. Schemes 1 to 6 in the color reproduction on page 87, "Suggestions for Color Schemes," demonstrate some of these fundamental ideas.

THE MONOCHROMATIC SCHEME

The simplest scheme which the painter is likely to employ is an extension of the above; it consists of any desired values and intensities of a single hue, used with or without white, gray, or black. A good illustration would be a painting done on white paper or canvas with but one color—sepia, for example—the values perhaps ranging from light tints to dark shades. Such variations are sometimes referred to as "self-tones." As only one color is used, hence the term "monochromatic," there is no chance for an inharmonious color result. That monochromatic schemes can be effective is proved by the fact that all but colored photographs are in monochrome—usually black or brown. Schemes 7 to 12 show us the use of this color.

THE MODIFIED MONOCHROMATIC SCHEME

Seldom is the painter satisfied with a strictly monochromatic treatment. In order to gain slightly more variety, he often adds subtle suggestions of other colors, thus obtaining by economical means an impression of a satisfying opulence of hue. Occasionally, small touches of bright colors are used in a painting which otherwise is monochromatic. For example, most of the

93

canvas might be covered with varying tones of gray-blue (as in a night scene), small accents being added of complementary orange (lights in the windows, perhaps). In a further extension of this type of scheme, the effect would be generally monochromatic, but the dominant hue would be subtly supported by suggestions of analogous hues, the whole then being intensified through the use of small (possibly bright) complementary accents.

ANALOGOUS SCHEMES

Inasmuch as strictly monochromatic schemes are rare in the work of the painter, his main interest will be in various types of more colorful schemes. The simplest of these is the analogous or related scheme already discussed (on pages 81 and 82) in connection with our color wheel. It will be recalled that this scheme is made up of colors which are adjoining or adjacent in the spectrum, and hence on the color wheel. Orange, yellow, and yellow-green, for example, form an analogous scheme, for they all contain the common factor, yellow.

Let me repeat that it is well to keep such a color wheel at hand, for it shows at a glance what color groups are analogous. If we start with yellow (we might similarly begin with red or blue) we note that yellow-orange and yellow-green, consisting largely of yellow, are particularly close in relationship. These three form a "close" analogy, and so are almost certain to be harmonious. If we reach out to include orange and green, each of which contains some yellow, this entire five-hue group is also analogous and usually a safe combination. We can also often include red-orange and blue-green with reasonable safety (for each possesses a slight yellow content). The more of the circle we include, however, the more varied the elements which must be harmonized, so typical analogous schemes seldom take in more than a third of the circle, centering around one of the primary colors, red, yellow, and blue. Such schemes are among the safest and surest at the artist's command.

In other words, if you want to obtain harmonious color, limit yourself to a few hues showing a clear indication of mutual relationship. We should perhaps warn you, however, that even this is no absolute guarantee of success. I recently noticed a florist's delivery truck of pale violet parked beside a huge sun-bathed trailer truck of red-orange. The common factor of red was not enough to relate the two hues pleasingly; the delicate violet was entirely out of keeping with the vigor of the red-orange. But this is exceptional. Schemes 13 to 30 in "Suggestions for Color Schemes" show numerous examples.

WITH DOMINANT HUE

The very unification of close harmony which makes analogous schemes pleasing can at times make them monotonous. To convert them into something more interesting, it often helps to place emphasis on some one hue of an analogous group—in other words, to make this hue dominant. Always remember that a hue can be made to dominate because of its large area, its dark value (against lighter hues), its light value (against darker hues), or its intensity. See schemes 31 to 33.

WITH COMPLEMENTARY ACCENTS

As we saw in Chapter 8, many of the most successful analogous schemes are enlivened by the introduction of rather small but sometimes intense complementary accents. Such accents, particularly if brilliant, often have a power out of all proportion to their size. A single touch of color complementary to the dominant hue of an analogous scheme can give surprising life to the whole. See schemes 37 to 42.

COMPLEMENTARY SCHEMES

It is only a step from this use of complementary accents to completely complementary schemes, sometimes known as "harmonies of contrast." Under this heading we can include any pleasing schemes which conspicuously introduce opposite colors. The majority of color schemes used in painting are to some extent contrasting, the contrast generally being developed through the use of complements.

Despite the fact that colors which we term complements are wholly unlike in most respects, it should always be remembered, nevertheless, that a definite relationship exists between them. Green and red, for instance, while in most respects as unlike as any two colors could possibly be, are subtly related, as the word "complement" implies. When properly handled, complements can result in some of our most pleasing color harmonies. As a matter of fact, a majority of people seem to prefer harmonies of contrast to harmonies of analogy. Some of the finest paintings, chromatically, contain *all* the leading colors in balanced pairs. Nature, too, is profuse with complementary schemes.

We must learn to control our contrasts, however, or we may get, instead of harmony, chaos. Generally speaking, *never base a color scheme on complementary colors in equal areas and full strength.* (See schemes 43 to 45 on page 87.) A dress made of alternating wide stripes of intense

orange and complementary blue would compel attention, but it could scarcely be called harmonious! (See scheme 45.) But we have previously seen that we can employ complements to advantage when we use them in unequal areas (schemes 46 to 48) or in unequal intensities (schemes 49 to 51). We know that a large red area and a small green area often look good together, as does a brilliant red area contrasted with a dull green area; and vice versa.

Exercise 26: After-Images

To interrupt for a minute, did you ever play around with after-images? They are fascinating! They prove, among other things, the truth of what we have just said about complements being subtly related.

But test them for yourself; it will take only a second. Place (or paint) a small area of intense green—an inch will do—in the middle of a sheet of white paper. Lay it in bright light and stare at it fixedly for half a minute. Now shift the eye quickly to the center of another white sheet. Almost at once—wait for it—a light pinkish "ghost" will appear, stay for a few seconds and then gradually fade away. That ghost is a pale tint of the true complement of that particular green. Try other colors and find this ghost of the complement of each. You can even stare at several adjacent spots of different color simultaneously, and then see on another sheet the ghost complement of all of them.

In performing such an experiment, by the way, you will doubtless be struck by an interesting phenomenon. As you stare fixedly at an area of any given color, you will soon note that by gradual degrees it grows duller and duller before your very eyes. It is being neutralized (as the eye temporarily becomes tired) by its own complement! Perhaps as you stare you can see this complementary tint "bleeding" along the edges of the color area. And you can transfer it at will to another paper by merely shifting your glance.

NEAR AND SPLIT COMPLEMENTS

Returning to our main thought, in harmonies of a complementary nature the eye does not demand that exact complements be used. This would be difficult, even if desirable. Fortunately, complements which are only approximate or "near" seem more pleasing, many times, than those which are absolute. The term "near complements" is self-explanatory; violet is the true complement of yellow, while blue-violet and red-violet are both near complements of yellow. We sometimes speak of these in their relationship,

one to the other, as "split" complements, as they are split or separated by the true complement, violet. See schemes 52 to 54 in our "Suggestions for Color Schemes."

TRIADS

If we base a color scheme on a color and its split complements, or on hues mixed from them, we can obtain a fairly wide range of hues, but none of them can be brighter than the color itself and the two split complements in their full intensity. Sometimes such a range proves too limited, so in place of these split complements, which are closely related to the complement itself, we use other split complements, each a step further removed.

In the twelve-color wheel in Chapter 8, if yellow should be taken as a hue to dominate a color scheme, and the split complements red-violet and blue-violet (alone or in mixture) should prove too inadequate to hold their own, red and blue might be substituted, giving us a "triad" harmony. Yet there we are, of course, in a danger zone, for, although some mixtures obtained from triads can be very rich and beautiful (we have seen again and again that practically all colors can be mixed from the triad composed of red, yellow, and blue), other mixtures can be far from harmonious as each primary strives to dominate the other two. To get effective results, therefore, one hue of the triad is usually selected to dominate the scheme, and the other two are mixed together, or with the first, or with white or black, or some other color so as to render them less potent. Schemes 55 to 57 illustrate examples of triads with one hue dominant.

One of the most certain ways of preventing rivalry among the basic colors of a triad is to select one of the three to dominate, and then to "veil" (by means of a thin wash) or neutralize the other two with it. Schemes 58 to 60 illustrate examples of triads veiled with dominant hue.

A PLAY-SAFE METHOD

For the beginner, incidentally, there is a "play-safe" type of harmony which gives him reasonably satisfactory chromatic balance simply and quickly; he merely distributes some of each of his leading hues all over the canvas, blending a bit of "this" into a bit of "that" throughout the whole, thus weaving a sort of all-over pattern of color. Thus no one color is vigorous enough in hue, intensity, or area, to clash with any other.

Don't expect to grasp from this all-too-brief (and undoubtedly confusing) printed word more than a vague notion of the intricacies of color harmony. Some painters have concentrated on color harmony for a lifetime and entire books have been devoted to it. May I stress again that my main purpose is merely to get you thinking about color, so that you will develop a more critical color sense as you go along, plus an ever-increasing facility in harmonizing the various hues at your command?

Exercise 27: Color Schemes
Make some small color sketches to illustrate the type of schemes discussed above, or hunt up pictorial illustrations of each in books or magazines.

Chapter 11

PROFITING FROM
THE PHOTOGRAPH

NOW, HAVING DISPOSED OF our preliminaries, we are ready to begin the representation of actual subjects. But where to start? There is considerable difference of opinion as to the best starting point. Still life painting has much to recommend it, and should not long be postponed (see Chapter 13). It presents so many new problems at the very outset, however, that, as the result of years of classroom experience, I prefer substituting the uncolored photograph, the painting in monochromatic wash.

ADVANTAGES OF THE PHOTOGRAPH

Perhaps the chief virtue of the photograph is that it reveals how many interpretations you can make of one subject, without resorting to many hues. The photograph reduces all things, including colors, to comparatively simple contrasts of light and dark, helping us to understand that values are as important as hues. This conclusion often escapes the beginner who works from the objects at once. Furthermore, the photograph not only lacks the confusing color which causes objects to seem so complex, but it is also small enough for your eye to view it easily as a complete unit. The photograph maintains the same appearance night and day, too, making it available at any time and place. Above all, it presents a great wealth of subject matter, allowing you to paint things nearby and far away, huge and small things, rounded and angular things, rough and smooth things, etc. It often

distorts forms and values, however, and portrays many details so indefinitely that one cannot judge their true appearance.

SELECTING THE PHOTOGRAPH

Choose simple, well-composed photographs of pleasing subject matter, reasonably distinct throughout. Picturesque scenes—dilapidated buildings, for instance—are usually easy to interpret (mistakes don't show plainly!) and have an almost universal appeal. They also keep you from trying to be painstakingly exact. These scenes tend to encourage boldness, a desirable quality in your work. But pick any subject that you really like, so long as it is simple. Vary your subjects. Save good photographic material for future reference.

LIMITING THE SUBJECT

Often a portion of a photograph is enough. One method of selecting a portion of your photograph is to cut a piece of cardboard into two "L" shaped strips. Overlap the strips to form four perpendicular sides which you can move about experimentally. When you find a pleasing subject, clip the strips into position on the photograph, hiding the adjacent areas which might otherwise prove distracting.

SKETCHING THE SUBJECT

Now block out the main proportions lightly on suitable paper with a medium pencil. (It's usually better to make your drawing larger than the photograph.) Don't tip the photograph or you will foreshorten it, distorting the proportions. It is best to place it vertically before you, as on the back edge of your drawing table. Hold your paper so you can view it approximately at right angles.

THE PIGMENT

Sepia is popular for wash work, as is black. The old masters often used bistre (a warm brown) or sanguine (red). Blue is quite a common choice; gray-blue is pleasing. So select your pigment and prepare your accessories.

ANALYZING YOUR SUBJECT

Never paint a subject without first analyzing it. What are its main essentials, or, in other words, what things constitute its greatest appeal? These

are the things to go after. Do some essentials seem too subordinate in the photo and some trivial things too prominent? If so, don't hesitate, as you paint, to make any adjustments consistent with your purpose. Note such vital matters as the direction of the light and the textures of the leading features. Are the values pleasingly disposed? Or are some too light or dark?

ADVANCING THE WORK

With a general understanding of your subject acquired (and, if possible, with a plan of procedure mapped out), paint! Don't be afraid. Work as directly as you can. It is good practice in all watercolor painting to lay light tints first, then darker washes, and, finally, the darkest tones and accents. This prevents the mussiness which would result with the process reversed, causing the dark pigment to run when touched or superposed by another. Don't go over any given area more often than is necessary, for there is danger of losing the freshness and spontaneity for which watercolor is best known. Don't, however, complete a limited portion of your sketch at a time, but "keep the whole thing coming." This is because, as we learned in discussing simultaneous contrast, you cannot correctly judge a tone until the adjacent tones are in place. If you are ever in doubt as to the exact value of a given area, either on your photograph or on your drawing, cut a small opening through white paper as a "finder" and study the tone through that, as contrasted with the white.

In applying your pigment, use the means which seems most natural. Wash it on, dab it on, mingle it, or draw it with the end of your brush. Don't try to be too photographic, showing every slight gradation of tone and fussing over each detail. Interpret; suggest; indicate! A drawing which gives the appearance of having been done boldly (no matter how timid the artist may really be) creates, even though somewhat faulty, a better impression than one which is finicky and overworked.

APPARENT CARELESSNESS

Many washes are blurred and streaked. Some beginners think this is due to carelessness. There may be fans, runbacks, and blurred edges which disturb him. With the growth of his appreciation, he usually comes to realize that these matters are trivial and whether they are assets or not (often they are) they are not blemishes, as he thinks them. Sketches of this type, when done with sound reasoning behind them, are in many respects superior to the customary "tight" or "labored" sort. Surely this result catches the spirit of the subject, and one feels the artist had a lot of fun doing it.

CENTER OF INTEREST

If you look at a subject in nature, that portion on which your eye is focused becomes, for the moment, all-important. Things away from this focal point seem blurred. In making a drawing, the artist customarily assumes he is thus focusing his attention in one fixed direction (usually on some feature of particular interest), and he emphasizes those things which fall within his range of vision. In wash drawing, he obtains this emphasis through the employment of strong contrasts of light and shade, and a full development of details. In color work, he also utilizes sharp contrasts of hue. Thus he creates a "center of interest." Away from this, he blurs his effects. Generally, you would be wise (there are always exceptions to these rules) to follow such a scheme, as it tends to unify your work. Particularly avoid two or more competing centers of equal importance, as such rivalry destroys unity. There may be several centers of interest but only one should predominate.

Sometimes, instead of a "center of interest," we have a "path of interest," the area of focus being expanded to include several principal, related features, one of which is usually emphasized to form a note dominating the whole.

VIGNETTING

In most watercolor work, whether in monochrome or full color, the subject is rendered all the way to the margins, though the corner areas are best kept inconspicuous. There are times, however, when a sketch fades to nothing toward the edges of the sheet; it is said to be "vignetted."

When you vignette a painting, be sure to study the shape of the spot which the entire thing forms on the paper in order to make it pleasing. Also vary the treatment of the edges.

PATTERN INTEREST

Every drawing or painting—we often use the word "drawing" for "painting"—is, in a sense, a pattern or design, and just as we prefer one applied design to another (as in the case of fabrics, for instance) because it is more pleasing to our esthetic taste, so we find that our appreciation of a sketch is often influenced by its pattern. Paintings in monochrome offer an excellent opportunity for first experimentation in this direction. If you plan every sketch with the idea of creating pattern interest you will soon learn practical methods. If an area seems empty from a pattern standpoint, for example, you can dab on a few brush marks. But don't feel you must crowd every inch of your paper with pattern. The relief of plain areas is

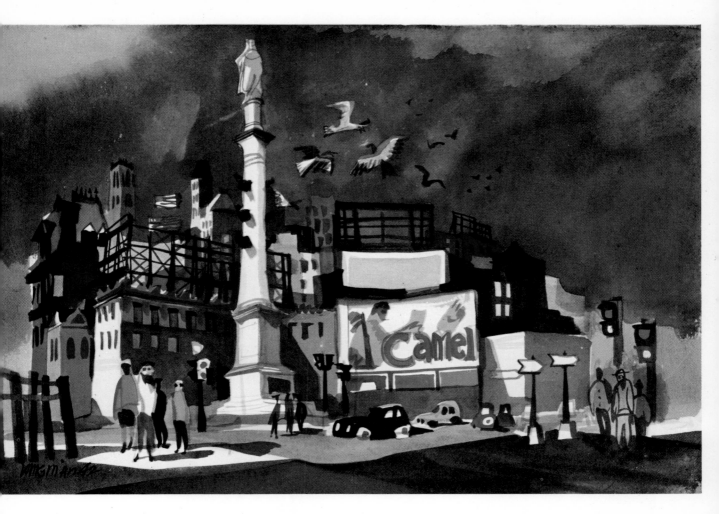

Dong Kingman

COLUMBUS CIRCLE *The drama of the pyramidal composition is heightened by the dramatic lighting which comes from the viewer's left-hand side and throws all the right-hand planes into deep shadow. The light planes, which face the light source, draw added strength from the sky; this is particularly true of the statue which is the center of interest, looming white against the stormy clouds. Fleeting light effects like this can often be recorded by the camera for further development in the studio.*

necessary. In arranging your values you can keep this design quality in view, too. This is not a thing which need worry you immediately, for if you select good subjects, and render them honestly, pattern will probably take care of itself.

EXAMPLES

Figure 47 was designed to illustrate some of these recent points. At 2 is a sketch (with dotted outline in diluted ink) of the photograph at 1. Pale washes were applied to reveal the natural pattern and to afford a foundation for the later work. The photograph itself is relatively well composed, so little adjustment was necessary. Its interest centers in the church, which, light in value, is pleasingly contrasted with the dark masses of the foreground, which form a sort of enclosing "U." The converging lines of the street and nearby buildings also help to lead the eye to the center of interest.

So, in the sketch at 3 (a continuation of 2) the photograph was followed quite closely, though not slavishly. The adjustments were mainly in the interest of greater expression of distance; note the softening of the darker accents in the church and figures. The sketch at 4 is introduced

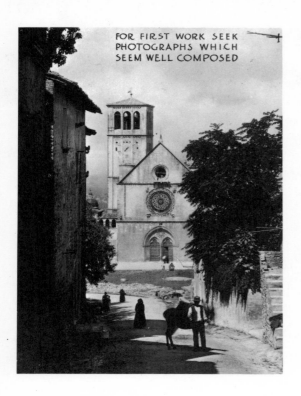

FOR FIRST WORK SEEK
PHOTOGRAPHS WHICH
SEEM WELL COMPOSED

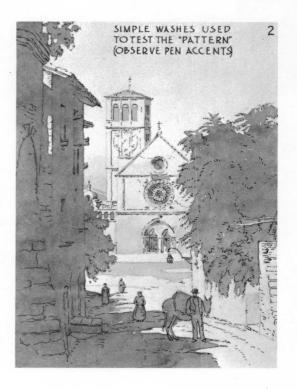

SIMPLE WASHES USED
TO TEST THE "PATTERN"
(OBSERVE PEN ACCENTS)

2

mainly to show that the artist need not feel handicapped by his subject as he finds it; he can make any such changes that seem logical. Here, great liberties were taken with the lighting, the values having been readjusted according to an altered direction of light, the buildings at the left, formerly in shadow, now becoming brilliantly illuminated, while the right-hand side of the street passes into gloom. The trees and figures have been recomposed, too. In this specific instance there was little point in these changes, beyond bringing the possibility to the reader's attention. All these sketches are perhaps too photographically exact, lacking the spontaneity which one gradually strives to develop.

INDICATION

Try to learn to indicate or suggest, especially when it comes to details which would demand too much time and trouble if treated photographically.

Figure 47

PAINTING FROM THE PHOTOGRAPH *For early attempts at painting you can find some advantages in using photographs. Here are a few wash interpretations of a photograph.*

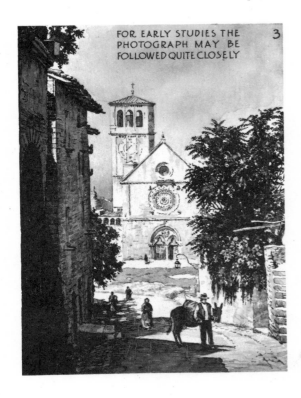

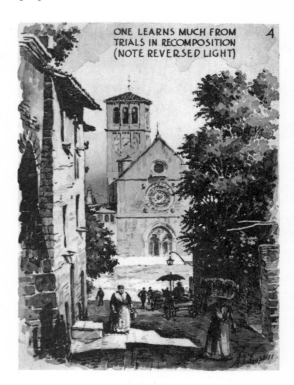

Figure 48
SIMPLIFICATION *Solid black and white are capable of surprisingly adequate results.*

SIMPLIFICATION

Simplicity is a virtue. Always remember that you needn't, by any means, picture every tone a subject reveals. The eye is satisfied even by poster-like treatments such as in Figure 48, where black ink represents all dark values and white paper all light values. To a less extent, most subjects are thus simplified and conventionalized in pictorial representations. Figures 49 and 50 illustrate the transition between the black and white effects and typical wash drawings. In them, gray was used to supplement the black-and-white. The student would learn much from making a few drawings of these types.

As further exemplification of what we might call artistic license, with emphasis on recomposing values with simplicity in mind, let us turn to the photograph and drawings in Figures 51 to 56. The photograph, as it stands, has little to condemn it; therefore, in the vignetted sketch in Figure 52 the existing values were not greatly changed. The leading alteration was in the

Figure 50
BLACK, WHITE, AND GRAY
You have almost unlimited opportunities with limited values. This is a transition between the solid black and white drawings and typical wash drawings.

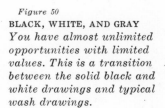

Figure 49
BLACK, WHITE, AND GRAY
Adding gray to the solid black and white produces effects worth practicing.

Figure 51

Figure 52

Figure 53

Figure 51

PHOTOGRAPH *This is a good kind of photograph to interpret. It is simple and bold, with sharp differentiation of value. Notice carefully how even a subject as simple as this offers a variety of possible value arrangements. Again, we are working only with black, white, and gray!*

Figure 52

FIRST INTERPRETATION *The original values were hardly changed at all in this first study. Only a dark area was added in front of the arch. Notice the number of values that now appear in the foreground area, absent in the photograph itself.*

Figure 53

SECOND INTERPRETATION *Much of the detail was eliminated here, a treatment of the Roman aqueduct which produces a strong poster-like effect. All these studies were made directly on tracing paper placed over the photograph.*

Figure 54

THIRD INTERPRETATION *Strong contrast was obtained here by completely reversing the value contrasts. Only the dark shadows under the arches have been left in the same value.*

Figure 55

FOURTH INTERPRETATION *Again the values were recomposed. Now the light appears to be coming from a different direction, the strongest shadows no longer falling under the arches, but on the face of the structure.*

Figure 56

FIFTH INTERPRETATION *Here the moon seems to be illuminating the aqueduct. The deepest value is in the sky. Compare this sky to the other sky treatments and notice how it affects the over-all handling of the subject. White has been eliminated almost entirely.*

Figure 54

Figure 55

Figure 56

foreground where a dark area was added, mainly to illustrate again that the artist is free to take any liberties he pleases.

TRIAL STUDIES

Even when the student realizes that he has artistic license, he often fails to know how to exercise it. This he can learn only by experience. He must experiment.

These drawings in Figures 53 to 56 not only show to what extent you can vary your interpretation of a subject by means of value adjustment alone (without altering any proportions or general characteristics), but they introduce a method of experimentation which can be highly recommended when you are wondering what adjustments to make. For these were done very quickly (in brush) on tracing paper placed over the photograph. While such tracing paper sketches buckle considerably, they serve very well as preliminaries to help you decide on a plan of action for a final drawing. You can of course substitute charcoal, pencil, or crayon for the wash and ink.

THUMBNAIL SKETCHES

The student is strongly advised to make some sort of preliminary sketch for every painting done from photograph, at least for a while. Many artists prefer to do preliminaries smaller than their photographs. Often these are only an inch or so in size and are therefore known as "thumbnail" sketches. Size matters little, however. The principal thing is to get the habit of making preliminary sketches to have a definite plan every time work is started on the final paper.

Exercise 28: Sketching from Photographs
Don't turn to the next chapter until you have painted from a variety of photographs, endeavoring to apply some of the principles here discussed. In some of your paintings, substitute colors of your own choosing for the neutral tones of the photograph. If you have no teacher, try to get criticism of your work from other qualified persons.

Chapter 12

LEARNING FROM
THE MASTERS

BEFORE WE TURN to painting an original subject, I think it is advisable to interject a word on the diversified aims and viewpoints of various painters, because, without knowing something of these, we may lack proper appreciation of their work. We shall confine our remarks to the conservative school, where the aim is to represent the subject matter with reasonable fidelity.

If you could look over the shoulders of a number of equally capable artists, simultaneously painting from exactly the same subject, in the same medium and from approximately the same station point, you would probably be surprised at the diversity of method and result. Sketches done under conditions such as these often exhibit such amazing dissimilarities that it is hard even to recognize them as painted from a common subject. If you could also read their minds you would perhaps be as much surprised by the different mental processes back of the varied methods and results, as by the methods and results themselves.

WHICH IS BEST?

If we were to examine the sketches with a view to picking the best, the problem might be difficult. For the best sketch is by no means the one which sets forth most explicitly and exactly every element of the subject, as a fine photograph in natural colors might do. Yet it is hard to define

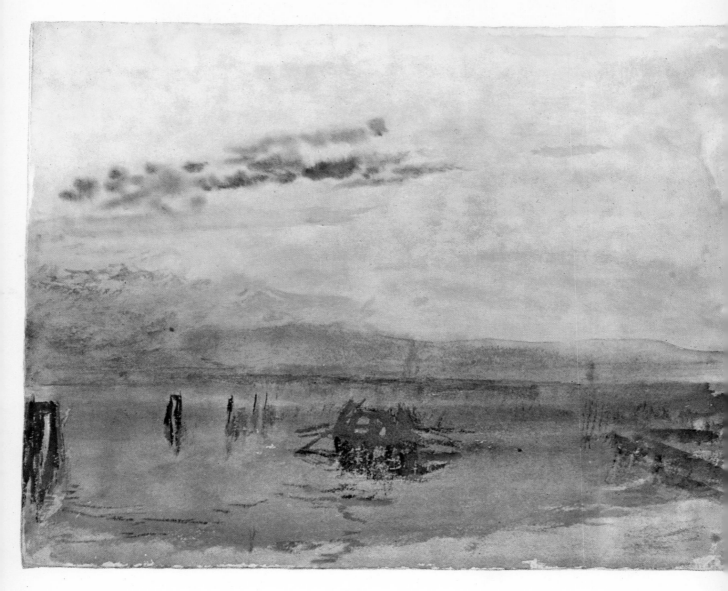

J.M.W. Turner

VENICE FROM FUSINA *The greatest of the English water-colorists, Turner, in his late work, verged on abstraction. Here the details are barely recognizable, yet they ring true. The sky was fluidly painted on wet paper, while the clouds on the horizon and the water in the foreground were laid wash upon delicate wash in the traditional English fashion. The boat and piles were dashed in with rapid strokes after the washes had dried. Collection, British Museum. Color plate, courtesy Museum of Modern Art.*

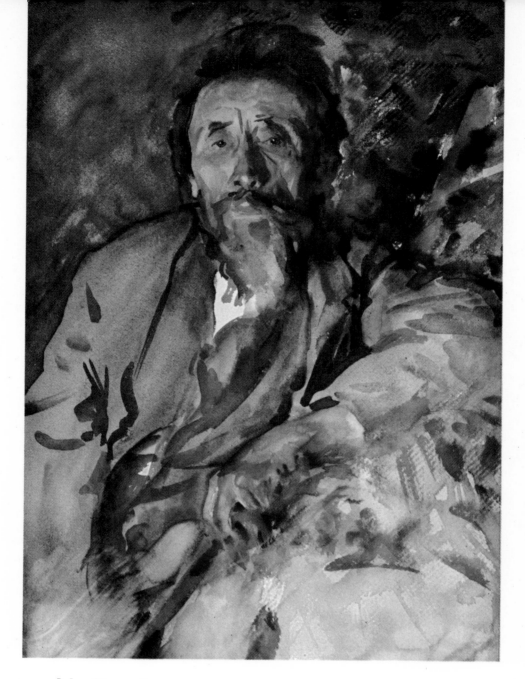

John Singer Sargent

THE TRAMP *Best known in his own day as a portrait painter in oils, Sargent painted watercolors for relaxation. However, even in his watercolors, he retained the decisive, slashing strokes for which his oil paintings were famous. The darks of the clothing are dashed in with a fully loaded brush. In many of his watercolors, Sargent combined transparent color with opaque white to produce a wide range of subtle, semi-opaque tones. Collection, Brooklyn Museum*

what the best sketch really is. Sometimes it is the one which records most faithfully some aspect of the moment, whether of sunshine or shadow, heat or cold, tranquillity or action. Again it is the one which catches the finest harmony of hue, symphony of value, or beauty of pattern. Or it may be the one in which the artist discovers, beneath all such visible manifestations, some truth commonly unnoticed or unrevealed, and bares it for all to see. In other words, the best sketch is the one which most successfully conveys to the beholder the attributes or impressions of the subject that its creator wishes. It is a product of that great triumvirate—the eye, the brain, and the hand. The artist observes the subject, filters it through his mind, and places the results of this filtration on paper. It bears the imprint, too, of his subconscious mind—yes, of his very soul. Therefore it often expresses to the observer a deeper meaning than does the subject itself. It appeals to his intellect and emotions as well as to his eye.

FOUR PAINTINGS

To illustrate this matter, partially, I point to an incident of a delightful sketching expedition along the Maine coast some years ago. Of a party of four, one was a painter, specializing in landscapes and marines, a second an illustrator, a third a designer from a landscape architect's office, and I was fourth, with architectural inclinations.

One morning we selected a quaint, weatherbeaten old fishing shack as a subject to sketch, and we each set to work to interpret it. It was extremely interesting and profitable to compare the final results.

The painter finished first. His treatment was far from literal: he made no attempt to represent the subject mass for mass, value for value, and hue for hue. Yet he caught a most vital impression of it. One could almost sense from his sketch the warmth of the sunshine, tempered by the cool breeze from the sea, the tang of the salt air, and the motion of the waves. In other words, he was able to grasp and register on his paper the spirit of the place and the character of the day. It is in this sort of thing that the painter excels. He knows that a quick impression, produced in the enthusiasm of his first contact with the subject, has, even when inadequate and faulty in some respects, a virility and conviction lacking in the more calculated effort. Hence, he fritters away no time on minor details such as often seem vital to the beginner, but at once translates the leading essentials into rapid brush strokes and hasty washes.

The illustrator wove a bit of a story into his painting. On the rickety steps before the time-worn structure, he introduced the figure of an old fisherman mending nets; in doing this he drew on his memory and powers of inventiveness, for there was no fisherman present. And he showed a cat

in the sunshine of the open doorway and a pot of geraniums in the window. In other words, he seized upon the dramatic possibilities of the scene, producing a "sweet" sketch which would have popular appeal. The illustrator is, in a sense, a playwright or a stage director. His figures are his actors and his settings the stage.

The landscape architect was particularly impressed by a group of wind-blown evergreens fighting for existence at the top of the ledgy bank which provided the foundation for the ancient structure. He evinced considerable interest, too, in the glacial markings of the ledge itself, sketching the entire bank in some detail. The building received only meager attention.

To me, the building—which possessed, among other quaint features, a peculiarly truncated gable—was a rare find. A bit of metal conductor pipe, picturesquely staggering downward across the gable end from an old wooden gutter to a bright blue water cask, especially intrigued me, as did a pile of lobster pots, bleaching nearby, and the prow of an abandoned dory, half buried in the sand. I featured these elements in my painting.

Words are scarcely enough to make clear to what an extent the four resulting paintings differed. Yet despite their differences it would have been hard to say which was the best. The layman would probably have chosen the painting by the painter or illustrator, yet the others were attractive and served their purpose very well, and so, in their more humble way, were perhaps equally successful.

All this not only gives us greater insight into why paintings vary as they do, but it should be enough to show that unless we understand why a specific painting was made, we have little means of judging how successful it really is. You should be cautious, therefore, about criticizing the work of artists unless you know its purpose, always remembering that personal opinion does not necessarily constitute the truest judgment. Similarly, you should accept some types of unfavorable criticism on your own work with a grain of salt.

LESSONS FROM THE MASTERS

As an introduction to work in watercolor painting from original subjects, you can learn much from studying, and even from copying, examples by other artists. Such practice is of particular help to the student unable to join painting classes or to see painters at work. Originals, if available, are far better to study than reproductions, not only for their more intimate appeal, but because their larger size reveals such details as the quality of the paper and type of brush strokes. When reproductions are the only things available, choose the ones that show technique the most clearly.

Probably it is unnecessary to caution the reader against persisting in

copy work for too long; its purpose is only to give him something of a foundation for the far more vital original exercises to follow. Some educators strongly denounce *any* copy work, yet it is safe to say that almost every artist has, at one time or another, done some copying, and to advantage.

SUGGESTIONS

Select a suitable subject. Make your copy as near as you can to the original size—not the reproduction size. Don't work too small. You can save time by choosing two subjects to carry along together, painting on one while the other is drying. Alternating your attention will also tend towards greater accuracy. Obviously, if your paper is like that used for the originals, your problem will be somewhat simplified.

PAINTINGS IN OTHER MEDIA

As no two media can be expected to produce like results, attempts to copy reproductions of originals done in media other than watercolor are quite certain to prove disappointing, unless you are satisfied with a very free interpretation.

ADVANCING THE WORK

The process of copying a color subject in color is in most respects so much like that of making a wash drawing from a photograph that it seems unnecessary to offer many instructions. The placing of the subject, the blocking out of proportions, and the analysis are practically the same. Constructing your work, and in your brushwork, don't strive for a slavish copy. Even the artist who made the original could not get *exactly* the same effect again, for in the free type of painting which we have in mind there is always an accidental quality hard to duplicate. But come as close to both the proportions and the colors as you reasonably can; above all, seek to catch the same spirit.

Analysis usually reveals traces of a foundation tone covering a large part of the paper, or at least all of it but the sky. Many artists apply a preliminary tint of pale yellow. Such a wash tends to improve the paper and to harmonize the colors which are later laid over it. Diluted Naples yellow, yellow ochre, or cadmium orange will do; much depends on the color scheme you intend to use.

With the foundation tone dry, the whole is worked up gradually. Match area after area to your best ability, following the scheme the artist origi-

nally used as far as you can decipher it. Remember that in discussing the laws of simultaneous contrast we saw that colors vary in appearance according to their proximity to other colors, not always being what they appear to be. This sometimes makes it difficult to judge individual hues. Here is another chance to employ your finder to detach each hue from the rest for better examination. In matching colors, your pigment acquaintance charts should prove useful.

If you follow the customary scheme of laying your light tints first, then darker and darker colors, and finally the accents, there may come, no matter how careful you have been, a time of discouragement. This will probably occur when your copy is about half completed, for no copy appears much like the original until the dark areas and finishing touches are in place. You must simply have faith that it will turn out all right, and work patiently toward that very desirable end.

Rest your eye now and then; returning to your work you will discover faults not previously noticed. Also try the test of putting the original and the copy side by side in an inverted position. Or reflect the two in a mirror. Thus viewed, incorrect areas will show more plainly. And always sit back from your paper a fair distance as you paint, remembering the good old rule, "don't paint with your nose."

PORTIONS OF SUBJECTS

Don't feel you must always try to duplicate entire subjects; select portions of supreme interest and copy them. Make a sheet of trees, perhaps copied from several drawings; another of skies, etc. Save them for reference. This will prevent you from adopting too many of the mannerisms of any one individual.

Later, when you have learned to match colors fairly well and have accumulated a fund of technical tricks, you will perhaps become more interested in what you can learn of composition, the balancing of colors, methods of emphasizing or suppressing features, of securing effects of projection and recession, of suggesting detachment, light, shade, atmosphere, etc. In all this, endeavor to develop your own critical judgment; don't copy without attempting to read the purpose of the artist. Strive also to memorize as many impressions as you can. They are bound to prove helpful.

COPIES PLUS PHOTOGRAPHS

When you have completed a copy of a painting (or while you are at work on it) it is extremely helpful to do another similar one, using the same general

color scheme and method but basing the subject matter on a photograph of a similar type. This puts you on your mettle, for the problem becomes more creative; the result is your own and not a copy. Even professional artists adapt in this manner.

THE WORKS OF EARLY PAINTERS

You are not taking full advantage of the work of other artists until you familiarize yourself, to a reasonable extent, with the history of watercolor painting. There are many books available which touch on this phase of the subject. Also visit museums whenever possible.

Exercises

The text suggestions above are so definite that numbered exercises seem superfluous. But don't neglect this work!

Chapter 13

STILL LIFE:
PAINTING THE
SINGLE OBJECT

IN THESE WATERCOLOR "LESSONS" we have now looked into a good many things which you should know something about if you hope to become at all successful as a watercolorist: painting materials, methods of their use, tests for opacity, resistance, and permanence, mixing and matching colors, color application, value scales, using the color wheel, color phenomena, color schemes, painting from photographs and from master paintings, etc. So, at last, we are ready to get down to our principal business. At last, we have reached the point where, for the first time, you are really on your own. No copying now; no secondhand interpretations. Instead, an actual beginning in representational painting.

THE VALUE OF STILL LIFE

First, a paragraph in favor of object painting, for there are always some who, impatient to get at other subjects—landscapes, buildings, etc.—scorn the more humble things. Many students are inclined to turn up their noses when it is suggested they paint books, cardboard boxes, dishes, and the like. They forget that larger structures are similar in form, color, and texture to these objects which, because of their greater simplicity and smaller size, lie more nearly within their capacity. Perhaps the greatest advantage in working from such everyday objects as dishes, books or vegetables is

that from these simple and fully familiar things one can most easily master fundamentals, applicable to all sorts of subjects, no matter how large or complex. It has been said that if one can develop facility in painting such geometric solids as the sphere, cylinder, cube, prism, and pyramid, one can paint anything—and to a large extent this is true. Buildings, for example, are, in basic shape, almost invariably nothing but combinations of cubes, prisms, and pyramids; domes are hemispherical (like half of a ball or orange); even trees, clouds, and a hundred other apparently complex things will often, on close examination, be basically similar to balls, eggs, or other equally simple objects. Still life not only gives you invaluable lessons in form, but can teach you to render a multitude of different values, colors, and textures.

In short, if you see how many steps you will ultimately save if you are content to do simple objects for awhile, well within your capacity, you will gladly postpone attempts at the far more difficult——though perhaps more stimulating and alluring—landscape, animal, and figure subjects.

EQUIPMENT

As the student customarily gives quite a bit of time to still life painting, it pays him to provide a convenient working space and suitable equipment. Whereas the painter in oils often stands at an easel, the watercolorist working indoors, especially if his subject matter is small, sometimes prefers to sit. Not infrequently he leans one edge of his drawing board (or watercolor block) against the near edge of the table supporting his subject matter, with the other edge in his lap. This gives his paper about the right pitch so that he can view it easily (otherwise his drawing might develop distortion) and apply his paint without danger of its running off.

Still better, perhaps, is the practice of using either a watercolor easel, with the top adjusted to a nearly horizontal position, or an extra stand—not the one holding the objects to be painted—on which he can block up his board to the right slant. This same stand can hold the student's watercolors, mixing dishes, etc., or another can be provided. These accouterments should always be placed in the same relative positions, if time-saving working habits are to be formed.

LIGHTING

When you prepare subject matter indoors, you are fortunate in having much more control of the amount and direction of the light illuminating your subject than when you work outdoors.

118

Seldom should you place your objects—or your paper—in direct sunlight (from a door or window, for example), because this can prove very confusing. Nor should you have light coming from several sources (whether windows, doors, or lamps), as this will produce a complication of cross-lights with shadows falling in different directions, one series overlapping another. Even a single window may produce more light—or light of more varied direction—than is desirable, so frequently the artist covers part of such a window—perhaps the lower sash—with a curtain or cardboard shield. North light is best. Being largely reflected from the sky, it is purer in hue and more uniform than other light.

Daylight indoors is, of course, quite different from artificial light or from direct sunlight outdoors, being as a rule far more soft and diffused, often causing extremely pleasing, harmonious effects. The resultant shadows are generally soft-edged, whereas, when the light is direct, shadows are sharp and clean cut. When you paint, therefore, you should give considerable thought to the existing kind of illumination, the tones it reveals, and particularly the shadow edges. (See Figure 61.)

Artificial light should approximate natural light in quality and direction. An adjustable electric light with a maneuverable "neck," permits extension at any angle. This is practical, as is any common light with an extension cord. Unless some sort of "corrected" lamp, with filters, is employed (the lamp in Figure 30 provides for this), the bulb should be the "daylight" type. Such bulbs are available everywhere and can be used in standard sockets. You can judge your color far better by them than by ordinary bulbs. More will be said in the next chapter about using light to *compose* your still life painting.

CHOICE OF SUBJECT

Obviously the initial move in making a painting is to find a suitable subject to paint. It is generally agreed that, at the start, it is best to choose something extremely simple. Still life objects—dishes, household utensils, fruit, vegetables—have much in their favor and for a number of reasons. First of all, the student can usually paint them at full size (or nearly so) ; therefore, he is free from the problems that arise when he has to shrink a tree or mountain to fit his paper. Again, still life objects, as customarily posed indoors, show little change in lighting from minute to minute, while outdoor subjects alter in appearance constantly, both in the shapes of their light, shade, and shadow areas (because of the continuous shifting of the sun) and in the colors, which, under different conditions of light and atmosphere, give surprisingly varied impressions as the day goes on. One can

work indoors with greater comfort, too, free from the vagaries of weather, not to mention possible molestations by cows, mosquitoes, and inquisitive people.

VARY YOUR SUBJECTS

In order to accomplish all this to greatest advantage, vary your choice of objects for different paintings. Select some which are rough, some smooth; some dull, some shiny; some light, some dark; some rounded, some flat. Often it is wise to combine several objects in a single picture, perhaps choosing things so different that each has a marked characteristic which you will try to record successfully. One of the constant jobs of the artist is to catch the individuality of each subject—the quality or characteristic which noticeably distinguishes it from other subjects.

But before attempting to paint a complete still life picture, it may be profitable to try out your skill and your brushes in rendering a simple object without considering background, foreground, and the interrelation of objects with environment. As to skill, those who have never painted will have to be rather patient because only through much experimentation will the brush consent to do what the eye and the hand command. Watercolor has been called a "tricky" medium, and not without much justification. The beginner will have his problems in making it behave. The wash will dry too quickly, giving hard edges where they do not belong; or it will dry so slowly that other washes, adjacent or overlaid, will run and blotch in the most aggravating manner. We have to learn a great many ways of watercolor before control of the medium is achieved. But even the mistakes and the failures are fun when we realize that every effort teaches us what not to do next time.

Figure 57
STEP ONE *Little modeling is attempted at this stage. A light tone was washed over the jar.*

Figure 58
STEP TWO *In this stage the jar is modeled very crudely, the most fundamental conditions of light, shadow, and reflected light strongly pronounced.*

THE SINGLE OBJECT, STEP-BY-STEP

Now you might select some simple and interesting object for your first exercises, something bulky like the vase of our demonstration; and, to make the lesson as simple as possible, suppose we work in monotone instead of color, using either ivory black or lamp black or, if you prefer, Vandyke brown. The black is really simplest and serves the purpose of our exercise perfectly. By working in monotone, we eliminate the problem of color and can concentrate wholly upon the handling of our washes. We can learn how the medium is handled just as well as though we were painting in full color.

We will begin (Figure 57) by washing a rather light tone over the area of the jar—except for the highlight, the light side of the neck, and the

opening. In this first lay-in we do not attempt much in the way of modeling, except that by a dilution of the gray we make the lighted side considerably lighter. Although the highlight will not be pure white in the finished state, it is wise to leave it white at the beginning. We treat the pear in a similar manner.

In Figure 58, we begin to model the form, step two. This looks very harsh and unpromising. As a matter of fact, our painting was arrested at this point to emphasize the fundamental conditions of light, shadow, and reflected light upon a rounded object. The darkest shadow does not extend to the contour of the shaded side, as we will see in the next chapter; light reflected from adjacent objects illuminates the shaded side more or less, depending upon the strength of such reflections. When the light comes from some very light object the reflection is most pronounced. However, there is always some reflection to lighten the shaded side near the object's contour. This may not be obvious, but if you neglect to recognize this essential condition, the object will lack the appearance of roundness.

In step three (Figure 59) as intermediate gray washes are applied on either side of that dark shadow band, the modeling of the jar begins to develop. Don't be disturbed when edges of the washes show abruptly as they do in these early stages; as successive washes are overlaid, the edges will disappear to a considerable extent. However, it is not our aim to "polish" the watercolor painting, obliterate all edges, and give the rendering a photographic effect. Note that in our final stage some of the edges of washes remain as a desirable aspect of the painting.

In Figure 60 (step four), we have developed the modeling further and have added a secondary highlight in the shaded side. Such reflected highlights often occur and they add considerable interest. That light was picked out of the solid tone with a small flat bristle brush slightly moistened with water. The brush must not be too wet or it will make a blob. Of course this highlight might have been taken out of the dark shadow mass in step two, but that would have been more difficult. In this state, we start the shadow of the vase and pear on the ground and begin to develop the jar's mouth.

In Figure 61, the final stage, we have tried to pull things together, adding washes here and there, darkening the shadow on the ground and finishing the rendering of the mouth of the jar. We covered the highlight with a light gray tone to bring it in proper value—it is obvious (in Figure 60) that it should not be white. Note how the reflected highlight has been made more interesting by lightening it in one corner, picking out the light with that small bristle brush. The bristle brush also came in handy for accenting that light on the shoulder where it meets the dark shadow. Note how the edges of the shadow of the jar on the ground have been softened— except close to the jar where we want a sharply accented shadow edge.

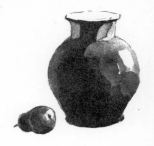

Figure 59
STEP THREE *The modeling is advanced slightly.*

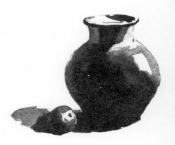

Figure 60
STEP FOUR *The cast shadow and the jar's mouth now receive some attention. The modeling has been advanced still further.*

Figure 61
STEP FIVE *Refinements are made in the shadows and modeling. These final touches help tie the still life together.*

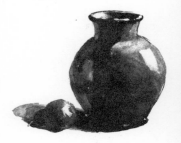

We have not talked about the pear, but the development stages show how light and reflected light apply just as in the jar.

Exercise 29: Still Life in Wash

Try painting a single object this way. Don't be satisfied with only one or two such studies; make many. To gain the greatest advantage from this work, you will want to vary your objects as earlier directed, choosing some light and some dark, some flat and some round, some rough and some smooth. Do a shiny glass object, and next a battered felt hat. We can't emphasize too often that this sort of variety can prepare you, better than you may realize at the time, for your larger and more colorful subjects to follow—still life groups, landscapes or figures, for example.

As you paint, continue to ask yourself, "In my painting, am I getting this feeling of roundness that the objects reveal—this three-dimensional quality? In short, do my objects seem to come forward in space as they should, or do they look flat? Have I caught their sense of weight and solidity? Am I indicating their texture convincingly?"

You can best judge these things by frequently placing your painting alongside the objects for direct comparison. Then stand away and examine the whole thing critically and without bias.

Exercise 30: Speed Work

After you have executed a number of these slowly-arrived-at paintings such as may result from Exercise 29, try some others in each of which you set a time limit, or at least work as rapidly as you can, attempting to record the essentials reasonably well without any slavish effort to produce a facsimile of the subject before you. Thus you will learn to "loosen up," to paint in a rapid but nevertheless relaxed manner.

One good approach is to attempt, in this speedy fashion, some of the very same subjects which you have previously rendered laboriously. Then compare results.

Don't be deliberately careless or sloppy in all of this—I don't mean that. But if you snap through each job as honestly as you can in a limited period, you will find that your work will automatically take on at least something of the free, dashing qualities generally considered desirable in watercolor work.

There is one particular advantage in all of this quick work. It will train you as nothing else can for your later work outdoors, or for painting animals or people. Nature's effects are ephemeral, changing so rapidly that when eventually you paint in the open you will discover that there is no time to linger over refinements of handling. As to people, they may hold

a pose for a short time but that's all, while animals, unless asleep, are almost never still. Therefore, the artist who lacks the facility to record his subjects rapidly will always be under a handicap.

It's a very good practice, for a while at least, to alternate the making of painstaking studies and quick impressions. In the studies you will observe deliberately, comparing carefully every portion of both your subject and your painting. You will draw meticulously. You will make corrections. You may even do over some passages repeatedly. In the impressions, on the contrary, you will let your subconscious take over; you will paint, paint, paint as fast and furiously as you can, trying with little conscious effort to catch the larger aspects of your subject.

Exercise 31: Memory Work

The greater the number, and the more accurate the pictorial images you can tuck away in your mind of persons, places, and things, the better. Many experienced artists, if entirely cut off from fresh subject matter, could paint successful pictures for years by combining on paper or canvas the mental impressions which they had already filed during a lifetime of keen observation. It is also highly important that every artist, as he works, relies not wholly on the subject matter before him, but in part on his mental impressions of similar matter. Thus, he can convincingly add, modify or subtract at will from his subject of the moment.

The greatest weakness of most beginning artists is the poverty of their mental pictures of even their everyday surroundings. You *think* you know what a wheelbarrow looks like, but unless (without referring to it) you can draw at least a recognizable portrait of it, you don't really know what it looks like. Test yourself on a dozen such things. Can you draw from memory alone, even a passable outline sketch of your own easy chair, your television set, your neighbor's front door? Can you do your mailbox, your front steps, the main masses of the house across the street? Probably not unless you have been especially interested in such appearances. So, realizing this, try to store up mental impressions. This is an art which you can very profitably cultivate during your spare time. Why not try to repeat —from memory—some painting you recently completed? Or attempt from memory subject matter with which you should, through long association, be familiar?

Chapter 14

STILL LIFE: COMPOSITION AND LIGHT

After your first exercises painting single objects, you will naturally want to set up groups of objects to make something more of a picture. You will then encounter the problem of composition, or arrangement.

As a typical first approach, choose several small objects—three will do nicely—which differ somewhat in size, shape, color, and texture. Place these where they can be easily seen.

OBJECT REST OR SHADOW BOX

If an object is to be seen to best advantage, a suitable background or setting must be provided. Figure 62 shows one kind of box—made from a piece of cardboard or thin wood—which can be used two ways: wings pulled for-

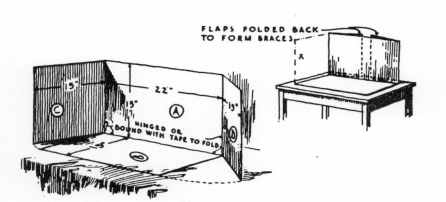

Figure 62
SHADOW BOX *The wings of this object rest can be pushed forward or pulled back. You can make one from cardboard or thin wood.*

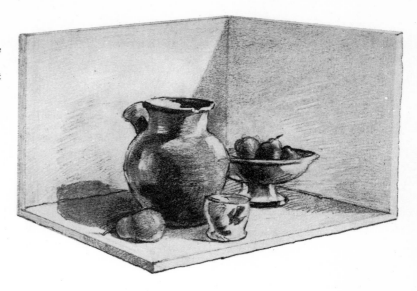

Figure 63

SHADOW BOX *Two sides have been cut away from a cardboard box to make this object rest. Fabric thrown over the box can provide a desirable color for your background.*

ward or folded back. Figure 63 shows a shadow box which was made from a cardboard box: two sides were cut away. The shadow box is effective in isolating the group from the room and giving interesting shadow effects. Cloth or colored paper can be thrown across or placed against such devices to provide the desirable background color.

COMPOSING THE STILL LIFE

Now you are ready to start making your first simple picture. If you wish this picture to be successful you can advantageously experiment for a few minutes with the arrangements of the component objects which comprise your subject. Just as you pose your figures against a suitable background in making a snapshot, so you do now with your selected objects. Cover the supporting table top with cardboard or plain cloth (patterns are usually disconcerting in such early work), and place more cardboard or cloth vertically behind the objects to hide anything distracting and at the same time to provide the desired contrast. In order to set off the subject matter effectively, it is seldom advisable to make this background white or of precisely the same color as your objects. Instead, it should preferably be gray, dull brown, or of some other rather neutral color. Or, if the objects are dull, the backing can perhaps be more colorful.

COMPOSING WITH THE VIEW FINDER

A little gadget can be made in a jiffy which may prove of great help in selecting or arranging subject matter. Through the center of a cardboard,

about post card size, cut an opening measuring an inch by an inch and a quarter. (The exact size doesn't matter, but the proportion should be that of the typical painting.) Sitting or standing in your painting position, hold this card upright as close to your face as necessary and, peeking through the aperture with one eye closed, use it to select (and arrange) your subject matter exactly as you would use the view finder of a camera. What you see through the opening, in short, is what you will include in your picture. When viewed in this way, do your selected objects form a satisfactory picture? Try them in another arrangement and then another, using the finder each time. Don't be satisfied until you have the best possible composition. Take your time. You may want to substitute one object for another, or experiment with a background of different color. (See Figure 64.)

LIGHTING AND COMPOSITION

The experienced artist has learned the importance of lighting. He realizes that shades and shadows are elements of composition and must be distributed or arranged just as effectively as the objects. In fact, the arrangement of the objects is, in many cases, largely determined by the shapes and values of light, shade and shadow areas, and the character of shadow edges.

Figure 64
GROUPING THE
OBJECTS *Arrange
and rearrange the
elements in your still
life until you arrive
at a composition
that suits you.*

REFLECTORS

Occasionally, in order to arrive at the most perfect adjustment of still life elements, the artist sets up cardboards to catch light and reflect it onto his objects, much as a photographer might do in portrait work. Obviously, the cardboard or cloth which forms the background of the objects is something of a reflector, too, throwing light onto certain surfaces. If such

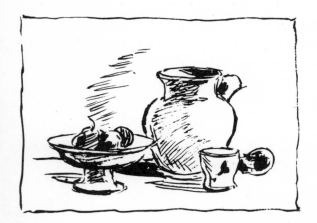 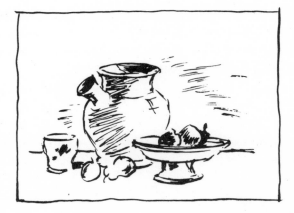

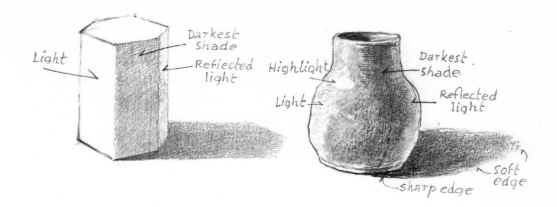

reflectors are of colored material, they, of course, modify the color effect of the entire grouping.

Such reflected light can play a great part in the difficult art of giving objects a three-dimensional character (see Figure 65). Colored reflections, through distribution of hue, contribute to the color harmony of a composition.

This is enough to demonstrate that, while you surely can't be expected to become expert in still life composition at your very first attempt, you can at least be made to realize that good still life paintings don't just happen—they are skillfully planned. Light areas are carefully contrasted with dark areas; one color or one texture is set off by another. Controlled shade and shadow tend to integrate the whole, weaving it into a pleasing pattern. If several objects are combined, each is selected to complement the others, and the whole. It can prove especially bad in a group of objects to have two of equal interest, each fighting for supremacy. Usually one should dominate the composition.

Figure 65
REFLECTED LIGHT
Three-dimensional effects are achieved by proper use of reflected light. The object on the left simplifies the conditions of light which exist on the rounded object to the right.

Exercise 32: Experiment with Lighting
Select a simple object with little or no color. One with flat planes offers the most definite contrasts in light and shade and so is easiest to do. Place it on your object rest against a simple background—white or gray is suitable. Turn both object and background until you obtain a pleasing variety of light, shade, and shadow. If there is confusion of shadow, try to simplify it, experimenting with your window shades or daylight lamp.

Now block out the proportions lightly in pencil, placing your subject well on the sheet. Don't include too much background. Set the drawing beside the object from time to time for comparison, correcting it until the drawing is reasonably accurate. When you are seated, always remember to hold exactly the same position, for the slightest shift gives a subject a

changed appearance. For this reason particularly, objects are more difficult than photographs.

Before "shading," analyze your subject. Which area or areas seem the lightest? Which the darkest? Note the relative differences between the areas lying between. Do some grade from light to dark or vice versa? If your object is of uniform local tone (the way it is when every part is made of the same material), like the box in Figure 66, try to realize that the only reason why some parts look darker than others is that they receive less light.

LIGHTING AFFECTS SURFACE

In this connection, hold up a sheet of white cardboard and turn it gradually to catch the light at different angles. The more directly it faces the source of illumination the lighter it will appear. A few minutes' experimentation will demonstrate to what extent even the simplest surfaces vary in value according to lighting.

REFLECTED LIGHT

Now hold this card to the right of the object (assuming the light is from the left) and, shifting it into different positions, use it as a reflector to throw light onto the object. You will discover that you can thus change the light, shade, and shadow tones to an astonishing degree. Similarly, you can even illuminate the dark corner of a room appreciably by reflecting light into it by means of a large sheet of cardboard or a white cloth. If you can place your reflector in sunshine, such results will be more striking. All of which adds to our proof that the appearance of things varies according to the amount and direction of both their direct and their indirect (reflected) illumination.

As you analyze your subject (without using a reflector) undoubtedly you will discover evidences of indirect illumination reflected from the object's background or setting. In Figure 66, the plane at b is lighter than at a because of light reflected from the vertical surface of the object rest.

SEEING VALUES WITH THE VIEW FINDER

One of the best ways of correctly observing the values of the various surfaces is by peeking at them, individually, with one eye closed, through the view finder described earlier—a small hole in a sheet of white paper or cardboard. If you study each value in turn, comparing it with the white of the finder, you will learn what you must do with your pigments. Black and

Figure 66
CARDBOARD BOX *Although this box is made entirely from the same material, certain parts look darker than others. This happens because some areas receive less light than others.*

neutral gray finders are useful, also. You can never do too much of this experimenting, for your main object just now is to familiarize yourself thoroughly with natural values of light and dark. Finders are particularly helpful because, by permitting you to view a single limited area at a time, they overcome the confusing effects often caused by simultaneous contrast.

Figure 67
QUALITY OF EDGE
Sometimes a sharp edge is caused by two contrasting planes (a) or by a sharp shadow edge (c). At d you can see a soft, diffuse shadow edge.

QUALITY OF EDGE

Planes of light and shade (or color) in nature are seldom bounded by definite lines; we find no true "outline." (Occasionally we see what seem to be outlines, both light and dark, but these are only narrow areas of tone, such as those representing the thickness of the cardboard of the box, Figures 66 and 67.) We observe the difference between one plane and another because of dissimilarity of value or hue. Sometimes the line of contrast between two planes seems sharp, as at *a*, Figure 67; again, it is soft as at *D* and *E*, Figure 70. Shadow edges vary, too; note the change from *A* to *B*, Figure 67. You must learn to observe and render all such edges with care, whether light or dark, distinct or blurred.

Exercise 33: Trial Sketch
As an aid in your analysis of values and edges, a trial sketch such as was described on pages 97 and 98, is extremely helpful.

THE FINAL SKETCH

For your brushwork on the final sketch, select a neutral pigment in order to match the values of your object as accurately as possible. Lamp black was used for the sketches in Figures 66 to 71. Ivory black is satisfactory. Proceed as your subject suggests, using the same methods as you did when you worked from the photograph. Make up your mind what you intend to do with a given area and then do it, directly, superposing as little as possible. Save the darkest tones for last. Get away from your work now and then for a moment's rest. Set your drawing near the object occasionally for comparison. Use your finder frequently.

In making the box in Figure 66, the end *E* was the lightest area visible and so was represented by the pure white of the paper. The darkest tone was beneath the box at *A*, although the value of *F* was almost as deep. Several of the edges, including the edge at *G*, were extremely light. Practically all the planes showed gradation of tone. The shadow which the box cast on the table was very dark and definite at *B*, but was almost lost at *C* through reflection of light. A second shadow showed quite definitely at *D*;

Figure 68
REFLECTED LIGHT
At A you can see the reflected light in the shadow tone. Notice the subtle gradation in the tone.

this grew light at *H* on the vertical plane. Though the line *e*, marking the division between box and cover, was fairly prominent for its whole length, its near end was sacrificed in the drawing in order to emphasize the light flap in front of it.

The box in Figure 67 is much like the box in Figure 66. We have seen how the shadow grades from *A* to *B*. The "table line" at *C* has been kept rather inconspicuous in order to hold it back where it belongs. Note the gradation of tone from edge *a* to *b*. Observe how sharp the shadow edge is at *c* and how soft, through diffusion, at *d*. The back inside corner of the box has practically disappeared.

The candy box in Figure 68 shows interesting reflected lights which have crept into the shadow tone at *A*. Note how inside corner *e* has been sacrificed to express depth and detachment. The cover top was drawn lighter than it looks here.

The book in Figure 69 illustrates a somewhat different condition, for the old book had a bit of color, including the dark touches shown. Note the gradation of tone on the spine; it grades to a deep value at *A* and then lightens, because of reflection from the table, at *B*.

Reflected light is again conspicuous in the paper bag, Figure 70. Perhaps the darkest value is at *A*, which marks the division between light and shade; at *B* the tone, due to reflection, has much less strength. The shadow beneath the bag is very dark; see how this lightens at *C*.

Exercise 34: Outdoor Objects

When you have made a half-dozen satisfactory sketches somewhat similar to these, try one of a white or neutral object in sunshine. This helps to acquaint you with the vitality of outdoor light. An object in bright sunshine, like that in Figure 71, usually has definite shadow edges, for there is little diffraction. If an object is removed some distance from the surface receiving its shadow, however, the shadow edges will be proportionately softer. Sunlight is so extremely brilliant that the shadows, because of simultaneous contrast, seem relatively darker than indoors. In the case of the basket in Figure 71, the shadows appeared very dark (see *A*), including the farther one at *B*. This was somewhat lightened in the sketch, being graded from *C* to *B* to suggest distance. Observe that though the shadow edge, *D*, is clean-cut, edge *e* is almost lost in gloom; this was sacrificed a bit to aid in expressing depth.

Exercise 35: Rounded Objects

Your efforts should by no means be confined to straight line objects; turn, soon, to things which are rounded, working indoors once more. Figure 72

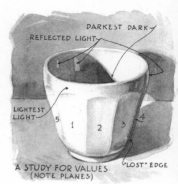

DARKEST DARK
REFLECTED LIGHT
LIGHTEST LIGHT
5 1 2 3 4
A STUDY FOR VALUES (NOTE PLANES)
"LOST" EDGE

Figure 72
ROUNDED OBJECTS *Because this cup has both curved and flat surfaces—and is a white object—you can easily see what happens to the values of the planes: when the planes receive more light they are practically white; their values deepen proportionately as they receive less light. A glazed object, such as this one, is also bound to mirror many reflections on its surface.*

presents an ideal transitional subject, as it combines curved and flat surfaces. It is interesting to study the gradual change in lighting from Plane 1, which, facing the light directly, was practically white, to Plane 4, relatively much darker. Plane 5 was about the same in value as 2, receiving approximately as much light. Objects like this, showing a succession of planes, teach us that surfaces deepen in tone proportionately as they receive less light. Rounded objects often show this, too.

This object differed from our previous ones in quality of surface, for it was glazed. At the point marked "lightest light" it mirrored a miniature image of the window far brighter than white paper could express. Many minor reflections were evident, too, some of which we have shown. You must look for such reflections when drawing smooth objects. While it is neither possible nor necessary to represent every slight variation in tone, the general character must be expressed.

Exercise 36: Varied Objects
Though white objects are best for a time, as their values depend on light, shade, and shadow alone, it is helpful to swing gradually to objects of greater contrast of tone. Vary their size, shape, texture, placement, etc. Try some outdoors and some in. Sketch groups of objects, also.

Exercise 37: Colored Objects in Wash
Next, substitute colored objects of similar variety. Paint the first few of these in wash, as the interpretation of color in terms of black, gray, and white is always helpful. Figure 73 presents a typical example. Though crude in finish (don't worry too much about finish at first) it has caught the vital characteristics of the subject, which was shiny and, on the whole, light. The lightest light was at *A* and the darkest dark just above it. Observe the reflected light, particularly evident at *B* and *C*. Comparing this sketch with the previous one, we discover that where here at *C* we have a strong reflection, the corresponding area in the cup showed a "lost" edge. As both objects were glazed, this difference was due to a reflecting surface not far away.

Figure 73
COLORED OBJECTS *It is a valuable exercise to interpret colored objects in black, white, and gray, concentrating solely on the way surfaces are affected by light.*

Half hour Sketch.

Chapter 15

STILL LIFE:
PAINTING
THE PICTURE

Figure 74
PICTURE PROPORTION
*Vertical objects
often suggest an
upright picture.*

IN THE LAST TWO CHAPTERS dealing with still life, we have been developing our abilities to render simple still life objects, to compose the still life group, to use light properly, and to interpret surface planes in their correct value. Now let us attempt to paint a complete still life picture, using the elements we have acquired in the last exercises.

PICTURE PROPORTION

There should be a definite relationship between the shape of the paper you choose (or of the painting you make upon it) and the entire mass of the grouped objects, vertically massed objects often calling for a vertical picture while horizontal object arrangements are better expressed by a horizontal picture (see Figures 74 to 76).

Figure 75
PICTURE PROPORTION
*Horizontal objects
suggest a horizontal
picture.*

Figure 76
PICTURE PROPORTION *The
mass of objects determine
proportion rather than the
individual objects.*

Not until your set-up suits you reasonably well should you select an appropriate sheet of watercolor paper. For best results you will stretch or mount this as earlier directed. The choice of paper will depend in part on the textures of the objects to be pictured, rough paper often being more appropriate than smooth for rough-textured objects. There is, however, no set rule, and some watercolorists do all their work on one kind and surface of paper.

DRAWING

Now comes the construction drawing on the watercolor paper—the delineation of the objects in correct proportion. In this book we take it for granted that the reader is already reasonably adept at this. If not, he should brush up on it, for it is fundamental to all pictorial delineation. Full instructions are given in my earlier books, *Pencil Drawing Step-by-Step* and in *Freehand Drawing Self-Taught*.

As a rule, this layout is done in pencil—a medium grade such as HB is good (much depending on the roughness of the surface). Try to get the main proportions as accurate as you can, but don't add every trivial detail. Draw lightly so as not to injure the paper. (In doing this work, constantly view the objects from exactly the same point. Otherwise, being so close to them, if you shift your eyes even a few inches the proportions will change very noticeably.)

ANALYSIS OF SUBJECT

With the subject matter selected, arranged with reasonable satisfaction, and blocked out lightly on the paper, you should next ask yourself such questions as: what is the lightest area? The darkest? Where are the strongest contrasts of light and dark? Do the tones grade or are they uniform? What are the sharpest edges? The softest? What of the surfaces —are they shiny, dull, smooth, rough? And how about color?

PRELIMINARY SKETCHES AND FULL SIZE STUDIES

Much time will often be saved and better results insured if, before starting to paint your final picture, you make a preliminary study or two in color (if you propose to use color) or black and white. Such studies needn't measure more than three inches or so in greatest dimension. Much of your

analytical thinking can be done as you sketch, so that when you tackle the far larger—and often formidable—blank areas penciled out for the finished painting your procedure will already be well planned.

You may find that, for a while at least, it will pay you to make even larger preliminary studies. Many artists do a careful study at full size, either in black and white or in color, for every finished painting.

ARTISTIC LICENSE

Usually in your early paintings you are attempting to learn all that you can about nature's appearances. For the time being, therefore, you become a sort of camera, drawing and painting the objects before you with much of the fidelity (though without the slick finish) of a good photograph in color. When your painting is finished it should give a convincingly realistic impression of your subject.

If, however, in making the preliminary sketches of the final painting, you feel that it would be better to alter the shape of some object—or make it larger or smaller—in the interest of better all-around composition, that is your privilege. You may also want to omit or suppress certain details which seem disturbing, or to add others of your own invention or borrowed from similar subject matter. When it comes to coloring, you may similarly feel that you can improve the final result by modifying some of the colors which your objects or background reveal, or by adding colors of your own choice. Again this is your right.

OIL VERSUS WATERCOLOR

In applying your watercolor paints, you will need to forget any knowledge you may possess of the application of oil paints, for watercolors are used in quite a different manner. In oil you can paint over an area almost as many times as you wish, adding color, scraping it off, changing the effect again and again until at last you are satisfied. In watercolor, on the other hand, if you are to arrive at the crisp, fresh sort of result usually expected of the watercolor medium, you will generally have to work far more directly, with few changes.

DIRECT METHOD

Try to develop the ability to paint any given area with a single wash (flat or graded as the subject requires) exactly right in both value and hue, then calling that area finished. In other words, keep in mind that if you can immediately put the right color in the right place, success will be assured!

Of course it isn't that easy, especially in view of the fact that most work in watercolor lightens as it dries so that it often proves necessary to go over an area more than once to bring it to the desired tone. Often, too, it is essential to add details on top of the original wash or washes.

INDIRECT METHOD

A method more within the capacity of the average beginner—in that it enables him to build up any given effect more gradually; keeping it constantly under better control—is first to apply comparatively light tints of the desired hues to all parts of the painting, next adding other washes here and there on top of this foundation, going over them several times if necessary until at last each portion is developed to the desired strength. Such results are almost certain to appear somewhat muddy and worked over unless care is taken to use the more water-resistant paints for the foundation application. Here is where the exercises recommended in Chapters 5 and 6 will prove their worth.

Sometimes a muddy looking tone can be made to seem more crisp and transparent by adding on top a few quick, clean-cut strokes of darker tone. Again, a muddy tone can be veiled to advantage by a final application of a wash (or a few wide brush strokes) of a slightly opaque paint such as cerulean blue or Naples yellow. This, drying on top, can greatly improve the effect.

SANDPAPERING

Still another expedient which can be employed (when the paper is rough) to overcome muddy or overworked results—though it should be used but rarely and with great discrimination—is to sandpaper cautiously the faulty area (when thoroughly dry) until little lights break through. Sometimes the lights or whites thus exposed will be too conspicuous and, therefore, will call for a final tint of appropriate hue applied over them to render them less so. More will be said about sandpapering in Chapter 17.

SCRUB METHOD

Though the following "scrub method" is not the orthodox and most generally approved method of watercolor painting, in skillful hands it can produce excellent results. Also it can often be used to restore paintings which otherwise are beyond salvation. In this method, color is first applied quite freely and in considerable strength throughout the entire picture.

When dry, a sponge or soft brush, drenched with water, is used all over the painting to soften and remove much of the paint, blending the rest. When the soft foundation tones thus created have completely dried, crisp washes and brush strokes are added. Sometimes thin, pale washes over such scrubbed areas will give them a pleasing character.

Certain colors will dye the paper in such a way that a sponge or soft brush will not lighten them sufficiently. In this case, a bristle brush may be used. Caution must be exercised in all this scrub work not to soften and injure the surface of the paper. More will be said about scrubbing in Chapter 17.

COMBINED METHODS

Few pictures are painted wholly by any one of these methods. The direct method has been pointed to as our ideal, for it is capable of producing the spontaneous effects—the sparkling, crisp, lively effects—which have brought to the watercolor medium much of its popularity. The beginner is urged to use this method as his fundamental approach. If he fails to arrive at the desired result, he can then do some touching up via the indirect method. If his painting grows worse until it looks just about hopeless, he might find it advisable to turn to the scrub method, washing it down—or a part of it—and then restoring it. Sometimes soap is added to the water and the painting is practically washed from the paper as a preliminary to repainting.

HIGHLIGHTS

As to large light areas and highlights, which in oil painting would usually be rendered with white (or very light) paint, it is customary in any of the above watercolor methods to leave the paper white or only lightly tinted. Incidentally, it often happens that small areas easily escape the brush, particularly on rough paper, and little bands of separation are often necessary to prevent one wet wash from running into another. All these "accidentals" add life and sparkle. (In the scrub method, highlights are often blotted off after they have been scrubbed with a brush of suitable size.) Opaque white, for highlights, is used only sparingly if at all, the original tone of the support playing a far more important part in watercolor work than in oil. Occasionally—and then often as a last resort—a few small highlights or other finishing touches are added at the end with some such opaque paint as Chinese white, clear or tinted to suit. Try to avoid these opaque touches, however, as they often seem disturbingly

conspicuous and inharmonious. Also, with any excessive use of opaque color, your work will fall under the heading of gouache or tempera painting. There is nothing wrong with these media, but they are quite unlike the true or so-called "transparent" watercolor—the customary type—and are not our subject at the moment. They will be discussed at greater length in Chapter 25.

Exercise 38: Still Life
Carry out for yourself the exercises this chapter suggests and that are further discussed and demonstrated in the following chapter. Don't be impatient! Work out every step thoroughly.

STILL LIFE IN COLOR

Probably very few of the objects which you will choose, even for the wash studies of the previous discussion, will be pure white or black. Some will show at least subtle indications of color. Soon you may decide to represent these colors, using paints of similar hue. In this way you can sneak up on color by degrees, learning that value and hue are so interrelated that they must be treated as one.

Exercise 39: Full Color
Eventually you will accept nature's challenge to turn to full color, working first from still life objects of various hues. For your first studies, paint single objects against white or light backgrounds; later, group varied objects against harmoniously colored backgrounds.

YOUR APPROACH TO COLOR

There are really two different methods of approaching color when you paint still life. The most natural method for the beginner is to try to match the color of each area as exactly as he can. For early work I am inclined to think this is the right approach (though note the qualifications that follow). We have seen, however, in discussing simultaneous contrast and the like, that colors, like lines and values, present many optical illusions. If you wish to follow this method, therefore, you should peek at each color through a hole in a white card in order to view it by itself and judge it correctly. As in the earlier copy work, lay your light washes first, then your middle tones, and finally the darker ones. Set your drawing back near the object frequently for comparison. While you cannot hope to make perfect representations, do as well as you can, giving as much attention to

form and texture as to color. You are striving, in this method, to approximate the effect of good color photography.

The other method, employed by most artists, is less photographic, for one makes many adjustments both in value and hue, varying them somewhat according to point of view or purpose. The results usually show more interplay of color. As a matter of fact the skilled artist *sees* more color than the beginner, who is handicapped both by eyes untrained to perceive colors correctly and a mind filled with faulty impressions. The novice thinks of many objects as pure white, black, or neutral gray, yet, strictly speaking, almost everything shows at least subtle hints of hue. Bring together the whitest, grayest, and blackest things you can find, to test this point. Again, objects (and this includes backgrounds) are affected by reflected color, just as they are by reflected light. If you were to see a white bowl (in sunshine) on a green blotter, you might be surprised to find that it would have a greenish appearance and green paint would be needed to represent it. Shiny objects are particularly affected by reflections.

Even walls and ceilings are customarily modified by colored light reflected from draperies, rugs, furniture, etc. Which introduces another point: draperies, window drapes, and window shades often stain or dye the light which comes into a room; in other words, light itself is seldom white. Whatever it touches is tinted with its own color. Even in the photographic sort of work described above you should be on the alert for all such modifications. It is not enough to give each area a wash of what you believe to be its local (actual) color.

Aside from these factors, we have several others which offer the artist valuable hints. Take the matter of after-images, for instance. If you are painting a bright red vase against a white background, and fix the eye on the vase for a short time, then transfer the gaze to the background, the latter will be tinted for a moment with a pale greenish after-image of the vase. Many artists utilize this definite relationship between such a red and complementary green, actually painting the background green, thus producing a harmony of contrast. Green is frequently used, too, for mixing with or painting over the red in shadow areas. Not only does it have a satisfactory neutralizing effect, but it usually produces tones of vitality and interest. This is true of complements generally.

There is still another reason for this common practice of using complements or near complements. Returning to the matter of simultaneous contrast, it will be recalled that "colors are influenced in hue by adjacent colors, each tinting its neighbor with its own complement." (This is why the view finder is so essential in color matching, as it temporarily defeats these illusions, though if individual colors are matched exactly, a painting of objects will, when finished, reveal much the same illusions as the objects.)

The artist knows, for instance, that if he places a gray object against a bright green background, the object will appear slightly reddish. Against blue it will lean toward yellow or orange. If a red object is contrasted with a white background, the background itself will assume a greenish cast. In other words, the laws of simultaneous contrast give him the same cue toward complementary combinations as do after-images.

All of these features of light and color are principal harmonizing factors which tie together compositions consisting of several objects. The discerning artist constantly takes advantage of this factor by distributing his hues throughout his composition according to nature's plan. At times he may even somewhat exaggerate these reflected tones which nature tosses about so freely.

You needn't worry about a complete understanding of the reasons behind all this: it is enough for you to know that there is a definite relationship between colors and their complements. If an object is a certain color, you are justified in using its complement or near complement in its shadow, background, or elsewhere; similarly, if you see an almost colorless object against a color, it is not only pleasing, but logical, to give it a faint complementary tint. For that matter, since your principal aim is customarily to make not only a reasonably honest drawing, but a beautiful one, you are at liberty to use any colors you please provided they do not defeat your main purpose. So the prime difference between the second approach toward color and the one first discussed is that it allows the artist to become an intelligent interpreter rather than a chromatic camera.

TEXTURES

During our discussion to this point we have mentioned several times the word *texture,* referring to the visible surface quality of diverse types of subject matter. Some surfaces are rough, some smooth, to varying degree. Wood, stone, tree trunks, cloth, water—everything which we see in nature has its individual surface characteristics. It is fully as important to learn to represent these textures well as it is to picture successfully their forms, values, or colors. You could advantageously spend many days in learning to interpret them.

Exercise 40: Texture Representation
The elements that play an important part in texture representation are: paper surface, types of pigments, and your method of applying the pigments. I strongly advise you to experiment with each of these elements. Vary the tilt of your board; vary the kind of paper you have been using;

experiment with the different kinds of washes described in Chapter 5; practice with stipple, spatter, and spray (discussed in Chapter 21); experiment with scrubbing, sandpapering, razor blades, erasing. By exploring these elements, you will learn to portray any variety of textures so important to a convincing painting.

Exercise 41: Subjects Outdoors and Indoors
When you have made a wide variety of object drawings such as we have shown, experimenting with both artificial and natural light, turn to larger subjects such as pieces of furniture, room corners, and the like, with special attention to the fabrics common to draperies and upholstery.

Appearances indoors and out are dissimilar to a surprising extent. Not only does one find different materials indoors, but a changed quantity and quality of illumination. Most outdoor light comes directly from a single illuminant—the sun—and results not only in far brighter effects than are common to interiors, but generally in clean-cut shadows of systematic formation and sharp contrasts. Interior appearances (barring those due to artificial illumination) depend almost wholly on indirect or diffused light, which, instead of coming from one direction in the form of parallel rays, often radiates from several sources such as doors and windows. These sources not only provide less brilliant illumination, but, being comparatively low in position, introduce it on a level with, or below, many of the objects. The shadows formed by this radiating light not only vary individually in direction, value, and quality of edge, but, since the light comes from several sources, they often multiply or overlap in complex ways. Even when sunlight pours into a room, it provides clean-cut value contrasts only in limited areas, the rest of the room (which seems all the more gloomy in comparison with this bright light) receiving its illumination indirectly from these sunlit spots (or from bright things outdoors) as reflected in every direction.

The artist of interiors, therefore, looks for less brilliant lighting and coloring than we find outdoors, and for greater variation in strength, character, and direction of light. He expects multiplicity of shadow—a lighting fixture may cast several shadows on the ceiling—and great diversity of edge. Because of the preponderance of reflected light indoors, light and color are thrown from surface to surface in a truly amazing manner. All this complexity is sometimes to the advantage of the artist, who can paint much as he pleases and still have things look right, yet more often it proves confusing. And in another way he has a handicap not found outdoors —he can't stick in bushes, clouds, and like accessories. His location of point of view is more restricted, too: he can't, as a rule, look up or down

at his subject or push it into the distance. So, on the whole, it is hard to say which is easier to do, the exterior or the interior. It is certainly true that in the architectural profession there are comparatively few men who render interiors as well as they do exteriors. The main thing for the beginner is to realize from the start that the two are different, and to understand what the main differences are.

SIMPLE OUTDOOR SKETCHES

Sketching from simple colored objects outdoors will give you an ideal foundation for your more serious outdoor sketching to follow, such as we discuss in the coming chapter. Figure 77 shows a subject of the type now in mind. All such things—wheelbarrows, watering pots, pails, tubs, etc.—offer an excellent test of one's skill. Outdoor subjects above eye level should not be neglected either. Look for old lanterns, for example, as shown in Figure 78.

So far as the technical procedure of such work—in fact, any watercolor work—is concerned, rest assured that many methods are followed. There is no one right way. Some artists build their effects mainly by running washes, with the board rather flat. Some paint very freely, with their paper almost vertical, which, though preventing careful wash work, permits the painting to be seen easily and compared with the subject at all times. In this method less water is used, the pigment being "drawn" and dabbed into place with a brush large enough to convey plenty of pigment to the surface without the danger of having it form in actual puddles and run off. So never be restricted by anything you are told: your work will be judged by results, not method.

Figure 77
OUTDOOR SKETCH
The cellar, attic, and yard offer a wealth of subjects. Practice painting objects below eye level.

20 minute Sketch

Antique Lantern

Figure 78
OUTDOOR SKETCH *Outdoor subjects above eye level are good practice also.*

Chapter 16

NOW LET'S PAINT OUTDOORS

EVEN THOUGH INDOOR WORK directly from still life, flowers, or what have you can teach many valuable lessons and result in some fine paintings, I must admit that at times most of us have a strong desire to paint in the open. Let's take a look, therefore, at a few basic problems. You will need all the suggestions you can get, for you will soon discover that work in the open is quite different from work indoors; you will find yourself exposed to a wholly new set of problems.

Is there ever a time when the artist or student fails to experience a sensation of pleasure at the opportunity of getting out under the open sky to pit his skill against Mother Nature's? Probably not, for outdoor sketching, though serious study, is also a jolly game—a sort of hide-and-seek. Nature, while boldly placing on display an almost inconceivable variety of effects, hides the key to their successful representation, and then taunts puny man, with his imperfect perception and inadequate tools, to find it. Nature always wins in this unequal contest, for even the most gifted individual cannot hope to gain a thousandth part of the thing he seeks. Yet failure ever spurs him to fresh endeavor, for there is "zest in the quest" and joy in one's most meagre accomplishment.

And it is pleasure coupled with profit, for not only do outdoor subjects provide the artist with an excellent means of acquiring speed and accuracy in the representation of line and form, light and shade, color and texture,

Figure 79
WATER-BOTTLE BOX *For sketching outdoors, this type of box is handy, providing space for paints, brushes, cup, and water bottle.*

Space for brushes

CLOSED

OPENED

For water

but they familiarize him with impressions, often subtle, of atmosphere, distance, detachment, movement, etc. These are the things which, properly interpreted, raise the artists' work above the mediocre, goals well worth attaining.

OUTDOOR EQUIPMENT

When you head outdoors, don't make the common mistake of loading yourself with too much paraphernalia! You need only a few things when you go sketching, but they should be selected with care. The same materials employed indoors are customarily suitable, especially if they are light and compact. If the color box you generally use is large, we recommend a smaller fitted one. The box in Figure 79, in addition to having spaces for the pigments and brushes, contains a cup and water bottle. With the ordinary box, some sort of water container must be provided: a type not easily tipped over is best. The artist generally dispenses with color saucers and does his mixing directly on his paper, or on the palette which is a part of his box. Brushes can be slipped easily into the pocket, though moist hairs should not be allowed to dry in a cramped position. Figure 80 shows a convenient pocket brush, while in Figure 81 we picture a carrying case for ordinary brushes.

Figure 80
POCKET BRUSH *Designed especially to be transported, this brush can be slipped easily into your pocket without destroying the brushes.*

Coarse or fine points

Propelling pencil in handle

Figure 82
WATER BOTTLE *Two cups can be attached to this water bottle.*

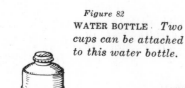

Rubber bands

Runs in grooved slide

Figure 81
BRUSH CASE *This provides a means for carrying ordinary brushes. The case is tin.*

143

Figure 82 portrays a water bottle, with cups which become a part of it when not in use. Incidentally, don't forget to take plenty of water unless you are certain to be near a supply. Jacob Getlar Smith, in his book *Watercolor Painting for the Beginner* (Watson-Guptill), recommends keeping paints and brushes in a metal box like the one sold for household tools. This can also contain your water, water cups, pencils, erasers, and paint rag.

PAPER

As to paper, the most popular kind is probably the sketch block made up of several sheets. However, the sketch block is used rather for its convenience than for its other virtues, for the paper usually buckles badly when moistened and seldom comes flat again. Spiral bound sketchbooks of heavy unmounted paper are becoming increasingly popular. I prefer half-imperial sheets (15″ x 22″) of mounted board. Take several, varied in surface, to offer some choice according to the subject you will paint. These mounted boards stay reasonably flat and are easy to handle. Or heavy paper can be stretched on both sides of thin boards—wall board will do—a sketch being made on each surface.

OUTDOOR EASEL

Easels are not as popular as in oil work. This is mainly because of the difficulty of running washes on an upright plane. We do find watercolorists now and then who have developed methods permitting the use of the vertical paper, and they customarily select folding sketching easels light in weight, yet rigid. Some sit and some stand. There is no denying one advantage of this arrangement: it encourages the artist to back away from his work frequently in order to compare it with his subject. If the artist paints with his paper nearly flat he should set it up from time to time and get away from it, to study his results. There are easels which permit using the paper either flat or upright, see Figure 23 in Chapter 2. Some artists never bother with an easel when painting in the open. They lay the board or frame which supports their painting nearly flat on the ground—sometimes between their feet—or support it on something like a stump, log, box, or wall.

VIEW FINDER AND REDUCING GLASS

The view finder is a small but important item too often overlooked. The type we have in mind consists of a white cardboard, post card size or so, pierced with a rectangular aperture, perhaps an inch and a half by two inches in size. In a moment we shall speak of its use.

144

Figure 83
REDUCING GLASS *Use this to*
simplify your subjects.

Another instrument favored by some artists is the reducing or diminishing glass, Figure 83. Looking through it, one sees things pulled down to small size, and therefore simplified. Both subject and drawing can be studied with the glass.

When you start on a sketching trip, check your materials to make sure you have with you (in addition to paints, brushes, and paper) a pencil for layout, an eraser, blotters or rags—in short, everything you think you may need. A wide brimmed hat or an eyeshade sometimes proves desirable, or sunglasses of neutral quality. You may like a stool—see Figure 25 in Chapter 2. In rare instances umbrellas are employed—see Figure 33 in Chapter 2. Some like two stools, employing the second as a rest for the paper.

SELECTING THE SUBJECT

With equipment ready, go to a likely spot and hunt for a suitable subject. It's pleasant to have a congenial companion along. Don't choose your subject too hastily. The view finder should prove helpful, used much like that of the camera. Hold it upright, sighting through it with one eye closed. Try it at arm's length, and near the eye. Try the opening vertically and horizontally. The finder functions as does the frame of a picture, permitting you to concentrate on a limited area at a time. Its value cannot be overemphasized.

Don't spend all day hunting for something to paint. Too many students search and search for the perfect ready-made picture just waiting to be transferred to paper. While a truly outstanding painting often shows unusual subject matter or, at least, a fresh mood or aspect of it, some of the greatest masterpieces ever painted picture the simple everyday things known to all. Interesting sketches can be made from commonplace things. They need not be beautiful, but should have character. Dilapidated or humble buildings do very nicely. Try to choose something which composes well (makes a good picture) practically as it stands, though the artist always feels free to recompose to any reasonable extent. After all, you are not entirely limited by your subject. We have repeatedly emphasized that it is your prerogative as a painter to take as many liberties with subject matter as you wish, and in this way translate the mere hint of a picture into something of worth. If your subject is too complex, you can simplify it;

145

if too large, you can shrink it or omit part of it. You will be wise, though, to limit your early attempts to relatively small subjects. Too many elements are bound to prove confusing. One hint on subject selection may prove useful: the easiest subjects to do are those having well-defined areas of color and tone.

POINT OF VIEW

It is important to sketch any subject from the best angle. Walk around it, if possible, studying it through your finder from various positions until you discover the ideal "point of view" or "station point." If you can, sketch it from here. Don't get too close to your subject or you may lose its larger impression because of its bewildering intricacy of detail. And if it is extensive, and you are too near, you will be forced to shift the eye from part to part as you work, which may cause the development in your sketch of perspective distortion. Or it may become a composite sort of thing, lacking unity. You will find it easier, also, to judge colors and values when a subject is at some distance. In the case of small things this precaution is less necessary.

LIGHTING

There is usually a time of day when any given subject will appear to greatest advantage, particularly so far as the composition of its light, shade, and shadow is concerned. Obviously this is the best time to sketch it. As a rule, appearances are most pleasing under the slanting rays of early morning and late afternoon. Masses of light and shadow are then well-defined and attractive in shape. Changes in lighting are rapid at such hours, however, which make them more difficult for the beginner than those nearer midday. For your first sketches you will simplify your problem if you pick things which you believe will probably show definite contrasts of light and shade (and color) until your work is complete. As you gain experience you can exercise greater leeway: not only will you learn to recompose all such things according to your needs or mood, but you will develop the ability to hold fleeting impressions in your mind long enough to transfer them to paper.

COMFORT

Make yourself as comfortable as you can. Sit or stand with your paper in the shade, for sunshine can be very misleading, and may prove trying to

the eyes. Once you have taken your position, hold it until your subject is completely blocked out.

At first you will probably prefer an isolated position, away from spectators. Gradually you will become accustomed to them. If such a large group ever collects that it proves disconcerting, pass your hat, occasionally, with feigned seriousness; this method, which many of my friends and I have tried out, is guaranteed to disperse the crowd!

ANALYZING THE SUBJECT: CONSTRUCTION

Once you have settled yourself before a promising subject (with your equipment within reach), study it analytically just as you did your still life objects. Ask yourself questions about its size, shape, color, textures, etc. You must determine its most essential elements—the factors which make it intriguing to you.

Assuming you have a rather realistic interpretation in mind, you will want to block out the masses quite correctly. The pencil is best for this, though with increased experience you can often paint directly, with no previous construction. Before you draw a stroke, study the subject until you have it clearly in mind. Determine where your eye level is, for this corresponds in height with the horizon line. Imaginary vanishing points lie on this horizon line and receding parallel horizontal lines appear to converge on it if they are sufficiently extended. Sketch this eye level. Determine, also, by means of your finder, the limits of your picture, and "place" the subject on the paper accordingly.

With your subject blocked out, your analytical faculties will be directed to its light, shade, and shadow, and, more particularly, to its color. A minute's contemplation will be enough to convince you that you could not, even if you wished, portray in detail every bit of your subject matter on the limited surface before you and in the short time at your command. Instead, your aim is to imprison something which will convey to the spectator an adequate impression or illusion. It is by no means necessary to match each visible form and value and hue. So, as you analyze, try to understand which aspects of the whole really count. As you paint, attempt to interpret these aspects—the spirit of the subject.

To be more specific, if your subject is striking because bathed in sunlight, sunlight is the thing you should strive to suggest. If, instead, you attempt to match every color before you, individually, thinking the sunlight will take care of itself, you will probably, despite every care, fail to emphasize sufficiently this vital impression. So you must sacrifice little things all the time if you are to express the big things. This takes self-

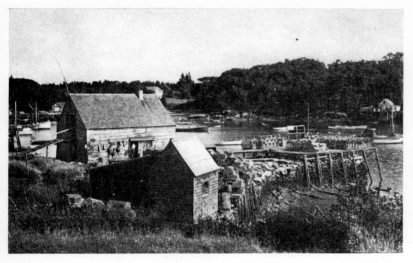

control. If a building is before you, it is the roof and the walls you should represent, and not all the shingles and bricks of which they are composed. Keep this in mind if you can. In this analysis, try to look at your subject as a strange curiosity, never seen before. Examine it in a speculative, critical sort of way. Good sketches result more from discriminating observation than from skillful delineation.

PRELIMINARY SKETCHES

Before starting to draw on your watercolor paper, it will pay you to work out a plan of attack by making one or two small sketches—"thumbnails" such as we discussed in connection with still life. In these, you can decide what to put in your final picture, what to leave out, what to emphasize, and what to subordinate. If you wish to move certain elements about, do so. Unless color was the leading factor which caused you to pick your subject—in which case you will doubtless make your preliminaries in watercolor—pencil or charcoal will be your logical medium. Figures 85 and 86 show typical thumbnails in pencil, for possible later development in watercolor.

To illustrate, I show two pencil sketches (reproduced at exact size of originals) of a subject photographed at the time. In the first sketch the arrangement has not been radically changed. But note that the building in the foreground has been reduced in size and that the "lean-to" covered with dark building paper has been eliminated because its shape is awkward and its color uninteresting.

Figure 86 was sketched from a position considerably to the right of

148

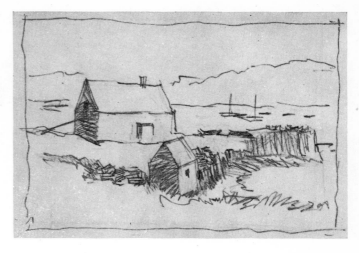

Figure 85

THUMBNAIL SKETCH *Only a few adjustments were made: the foreground structure was simplified and reduced. These sketches are reproduced in their actual size.*

Figure 86

THUMBNAIL SKETCH *A totally new composition—a better one—was obtained by moving the station point to the right of the original point.*

the point from which the photograph was taken. This, in my opinion, is a better composition. I considered yet another view at the left of the camera's position, but it seemed so unpromising that I did not even try it out in a quick thumbnail.

RECOMPOSITION

Even if you choose your subject with the utmost care, to get the best effect you will doubtless have to use some artistic license, recomposing as you go along. You are not merely a chromatic camera. You will place greater emphasis on some essentials than your subject shows. You will enlarge or decrease some in size. You will rearrange. You will subordinate or omit non-essentials. Things in the distance you will perhaps paint a bit softer than they appear.

Remember that as a rule, the artist develops in every sketch a center of interest, or focal point: it is here that the attention concentrates. (See Chapter 11 in this connection.) Too often the beginner's work shows scattered interest. This is natural. He looks first at one thing, and paints that. For the moment it is all-important. Then he paints another thing which, in turn, seems vital. Continuing in this way, when the whole is finished these individual parts demand even more attention than in the original subject, as normally viewed. In a painting, the artist, as we have said, should be less concerned with this exact delineation of detail after detail than with building up a convincing impression of the whole. By placing his strongest emphasis of value and color on his leading elements, which usually are shown at or near the center of his paper, he builds this center of interest to which he subordinates all else, thus arriving at a satisfying result. Sometimes, to be sure, a sketch has two or more centers of interest, and this is all right providing they are not rivals for attention. One should dominate.

PROCEDURE

With your campaign thus mapped, you are ready to sketch your subject in pencil on your large paper. With the sketching completed, there are now two common ways of proceeding with the rendering. You can creep up on your subject by degrees, starting by applying light tints which will hint at things to follow. Then, gradually, you will add stronger colors, some here and some there, until eventually a satisfactory result is built up. Or—and remember that this will produce fresher, more spontaneous results—you can try to apply each wash or brush stroke with finality, coming at your first attempt just as close as possible to your preconceived effect for that area. Thus you can work more rapidly, getting a good start before nature's ephemeral effects drastically change. You will also achieve something of that crisp fresh character for which—as we earlier pointed out—watercolor paintings are so often admired. In either procedure, remember that colors usually appear lighter when dry than when applied.

Briefly, once you have analyzed your subject and made up your mind as to what you should do, do it. Don't treat the matter too seriously. Have some fun! Sail in and get some indication of the main elements on your paper as soon as you can, advancing the work from this foundation. Apply your color in the way which is most natural. Run washes, if washes seem called for. Mingle pigments if this serves your need. Draw with your brush; dab with it. Use the largest brush you can manage. Don't select

small paper, for it will force you to work in too persnickety a manner. Stand back every few minutes to view the effect of your painting. Rush up and make your changes or additions quickly, while they are clear in your mind. Don't worry over little runbacks or other minor technical faults. Strive for crispness; a feeling of spontaneity. And, above all, an impression of truth.

WHITE PAPER

Always keep in mind that, unlike the oil painter, the watercolorist often leaves small areas of his painting surface bare. This is in part a matter of choice—for such areas cause life and sparkle—and in part because such separations of plain paper must often be left between washes to prevent still-wet areas from running together.

TURNING THE PAPER

Since washes tend to merge—and in order to keep his hands out of moist areas—the aquarellist frequently turns or tips his paper to the most convenient position for his task at the moment. He may, for instance—run a sky wash from horizon to zenith, with his paper inverted.

Viewing his painting from every angle has a bonus virtue; it reveals faults and so tends toward a better final result.

DRYING

To artists who use much water, drying—though it takes but a few minutes —seems annoyingly slow. They sometimes speed drying up by adding a bit of alcohol to their water; a little added glycerine will retard drying. (Indoors, a fan or hair dryer can be used to stimulate drying.)

The wetter you work, the flatter you are forced to keep your paper; the more washes you must run, the more your paper will buckle. It may form so many ridges and valleys—especially on a humid day—that the pigment particles slide from the ridges into the valleys so that, even if the paper finally comes flat when dry, evidence of the buckling will still be visible.

The thicker your paper, the less it will warp. Buckling can be avoided entirely if you paint only on the so-called "mounted" papers (boards), but these are heavier to carry and more expensive. The next best surface is obtained by stretching. Follow the instructions for stretching in Chapter 4.

Not infrequently a painter keeps two watercolor paintings under way simultaneously, working on one while the other is drying. Both may be of the same subject, though often of different proportions or color schemes. Or he may, for the second painting, choose another nearby subject.

There is an extra advantage in this: when he turns back to one painting after working on the other, he is better able to detect its faults or determine what to do next. The change of subject matter has given his eyes new critical powers.

"DRY" PAINTING

Because watercolor washes dry slowly and tend to buckle the paper (and hence slow one's work), some watercolorists manage with very few washes, simply staining areas of their paper without enough liquid in the brush to form puddles. In other words, they "draw" their paintings by working in a somewhat linear manner. Try this: with a flat brush of red sable an inch or so in width, cover large areas very quickly with strokes just touching or slightly overlapping. These will dry almost instantly. By turning or twisting the brush, you will find a wide variety of strokes possible. Small brushes may similarly be used for more limited areas. As a rule, though, lean toward the big, especially if time is at a premium.

As we saw when discussing materials, these flat brushes are particularly practical when doing street scenes or architectural subjects, as a single wide stroke can sometimes represent the entire area of a roof, a door or a window shutter. A wide brush can be dipped into two or more colors at one time; these will blend effectively as the strokes are made.

Colors may also be dabbed or patted on, usually with the point or side of a round brush. Results ideal for some purposes can thus be obtained, the little color areas being closely juxtaposed or even superimposed in places. (For more detailed information along these lines refer again to Chapter 5.)

SPEED

Most watercolors are completed far more quickly than oils. An oil can be successfully worked over hour after hour until a high standard of perfection is reached, while a watercolor, if it doesn't "arrive" in an hour or two, can often be classed as a failure, for once it loses its crispness and freshness few people would consider it attractive.

COLOR JUDGMENT

Don't let preconceived notions as to colors handicap you. Grass, in sunshine, is not usually green-green, but, rather, yellow-green. The sky near the horizon is seldom a deep blue; often it is greenish, pinkish, or yellowish. So don't paint a given thing the color you think it *ought* to be; look and see how it appears in relation to its surroundings, and paint it that way.

Also remember that the appearance of a subject depends not alone on its local tones, but also on climatic and atmospheric conditions. In other words, subjects have moods and colors affected by such things as temperature, wind, sound, the time of day, period of year, and position of the sun.

COLOR DISTRIBUTION

Subjects in nature seldom give us the best distribution of color. It's a fairly safe rule that if you use a color on one area it's a good thing to use it elsewhere, perhaps in reduced area. Many artists, for example, in painting the sky, see that some of the same hue is distributed in other places, as on the window glass. Perhaps the green of the foliage is brought into the shutters of a building. Thus is woven a pattern of color which tends toward chromatic balance.

PURPLE SHADOWS

You may ask—as so many others do—if the artist really sees all the purple shadows, etc., which he paints. Of course not! Naturally, with his trained eye he sees more color than the layman, but this doesn't wholly explain the matter. Yet the artist has sound reasons for "all these queer, impossible hues." First, remember he frequently desires to represent dazzling surfaces in bright sunlight. As his pigments and even his whitest papers are dull, compared with actual light, he has to "force" his color, taking advantage of his knowledge of simultaneous contrast: problems like these account for many of his somewhat artificial hues. So far as truthful impressions are concerned, he is actually being more honest, many times, in making these readjustments, than he would be if he matched his subject as well as he could hue by hue, for if he were to do this his final effect would be quite liable to seem dingy. Furthermore, the artist commonly tries to make each painting beautiful, so what is more natural than for him to work for a harmonious, and perhaps decorative, chromatic arrangement, even to the extent of allowing artistic license to modify true appearances somewhat? Additional uses of strong or "strange" color result

from the artist's attempt to hint at such unpaintable things as motion, sound, and even odors.

Getting back to purple shadows, the reader who has followed our discussions on simultaneous contrast realizes that if the problem is to catch the impression of bright sunlight, and the yellow and orange pigments customarily used for such a purpose prove inadequate, it is logical to force them to appear all the more brilliant by contrasting them with blues and violets.

So, whether in outdoor sketching or any other kind of watercolor painting, don't hesitate to use *any* color if it helps you to express your subject more adequately and pleasingly.

SQUINTING

It is quite common to see an artist squinting at his subject, or at his painting, through partially closed eye-lids. His thought is to reduce the whole to simple terms, shutting from view all but the leading elements, and softening some elements to judge better the main effect. This is often a good practice, just as it often helps to look at the subject through the reducing glass or, better yet, through some other lens or bit of translucent glass which permits you to see only the more evident contrasts.

SHADOW SHAPES AND EDGES

It should be remembered that the appearance of a subject depends to a great extent on its light and shade, and that these vary from moment to moment as the sun shifts in position. Shadow shapes change so rapidly that it is generally advisable to outline them all at one time in pencil; then to hold to the proportions as you have sketched them, regardless of any subsequent changes which develop. Or the rendering of all shadows may be postponed until about the last step in your painting, when they may be added hastily.

You must give attention not only to the areas of shades and shadows, and their values, but to their edges. Shadow edges on sunny days are usually sharp, on other days blurred. Effects due to diffraction must be considered; see Chapter 19. Edge treatment sometimes has much to do with the success of a painting.

A COLOR MATCHING TIP

When you are in doubt about the color of an area of a subject, bring it into direct comparison with the white of your finder. Or have with you one of

the little books of colored papers such as the school supply houses put out, and hold up some of them for similar comparison.

INCOMPLETE WORK: NOTES

If you are forced to leave a subject before your sketch is finished, and plan to complete it later in the studio, take a good last look before you depart, trying to form definite mental impressions of the uncompleted portions. A snapshot may prove valuable, too. As another help, make a few rapid pencil or fountain pen sketches, bearing descriptive notes. Some artists make many sketches of this sort—diagrams accompanied by notes—whenever they find interesting subjects and have no materials with them.

ANALYSIS

Whichever of the several above procedures you follow for making a painting, if you keep the painting rather flat, be sure to set it up into normal viewing position at least every half-hour or so in order to gain a true impression of its appearance. Stand back from it. Compare it with the subject. Also, view it by itself so as to judge how good a painting it is growing to be.

REPAIRS

Whereas an oil painting can be scraped, painted over or otherwise brought successfully through any discouraging stage, there sometimes isn't too much that can be done for a watercolor that has become muddy, overworked, or is otherwise displeasing in effect. It's always worth a try, however, and occasionally an astonishing improvement results from comparatively simple means. Refer to the next chapter for methods of making alterations and corrections.

KNOW WHEN TO QUIT

Many a watercolor painting which at the end of a half-hour or hour is coming beautifully, catching the spirit of the time and place, is later ruined by one's continued effort to improve it. There's a lot of sense to that old saying that it takes two to paint a picture—one to do the actual painting and the other to hit him over the head when he has carried the work exactly far enough.

MATTING SKETCHES

When the artist works outdoors he hasn't time, as a rule, to carry his washes exactly to margin lines. More often he takes them to the edges of

his paper. In his studio, later, he can decide on the most pleasing proportions for each sketch. In this connection, L-shaped pieces of paper or cardboard such as we described earlier, can prove of help in determining just how much of the entire subject matter is worth retaining. Experimentation often demonstrates that quite a bit of a sketch can be cut away (or hidden by mats) advantageously.

Proper matting can add a hundred percent to the appearance of a sketch. Seemingly inferior paintings frequently improve wonderfully when matted. Plain white or ivory mats not less than three or four inches in width all around are usually the best, though much depends on the subject. Sometimes a line or two of color adds to their effectiveness.

Exercise 42: Comparative Work

There is no limit to the number of paintings you may wish to make at this time. Save them *all;* even the poorest ones may serve well later as guides for studio work. And the main thing just now is to learn all you can. You can't help learning, even when you are producing your most disappointing pictures.

Many novices, on their first attempts at outdoor painting, become wholly discouraged. This is not surprising for in a sense they are not unlike a young pianist or violinist who, having had the drill of elementary exercises, now for the first time comes face-to-face with work calling for professional skill in interpretation. You mustn't give up when success is quite possibly just around the corner. But it won't come in a day or a week or a month. If the mastery of painting were *that* easy, everyone would do it. Don't look for miracles. No book, and no teacher, can perform them for you. Progress will come through holding your own brush, mixing your own colors, and painting your own pictures.

SPECIAL MATTERS

There is little more that we can offer in the way of instruction, for you must learn by doing. It is quite possible, though, that it would pay you to read at this time the coming chapters dealing with such special things as clouds, foliage, reflections, and buildings. You can't hope to master each of these, however, before you go out to sketch.

Such special media as opaque color, colored pencils, tinted papers, etc., are much used for outdoor work: when you think the time is ripe, turn to Chapter 25.

Chapter 17

ALTERATIONS
AND CORRECTIONS

PERHAPS THIS IS AS GOOD a point as any to pause for a word on alterations and repairs. If we had the skill to apply Hughson Hawley's rule, "Put the right color in the right place and success is assured," plus the will to leave well enough alone, this chapter would be unnecessary. But to err is human and to change his mind the prerogative of the artist, so it is seldom indeed that a drawing is carried to completion with no corrections or changes.

We emphasize this matter just now because beginners, discouraged by slight troubles which develop, often foolishly discard sketches which still have excellent possibilities. Sometimes the only fault is a defective wash or an inharmonious color, which one with knowledge of corrective measures could shortly cure. The artist should never admit he is licked until he has tried everything on his drawing which offers the slightest hope of success.

SCRUBBING

What we have previously said about scrubbing should be enough to make clear that it is an expedient which you can always fall back upon. Until the surface of your paper is destroyed, your drawing is never absolutely hopeless. If its faults do not yield to less drastic treatment, it can be taken to the sink or tub and scoured until practically white again. Soap is sometimes brought into play.

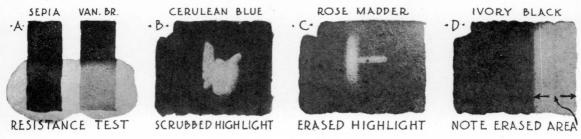

Figure 87

TRIALS IN SCRUBBING AND ERASING *Scrubbed highlights tend to be sharper and cleaner than erased highlights, unless you use the erasing shield. Erasing is ideal for lightening areas just slightly.*

Even when such wholesale scrubbing is unnecessary, there are times when it is helpful to scrub portions of a drawing more or less. This demands real skill, for one must confine the moisture to the offending areas. Usually alternate wetting (with rag, sponge, or brush) and blotting is all that is required. Sometimes a bristle brush, obtainable at your art supply store, is needed to start obstinate colors. The sponge is especially handy in cases where a mere dabbing at a tone will lift just enough pigment. Repeated application of a moist blotter is another remedy. Only clean water should be used for all such work, and the pigment loosened should be blotted up before it sets again to stain the paper.

SANDPAPER

If your watercolor is dry, sandpapering can often be done effectively in place of scrubbing, though only good paper will stand so drastic a treatment. Sandpapering tends to alter the surface more than scrubbing does. Perhaps sandpapering is most effective for lightening over-dark areas which might be muddied by scrubbing. Or, if scrubbing has been attempted with disastrous results, you can turn to fine sandpaper as a last resort. It forms a deposit of dust (which must be brushed away or removed with a kneaded eraser), and on some papers causes a gloss; this can usually be overcome by an application of plain water, which should be sprayed on if there is danger of disturbing the pigment particles.

The student should experiment on old drawings with both scrubbing and sandpapering.

THE ERASER

Though erasers have many uses, they are most effective for slightly lightening large areas. Soft erasers will do for this. Hard ones, well pointed, can be employed for forming highlights. Scrubbed highlights are likely to be

cleaner cut, however, unless the erasing is done with the aid of the erasing shield. Surfaces should not be erased while damp. Study Figure 87 for results of trials.

THE KNIFE AND RAZOR

Examining original watercolor paintings in museums and galleries shows that even recognized masters sometimes resort to the knife for the removal of unwanted pigment. Large areas are often scraped or scratched. Highlights are occasionally carved from the paper. A word of caution, however. If paper is scratched at all deeply, and washes are subsequently run over the scratches, the pigment is inclined to settle into them to form dark spots. Unless such effects are desired, scratching should therefore be the last thing done.

ALTERATIONS BY ADDITION

Though nearly every corrective process involves removing the pigment, we have exceptions, for there are sometimes light places which need to be darkened. An otherwise satisfactory wash, for instance, may show a disfiguring light spot. While we can give no method adaptable to all conditions, we can suggest this general procedure: place the board flat; if the spot is large, dampen it first, together with a bit of the adjoining surface. There should be no puddle. Then the brush, bearing a moderate amount of the needed pigment, and not too wet, can be touched to this moist surface here and there, allowing a bit of color to spread over the area. Let the spot dry and repeat if necessary.

A small light spot can be successfully darkened by means of stipple. One simply applies many separate tiny dots of pigment so closely together that from a little distance they appear to merge to form an even, continuous tone. Sometimes these dots, if conspicuous, can be blended by going over them with a soft moist brush.

REPAIRING FANS

In certain types of quick work, fans or runbacks—where one color runs into another—are not considered blemishes, yet where perfection of wash is desired they can prove most troublesome. To overcome them, some pigment must usually be removed and some added. You must go about this patiently. Occasionally it is best to wash off the entire area involved, fan and all. Again it is better to touch up the faulty spot, carefully lightening

the dark parts (the brush, together with the blotter, is generally the best for this), afterwards darkening where necessary with wash or stipple. You must experiment; the encouraging thing is that most blemishes yield to perseverance.

MENDING EDGES

Wash edges cause as much difficulty as any one thing. Many dry out to be wiry. This often happens when a wash is "puddled" on a flat surface of paper. Particles of pigment float off and form dark edges. Such edges can usually be softened and blotted away if carefully dampened, an inch or so at a time, with a finely pointed brush (care being taken not to moisten the adjacent surfaces).

Many washes either overlap or fall short of the proper boundary lines. The overlapping portions will generally yield to alternate dampening and blotting, while the lights can be filled in with tiny washes or by stippling.

PATCHING

Although pasting on paper patches to hide defects, and later rendering them, is not a thing done commonly in typical watercolor work, now and then it proves necessary in advertising drawing, architectural rendering, and other forms of commercial painting. A patch should be of paper like that used for the drawing, and of proper size. Its edges, when possible, are made to coincide with existing lines on the drawing, which helps to make it inconspicuous. To increase this illusion, the edges are usually sandpapered on the under side to a thinness that eliminates shadows. The patch is then moistened thoroughly and glued in place. Unless patches are very small, it is difficult to apply them successfully to any but mounted paper. The larger a patch, the more it may increase in size when dampened for application.

OPAQUE COLOR

Painters may turn to some of the opaque watercolor paints—gouache or tempera—or to casein, proceeding with the faulty watercolor work as a foundation to be entirely, or nearly covered with the new medium. Chinese white is occasionally used to paint out or soften undesirable passages. Be extremely cautious in using this method, however. Often, excessive use of opaque colors will produce conspicuous passages, contrasting greatly with the transparent quality of the watercolor in other sections of your painting.

BURNISHING

Though less a matter of repair than of preparation, we take this opportunity to point out that occasionally you can smooth a limited area of rough paper with a burnisher to meet some special need. This can be done effectively with a knife handle, a key, or other smooth, firm instrument. You simply rub the surface vigorously. In painting figures, the artist can employ this expedient where faces or hands are involved; it enables him to work up as much detail as he wishes.

Chapter 18

TREES AND
OTHER LANDSCAPE
FEATURES

WE SHALL NOW GIVE ATTENTION, in this and the next few chapters, to some of the individual features or details which cause the artist the greatest difficulty in outdoor painting.

First we shall take up trees, together with such related things as bushes, flowers, and grass. These present a real stumbling block in the path of the student; his early attempts to represent them are often amazingly bad.

LEARN ABOUT TREES

To lay a firm foundation for knowledge in this direction, you could hardly do better than read some of the many good books devoted to the subject. A splendid volume, approaching the subject from the artist's point of view, is Rex Vicat Cole's *The Artistic Anatomy of Trees* (Dover). This deals mainly with species native to England, yet it offers many suggestions applicable to the representation of our own. Other useful books are *Drawing Trees* by Henry C. Pitz (Watson-Guptill); *On Drawing and Painting Trees* by Hill (Pitman); *Trees and Landscapes* by Ernest Watson (Reinhold); *Painting Trees and Landscapes in Watercolor* by Ted Kautzky (Reinhold).

A careful perusal of a few volumes like these will not only familiarize you with the names and leading characteristics of the more common vari-

eties, and train you in the laws which govern their growth, but should also strengthen your love and appreciation of what is beautiful in nature. You should come to realize, at least, that a tree, instead of being a sort of gigantic green lollypop stuck in the ground (an effect common to beginners' work), grows from the ground—is supported and sustained by it. You should also learn that the tree's appearance depends not only on its species but on other factors, such as character of soil, climate, direction, and amount of prevailing wind and sunshine, and the influence of neighboring trees, buildings, hills, etc. You must learn, too, that the tree, like any other growing thing, has certain consistencies of growth which cannot be ignored.

This last fact we have endeavored to make plain by our sketches in Figure 88, which are included more as a means of calling attention to this matter than as an explanation of it. The principles involved apply to many forms of plant life, both large and small.

When we glance at a tree, its method of growth—alternation, opposition, etc.—is not always immediately evident, but usually reveals itself on close examination. You should try to discover the fundamental growth characteristics of any tree you draw, and should proceed with them in mind. You will sometimes find that one main principle is followed consistently in every part of a tree. Again, more than one is involved. When trees apparently fail to fit into any definite classification, it is often because they have met with a series of accidents, such as broken limbs, and the evidences of system are thus obscured.

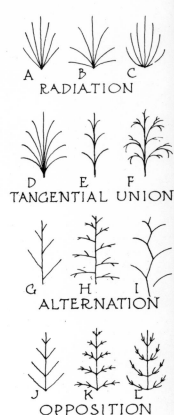

Figure 88
GROWTH *Each form of plant life has its own growth pattern, a pattern which is followed consistently throughout every part of the tree. This may not be evident immediately, but if you examine a tree closely you will soon be able to determine its growth characteristics.*

FIELD TRIPS: ANATOMY

Whatever you may learn about trees from books should be clinched by a critical survey of actual examples outdoors, so you should go to park or country, sketchbook in hand. You should sketch much and observe more. Add notes to each sketch.

An ideal time for the first of these field trips is when the trees are free from foliage, or practically so, because you can observe, under ideal conditions, that most fundamental thing: the tree skeleton. (See Figure 89.) Just as the artist who hopes to draw the human figure successfully must be as familiar with the hidden skeleton as he is with the muscles, flesh, and skin which clothe the figure, so the painter ambitious to represent trees in more than a superficial manner must have a knowledge of such "bones" as trunk, branches, twigs, etc. Perhaps the need is even greater here, for the tree skeleton is often exposed.

You should examine each skeleton from far away and from nearby, noting not only its form but also its value, hue, quality of bark, etc. Put to

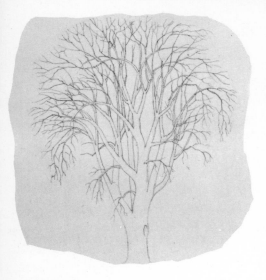

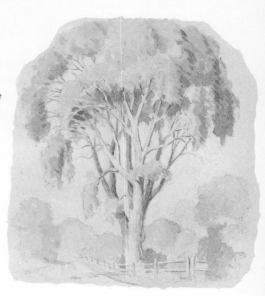

Figure 90

FOLIAGE MASSES *The skeleton was pencilled in freely, then the foliage masses were outlined and tinted. Be sure to consider the direction of light!*

Figure 89

SKELETON *The anatomical structure of a tree is most important. Building a tree upon its "bones" means sound construction.*

yourself such questions as the following: Is the trunk single or forked? Straight or curved? Vertical or tipped? Is it smoothly rounded or ridged? Do the branches point up, out, or down? Do the smaller twigs seem to merge as they terminate against the sky, or does each stand out by itself? Are the roots exposed? What of the value and hue of the various members? Are the areas in light much different from those in shade? Do some members cast shadows on others? How dark do the shadows seem? Does the entire skeleton exhibit any peculiarities of growth not typical of its species, perhaps permanently bent by sun or wind, or disfigured by ice or neighboring trees?

Figure 91

MODELING *Here the rendering is carried on very boldly, leaf texture being produced by both brush and pencil. Notice the varied values.*

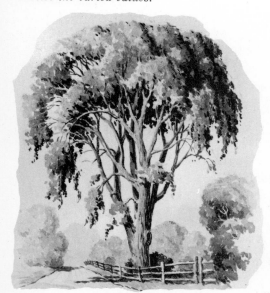

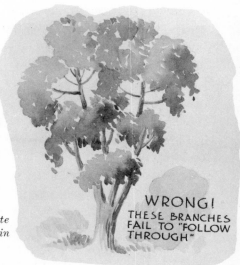

WRONG!
THESE BRANCHES
FAIL TO "FOLLOW
THROUGH"

Figure 92

COMMON FAULTS *A complete lack of structure is evident in this example. Don't neglect tree anatomy!*

It is not only the skeleton which you should study in this analytical manner; you should also observe trees in partial and full leaf.

The camera can be of real help in all this. You can learn much, for instance, by making a number of series of progressive photographs of typical trees, each series showing a given tree as seen from the same point at different seasons and under different lightings. One photograph would show the skeleton, one the scanty foliage of spring, one the full leafage of summer, etc.

Figures 89 to 92 were designed to give emphasis to the importance of becoming familiar with tree anatomy. The skeleton of an old elm in Figure 89 was done with considerable care from a photograph I snapped in winter. Figures 90 and 91 show two stages in the development of a sketch made from this same tree in midsummer from the identical point of view. In starting the sketch, all of the larger "bones" which were visible were first drawn, much as in Figure 89, but more freely. Though the less essential or hidden ones were omitted, their general direction was indicated. Next the foliage masses were blocked in with due attention to direction of growth. After this, light washes were applied to model the bones and the separate masses of foliage (see Figure 90), the location of the sun being considered. In the completed sketch in Figure 91 the whole was more fully modeled, and the texture of the leafage interpreted by means of both brush and pencil, the latter held flatwise. Note the great difference in the values in sunshine and shadow. In Figure 92 we see the kind of faults that often appear when the artist neglects structure: here there is a lack of proper anatomical relationship between the bones above, at the center, and below.

Exercise 43: Skeletons
From nature or from photographs, make many anatomical sketches of different species of trees, attempting to memorize the forms as you draw. Try details of roots, bark, and the like.

SILHOUETTES

One of the best ways of learning to express both tree anatomy and contour (the two are really inseparable) is by painting silhouettes such as we show in Figure 93. Study these with care. With trees thus reduced to their lowest

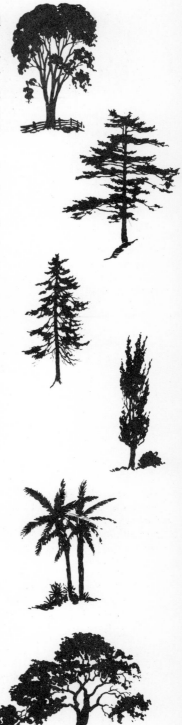

Figure 93
SILHOUETTES *Attention to fundamental forms is very important. Many species can be identified by their silhouettes alone.*

165

Figure 93
STRAIGHT CONTOURS *Silhouettes can be bounded by lines which are straight or nearly straight. Mass is far more vital than detail.*

terms, we learn that intricacy of detail is not the prime requisite to their adequate representation, but that much can be expressed through attention to fundamental forms. Mass, in other words, is far more vital than detail. These silhouettes can be simplified even further by drawing straight contours around them as in Figure 94.

Exercise 44: Silhouettes
Make silhouette drawings on the order of those in Figures 93 and 94. Work directly from nature, if possible. Use brush or coarse pen and black ink or dark watercolor. Represent only the principal elements. You will learn that trees vary in basic shape to a surprising extent.

Figure 95
CURVED CONTOURS
Most trees are shaped very much like spheres (A) or groups of spheres (B). This is another way to simplify tree shapes.

VALUES

Not only should you acquire this fundamental knowledge of tree anatomy (skeletons, contours, etc.), but you should learn something of tree values. As in other subjects, these values depend on local or natural tone, and on light, shade, and shadow. Values due to lighting are extremely complicated, because a tree, as it customarily appears in full leafage, not only reveals modeling of its entire mass, but shows gradations of tone in each individual leaf and branch. Literally thousands of light and dark areas are visible. Obviously all these cannot be represented, so your problem is to learn to suggest.

A good approach is to think of the typical tree as shaped like a ball or group of balls (*A* and *B*, Figure 95; *A*, Figure 101; *B*, Figure 102). As examples in Figures 101 and 102 on page 170 show, the normal shade area of a sphere takes something of a crescent form.

If we think of a tree as a group of intersecting spheres, as in *A*, Figure 101, with each sphere bearing a crescent-like area of shade, the shade of the whole roughly consists of these crescents in combination, plus such shadow as one sphere may cast on another.

Figure 96

EXCEPTIONS *Trimmed trees—violating the laws of nature—are exceptions to the general rules.*

But trees are not actually so regular in mass, and it is seldom that shade areas can be so clearly defined. Sometimes, in fact, it is impossible to discover any definite lines of demarcation between foliage areas in light and in shade. Figure 102 shows how they merge. This is particularly true if you stand so near a tree that you can observe all the slight variations of value, so it is better to judge trees, as far as essential differences of tone are concerned, from some distance.

HUE

If it were not for this matter of light and shade, we could often represent the hue of a tree with a wash of green on the foliage and another of brown or gray on the trunk serving the purpose, as in Figure 97, Sketch 1. One can seldom divorce hue from value, however, which greatly complicates the problem. But here is an exercise designed to simplify the problem somewhat.

Exercise 45: Planes

Make some sketches from nature similar to those in Figure 97, Sketch 1, in order to learn how to represent the combination of local color and light and shade in the simplest possible manner. Try a few of these sketches, seeing how expressively you can represent trees in a single flat plane. Use any colors you wish; shape your profile with care, but don't use an outline as here. Next, try sketches similar to those in 2, allowing one flat wash of color to represent all the foliage in light and a second color to represent all the foliage in shade. In subsequent work from nature, always try to see (or sense) these two fundamental divisions. Now, to get a bit closer to true appearances, paint some trees in three divisions, or planes, as in Sketch 3, Figure 97. Here *A* stands for the light, *C* for the dark, and *B* for the middle values. The sketch at 4 again shows this general scheme;

Figure 97
PLANES *First, practice drawing the tree in a single, flat plane. Second, draw the tree in two flat planes, where* A *is the lighted area, and* B *is the shaded area. Third, draw three areas of* A *(light),* B *(middle value),* C *(dark area). Fourth, elaborate on this general scheme.*

| 1. ONE PLANE | 2. TWO PLANES | 3. THREE PLANES | 4. AN APPLICATION |

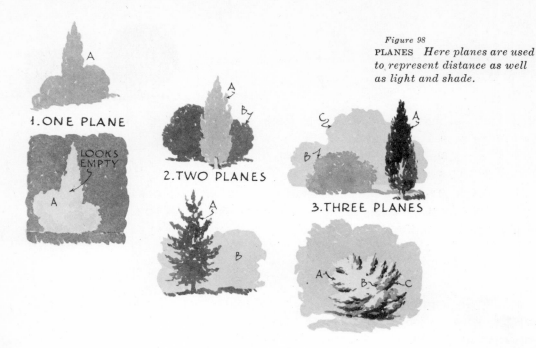

Figure 98
PLANES *Here planes are used
to represent distance as well
as light and shade.*

1.ONE PLANE

LOOKS
EMPTY

A

2.TWO PLANES

3.THREE PLANES

this is merely a somewhat more elaborate application of the principle of simplifying complex values by dividing them into a few definite areas or planes.

Not only will this exercise teach you to look for the broader divisions of value, rather than the less essential ones, but it will prove that trees, especially if somewhat distant, can be quite well suggested by simple means. Obviously when trees are nearby, or are shown at large scale, it is necessary to indicate a reasonable amount of their detail. Sometimes even individual leaves are pictured. Trees in backgrounds or in conventional renderings, on the other hand, can actually be represented by flat planes. This we demonstrate in some of the sketches in Figure 98 and again at *C*, in Sketch 2 of the color page 176. The first of the former sketches represents a group of shrubs by means of a single flat wash; in the second, two bushes, one behind the other, are painted with two flat washes, the nearer one the lighter; in the example just below this the values are reversed. The third sketch in the upper row shows how a sense of distance can be created by the use of three planes, each darker than the one behind it. (In this connection, see the larger study in Figure 156). The lower left-hand corner sketch in Figure 98 presents a less usual effect, where light shrubbery is left in silhouette against dark. Such an area generally looks empty unless it is modeled. Often, however, portions of trees or bushes—especially their tops —can be left light against dark. The last little sketch in Figure 98 exemplifies this. Try sketches to clinch these thoughts.

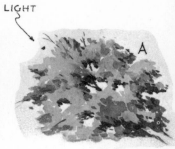

HOLES THROUGH FOLIAGE

One of the difficulties sometimes encountered, particularly when one works in wash rather than color, is to make holes through masses of foliage look like holes. Too often they appear to be highlights. Any opening through the thick foliage of a tree has, as a general rule, an area of leaves, either above it or beside it, which is in deep shade. Hence in representing such holes, especially if through sunlit masses, it is quite common practice to edge them with dark towards the source of light. This is illustrated at *A*, Figure 99.

Now and then you may be anxious to know how to render small branches so they stay back properly among neighboring leaves. You can usually solve this problem if you remember that branches customarily go into shadow as they disappear into foliage: closely inspect the sketch at *B*, Figure 99, and you will find that each branch is darkened as it is lost among the leaves.

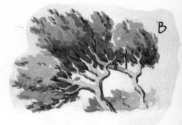

TRUNKS AND BRANCHES

Foliage will not be your only problem, as we have seen; you must learn all you can about the bark enclosed members. The beginner frequently thinks of bark as uniformly gray or brown. It scarcely occurs to him that it reveals a great variety of values and hues. "Bones" in dazzling sunshine, especially when smooth, sometimes appear as light as your paper and can be so represented, while in shade or shadow they may seem nearly black. Figure 91 reveals something of the variety of value which one finds in the skeleton of almost any tree. The point is further illustrated in the sketches in Figure 100, which remind us that we often see light branches against dark, or vice versa. The one at *C* demonstrates that shadows cast by branches on trunks or other branches are usually quite prominent and therefore should be so portrayed. This also shows that such members are

Figure 99
HOLES THROUGH FOLIAGE *This problem always gives the beginner great difficulty. Study these sketches and the text for suggestions.*

Figure 100
BRANCHES *There are many values in the branches too!*

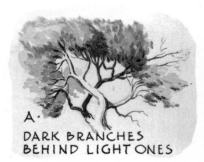

A·
DARK BRANCHES
BEHIND LIGHT ONES

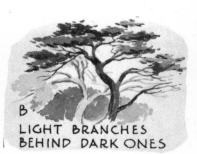

B·
LIGHT BRANCHES
BEHIND DARK ONES

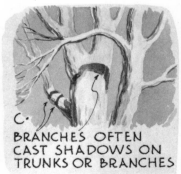

C·
BRANCHES OFTEN
CAST SHADOWS ON
TRUNKS OR BRANCHES

Figure 101
TREE SHADOWS *Remember to fore-shorten tree shadows!*

sometimes lighter in effect than the sky beyond.

As to the hue of all these members, not only are the local colors of different barks divergent, but they are modified in many cases by mossy growths, etc., some of which are particularly colorful when wet. Also, like all things, bark differs in appearance according to the kind of light which illuminates it. Towards sundown, for example, it often looks pink, yellow, or orange in light, and blue or violet in shade or shadow.

Exercise 46: Branches and Holes
Make sketches to illustrate some of these last points. Practice painting holes through foliage and trunks and branches. Pay careful attention to the possible variety of hues and values in the bark.

Exercise 47: Tree Shadows
Next let us consider the shadows which trees cast on the ground, or on neighboring trees and buildings. The beginner usually has trouble with these, getting them wrong in shape, value, and color. So spend a few hours studying and sketching shadows. You will discover that a tree shadow's appearance depends not only on the shape and character of the tree itself, but on the nature of the surfaces on which it falls.

First, a word about shape. We illustrate diagrammatically at *A* and *B*, Figure 101, the beginner's common mistake of failing to foreshorten a tree shadow sufficiently. This causes a tipped-up look, the shadow failing to lie flat. He also often paints the shadows of trunk and lower limbs too long, forgetting, perhaps, that portions of these members are customarily in shade and so cast no shadows. *B* shows a correction of the faults pictured at *A*.

ELLIPSES CAUSED BY TREE SHAPE

Note that the main shadow in *B*, Figure 101, is elliptical in form, as is the general rule. If we imagine a tree to be made up of several spheres—pictured in Figure 102—we can imagine the shadow consisting, roughly, of

Figure 102
TREE SHADOWS *If you imagine tree forms as spherical, you will notice that their shadows are elliptical. B is an application of A.*

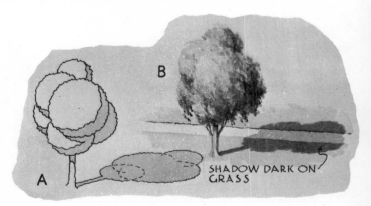

170

a number of overlapped or interposed elliptical shadows, merging to form a single one, bounded by more or less elliptical curves. Trees are not combinations of exact spheres, of course, and their shadows always show varied contours, yet it is true that in general shape they usually do exhibit suggestions of elliptical origin. See *B*. (As long as we are studying this sketch, we should perhaps point to the shadow values: note that where the tone falls on the rather dark surface of the grass, it appears darker than on the light surface of the concrete walk.)

ELLIPSES CAUSED BY DIFFRACTION

These ellipses just mentioned are shadow shapes common not only to tree shadows. Lay a large sheet of paper horizontally in a position where masses of leaves in sunshine can cast their shadows upon it (yet not so near that each individual leaf throws a shadow exactly silhouetting its own shape), and you will observe, if lighting conditions are right, the strange phenomenon that all various parts of the shadow appear bounded by curved lines, or at least have all angles rounded. If there is sufficient breeze to keep the leaves in motion, their individual shadows will constantly attach and detach themselves to form a composite shadow, and there will always be a soft edge and a round corner. Little circles or ellipses will form, disappear, and re-form. This is due to the diffraction of the light rays.

Study this phenomenon further by casting a shadow of your open hand on the paper, holding it several feet away. Spread your fingers slowly, noting the roundness of the bright spots which take shape as the light leaks through. Both these tests will demonstrate that many shadows, regardless of the objects casting them, seem to consist of rounded forms, frequently interspersed with rounded light areas. These rounded areas of light and shade, when seen in tree shadows, often appear (if you view the shadows from one side as you generally do) elliptical because of perspective foreshortening. This we illustrate in Figure 103.

Both these types of ellipses which we have mentioned—one caused by general roundness of tree forms, and the other by diffraction—give the key to a great deal of foliage shadow representation. The artist finds that if he

Figure 103
TREE SHADOWS
Many shadow forms seem round, regardless of the forms casting them. Perspective foreshortening makes shadows elliptical. Read the text carefully to avoid any misunderstanding of this diagram.

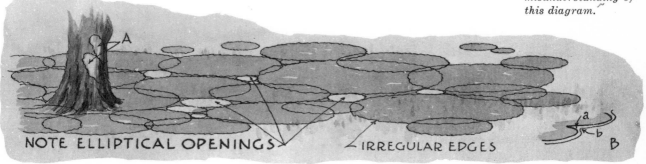

NOTE ELLIPTICAL OPENINGS — IRREGULAR EDGES

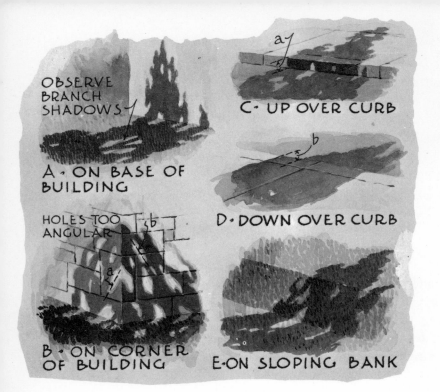

OBSERVE BRANCH SHADOWS

A · ON BASE OF BUILDING

HOLES TOO ANGULAR

B · ON CORNER OF BUILDING

C · UP OVER CURB

D · DOWN OVER CURB

E · ON SLOPING BANK

Figure 104
SHADOWS EXPRESSING FORM
Notice how the shadows in each of these sketches tells us something about the surface on which they are cast.

bases most of his foliage shadows on rounded shapes, somewhat like those in Figure 103, his results will prove more successful than when many sharp, angular ones are introduced. This is as true on vertical or sloping planes as on those which are horizontal. Figure 104 demonstrates this, though some of these shadows, especially at *B,* are too angular to serve as ideal illustrations of our point.

These remarks about shadows refer particularly to foliage. The shadow of the tree skeleton, or any portion of it, often looks much like the actual skeleton, though its angles are usually rounded and its edges softened by diffraction. Here, again, you must show reasonably correct foreshortening. Too many such shadows seem, through improper treatment, suspended in the air.

SHADOWS EXPRESSING FORM

Tree shadows help to express the forms of the surfaces on which they fall. Note at *A,* Figure 104, how the shadow, by turning up against the building, explains the change of plane, as does the shadow breaking across the corner at *B.* When shadows lie on walls, as here, many of the punctuating spots of light usually exhibit similarities in both shape and direction: we observe at *a* and *b* the directions which predominate in this sketch. In Sketch *C* the tree shadow, by breaking up over the curbstone, clearly reveals the change in level. See *a.* Sketch *D* illustrates the opposite condition, for here

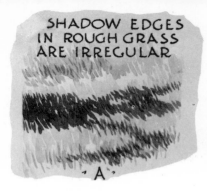

SHADOW EDGES
IN ROUGH GRASS
ARE IRREGULAR

·A·

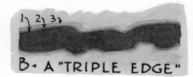

1, 2, 3,

B· A "TRIPLE EDGE"

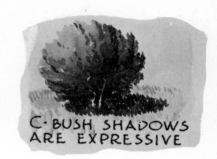

C· BUSH SHADOWS
ARE EXPRESSIVE

Figure 105

SHADOW EDGES *The edges of shadows are determined by the surface on which they are cast, by the quality of the light, and by the distance of the object from the ground.*

we are looking from the sidewalk toward the street. At *E* the shadow tells us the approximate pitch of the bank.

SHADOW EDGES

If shadows fall on irregular surfaces, instead of on smooth lawns and walks such as we have shown, their character changes accordingly. In Figure 105, at *A,* is an indication of foliage shadows on uncropped grass. The strokes used suggest grass as darkened by the shadow.

At *B* the shadow was painted with several distinct edges. Nature, through the same diffraction which causes the rounded light and shadow forms already discussed, often gives us an effect of parallel bands: in paintings it is common to merge them.

The sketch at *C* reminds us that bushes and other objects close to the ground cast shadows extremely definite in character of edge, the light rays being refracted only a little. The shapes of such shadows are often highly expressive of the objects casting them. Bushes frequently cast very dark shadows beneath them.

COMMON ERRORS

This seems the best point, however, to touch on one or two thoughts relating to trees in connection with buildings—some tips on what not to do—which may be helpful to you when you paint landscapes with foliage and buildings. At *A,* Figure 106, we illustrate a fault found in many drawings. Here the tree is graded so dark as it goes behind the ridge of the roof that it gives the impression of resting on it, if not actually leaning forward. It should be lighter at the ridge or less definite. At *B* the two trees, or at least the tree at the right, seem to grow from the roof. If trees are actually behind buildings, try to subordinate them to make them appear so.

Figure 106
COMMON ERROR
Guard against trees which appear to rest on (or grow from) roof tops.

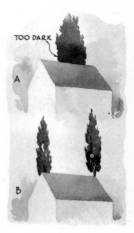

TOO DARK

A

B

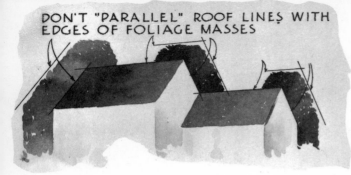

Figure 107

COMMON ERROR *Don't "line up" tree trunks or main branches with important lines of architecture.*

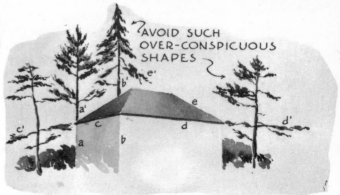

Figure 108

COMMON ERROR *The trees here are distracting elements because of their shape and because they unnaturally extend the lines of the architecture.*

AVOID SUCH OVER-CONSPICUOUS SHAPES

In Figure 107, another fault is pictured: here the edges of the foliage masses seem too nearly parallel with the roof lines, thereby becoming unpleasantly conspicuous. In Figure 108 is still another fault; the tree shapes not only detract from the architecture, because of their moth-eaten character, but they are so disposed that some of the principal lines of trunks and branches extend the lines of the architecture unnaturally. See *a, a'; b, b';* etc.

Figure 109 shows additional faults sometimes found in sketches, while Figures 110 and 111 hold a word or two of well-intended advice.

Exercise 48: Bushes

Now let us turn to bush representation: see our color representation of bushes and hedges, page 176. Make, in full color, a few sketches similar to these. Outline each bush, as at *A*, Sketch 1, and apply a light tint of color. Wash in your sky and grass. Add a few darker tones for shade, as at *B*, taking into account the direction of the light. Deepen these and add accents, as at *C*, thus gaining roundness and stability. Don't confine your efforts to bushes of one shape or color. Note that the evergreen shrub at 2 (*B*) was done with blue-green, the small bush and lawn with yellow-green, and the large bush with dull orange and red. Sketch *C* shows still another hue arrangement—one which gives particular emphasis to expression of distance. See how the tones on the evergreen grade, the top coming up into the light. The little areas of bare paper in this sketch add to its freshness.

Exercise 49: Hedges

Hedges are another type of detail simple enough for early efforts. Sketch 3 pictures, in two stages, a hedge handling; the method was the same as in

174

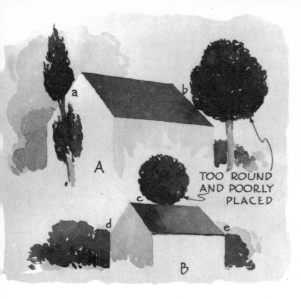

Figure 110
COMMON ERROR
Don't complicate distant masses of foliage (or important ones nearby).

TOO COMPLEX

Figure 109
COMMON ERROR
Avoid effects of foliage masses rolling or falling off roofs.

the previous examples. Representations of this sort are often disappointing until the final dark accents are applied. Sketch 4 brings into one composition a variety of landscape features. Note that in the distance a number of very pale colors were used; much the same hues, in greater strength, were brought into the foreground. The violet shadows forming the base of the whole add to the feeling of sunlight. Try some sketches of this general type, preferably from real places.

FOLIAGE METHODS

There are several methods of painting foliage. The most common of these is the one just described; this we might call "progressive."

At 1, in the color page called "Foliage Methods," a second method is shown (known as *pointillistic* or *stipple*). A pale foundation wash is usually laid, as before. Next, go over this with tiny brush strokes, placed in juxtaposition (*A*). When dry, this stippling is continued (*B*), forms being gradually modeled until completed (*C*).

A third method, not unlike the first in results, can be called *direct,* for the artist, instead of working over each area until it is built up to a satisfactory point, lays his color with the utmost economy of means. Many times he puddles an area with green, and while it is still wet, drops darker pigment in for the shade tone, thus obtaining his effect in a single process. More often, a few final accents are necessary. This method is speedy, but can be learned only through long practice. The sketches at 2, on the color page 177, were done by this method, though in reduction they appear to be more worked over than they actually were.

It is always something of a problem to know how to represent leafage without using so many tiny brush strokes that the effect appears labored.

Figure 111
COMMON ERROR
"Speckled" trees are particularly distracting, unless they are in the foreground.

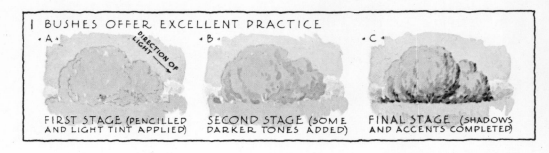

1 BUSHES OFFER EXCELLENT PRACTICE

·A· DIRECTION OF LIGHT

FIRST STAGE (PENCILLED AND LIGHT TINT APPLIED)

·B·

SECOND STAGE (SOME DARKER TONES ADDED)

·C·

FINAL STAGE (SHADOWS AND ACCENTS COMPLETED)

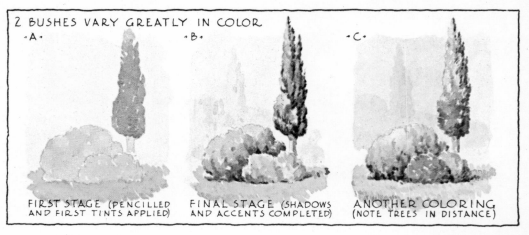

2 BUSHES VARY GREATLY IN COLOR

·A·

FIRST STAGE (PENCILLED AND FIRST TINTS APPLIED)

·B·

FINAL STAGE (SHADOWS AND ACCENTS COMPLETED)

·C·

ANOTHER COLORING (NOTE TREES IN DISTANCE)

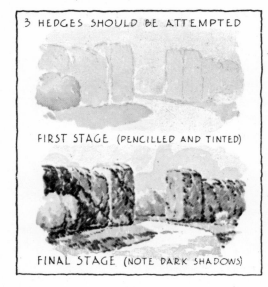

3 HEDGES SHOULD BE ATTEMPTED

FIRST STAGE (PENCILLED AND TINTED)

FINAL STAGE (NOTE DARK SHADOWS)

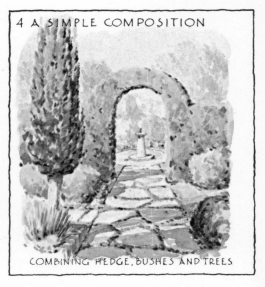

4 A SIMPLE COMPOSITION

COMBINING HEDGE, BUSHES AND TREES

BUSHES AND HEDGES *Foliage offers greater variety of hue than you might realize. Beginners often paint foliage too "green."*

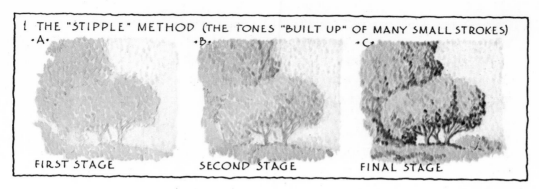

1 THE "STIPPLE" METHOD (THE TONES "BUILT UP" OF MANY SMALL STROKES)

·A· ·B· ·C·

FIRST STAGE SECOND STAGE FINAL STAGE

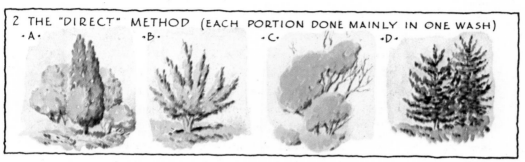

2 THE "DIRECT" METHOD (EACH PORTION DONE MAINLY IN ONE WASH)

·A· ·B· ·C· ·D·

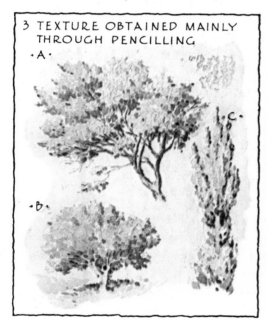

3 TEXTURE OBTAINED MAINLY THROUGH PENCILLING

·A·

·C·

·B·

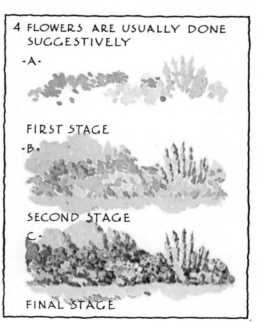

4 FLOWERS ARE USUALLY DONE SUGGESTIVELY

·A·

FIRST STAGE

·B·

SECOND STAGE

·C·

FINAL STAGE

FOLIAGE METHODS *Each of these methods—stipple, direct, pencilled, and progressive—has its merit. There is no one right way.*

One method is shown at 3, on the same page, where, in the several small examples, irregular lines like that in the upper right-hand corner were first applied with pencil. A sanguine (reddish) pencil was used at *B* and *C*. You can also experiment with this technique by using pen instead of pencil, or even charcoal, sprayed with fixatif.

Exercise 50: Foliage Methods
Try these various methods of rendering foliage, and any others that occur to you.

FLOWERS

We shall devote no space to flower painting as a subject in itself, since the principles involved in rendering foliage are the same in painting flowers. Yet a book placing emphasis on outdoor subjects would be incomplete if it failed to touch on the suggestion of groups of flowers common to landscapes.

Note on page 177 where at 4 is presented, in three progressive stages, a method of building up informal floral masses. As a rule such indications, if they are to exhibit the sparkle and brilliancy customarily desired, are done directly on the white paper, with no underlying washes (unless very pale). First the bright touches are applied, many flowers being merged into groups (*A*); there is often a tendency to make them too dark in value. Little whites are left among them to add life. If your pigments are not sufficiently vivid, try using spectrum colors, mentioned in Chapter 1, for these special effects. Next, washes indicative of the surrounding grass, bushes, etc., are brought approximately to the flower areas, as at *B*. Shade, shadow, and a few accents finish the whole (*C*).

GRASS

There is little that need be added to our earlier scattered remarks on the treatment of grass. Like other subjects, everything depends on its character and the conditions under which it is seen. The beginner's common mistake in rendering smooth lawns is that he employs too dark and cool a green. Grass in sunlight is generally yellow-green in effect, and sometimes practically pure yellow. Its value is light. So, for sunny lawns, a flat or graded wash of yellow-green is often all that you need, particularly if the paper is rough or the wash a sediment one. If this looks too unfinished, you can stipple it, in whole or part, with little upright strokes, or go over it with a second wash containing many small breaks to allow the first color to show through. The sandpaper trick may prove useful, too.

178

Shadows on grass must be carefully treated, as we have already discussed in this chapter. All too often grass in shadow is mistakenly rendered so differently from that in sunshine that it scarcely seems to be the same stretch of lawn. A bit of nature sketching is of great help here. Do some sketches facing the light, and some with the light behind your back. Close scrutiny will prove that a patch of grass, such as a lawn, has many hues. First, each blade reveals different effects of green, as brought out by the light, shade, and shadow. If you face the light, it will show through some blades, causing a most intense yellow-green. Again, blades are tipped in such a way that their shiny surfaces reflect the sky, introducing miniature areas of luminous blue. It is astonishing to find that even a large area of grass, in the right light, can be modified in hue to quite an extent by these sky reflections. Then, in addition to these diversified effects of the green blades, we have equally varied dead blades, weeds, and the like, each playing its own small part in the impression of the whole. So a book is of little use here: the student must get into the open and observe these things closely, painting them over and over.

Exercises

Though we highly recommend that the student undertake studies of all these subjects from nature, there seems no point in numbered experiments. He should plan an orderly series of projects, painting flowers, grass, hedges, walks, gateways, and similar subjects, as seen at all seasons of the year and under diverse lighting conditions. Later such outdoor studies, no matter how crude, can be utilized, customarily in simplified and conventionalized form, in studio paintings.

SUMMARY

Although this is hardly all there is to say about foliage, it seems wise to summarize briefly. Be sure to study nature and practice painting sufficiently so that you will master each of these vital factors: (1) The growth of all foliage, with special attention to the skeleton. (2) Natural contours, as expressed in simple silhouette. (3) Values, both of skeleton and foliage, representing local color and light and shade. (4) Shadows and their edges. (5) Color, always an essential aspect of any convincing painting.

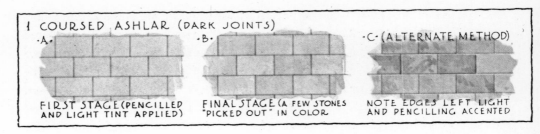

1 COURSED ASHLAR (DARK JOINTS)
·A·
·B·
·C· (ALTERNATE METHOD)

FIRST STAGE (PENCILLED AND LIGHT TINT APPLIED)

FINAL STAGE (A FEW STONES "PICKED OUT" IN COLOR

NOTE EDGES LEFT LIGHT AND PENCILLING ACCENTED

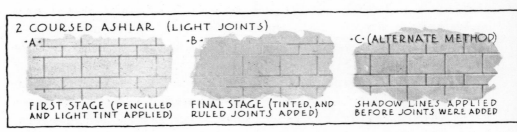

2 COURSED ASHLAR (LIGHT JOINTS)
·A·
·B·
·C· (ALTERNATE METHOD)

FIRST STAGE (PENCILLED AND LIGHT TINT APPLIED)

FINAL STAGE (TINTED, AND RULED JOINTS ADDED)

SHADOW LINES APPLIED BEFORE JOINTS WERE ADDED

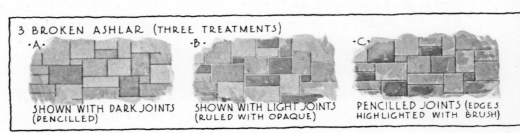

3 BROKEN ASHLAR (THREE TREATMENTS)
·A·
·B·
·C·

SHOWN WITH DARK JOINTS (PENCILLED)

SHOWN WITH LIGHT JOINTS (RULED WITH OPAQUE)

PENCILLED JOINTS (EDGES HIGHLIGHTED WITH BRUSH)

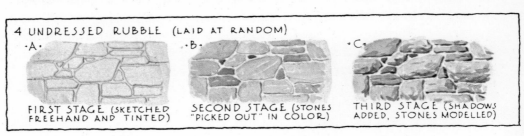

4 UNDRESSED RUBBLE (LAID AT RANDOM)
·A·
·B·
·C·

FIRST STAGE (SKETCHED FREEHAND AND TINTED)

SECOND STAGE (STONES "PICKED OUT" IN COLOR)

THIRD STAGE (SHADOWS ADDED, STONES MODELLED)

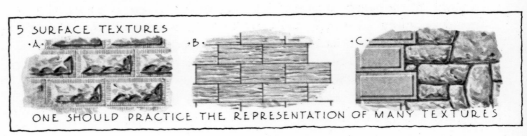

5 SURFACE TEXTURES
·A·
·B·
·C·

ONE SHOULD PRACTICE THE REPRESENTATION OF MANY TEXTURES

STONEWORK *Master these details one at a time. You should be able to render stonework in detail. When you paint from a distance you'll be more able to render these forms in suggestion.*

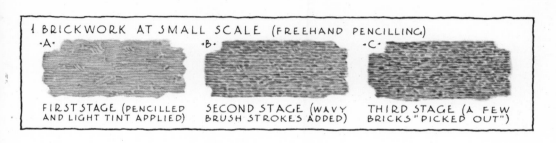

1 BRICKWORK AT SMALL SCALE (FREEHAND PENCILLING)

·A·

·B·

·C·

FIRST STAGE (PENCILLED AND LIGHT TINT APPLIED)

SECOND STAGE (WAVY BRUSH STROKES ADDED)

THIRD STAGE (A FEW BRICKS "PICKED OUT")

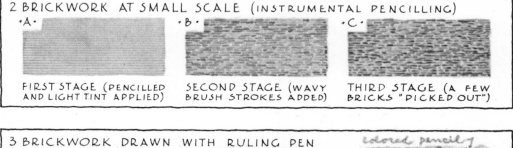

2 BRICKWORK AT SMALL SCALE (INSTRUMENTAL PENCILLING)

·A·

·B·

·C·

FIRST STAGE (PENCILLED AND LIGHT TINT APPLIED)

SECOND STAGE (WAVY BRUSH STROKES ADDED)

THIRD STAGE (A FEW BRICKS "PICKED OUT")

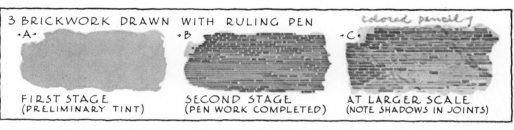

3 BRICKWORK DRAWN WITH RULING PEN

·A·

·B

colored pencil

·C·

FIRST STAGE (PRELIMINARY TINT)

SECOND STAGE (PEN WORK COMPLETED)

AT LARGER SCALE (NOTE SHADOWS IN JOINTS)

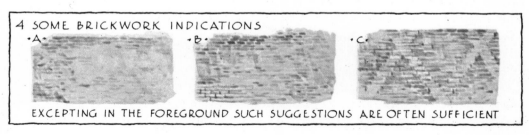

4 SOME BRICKWORK INDICATIONS

·A·

·B·

·C·

EXCEPTING IN THE FOREGROUND SUCH SUGGESTIONS ARE OFTEN SUFFICIENT

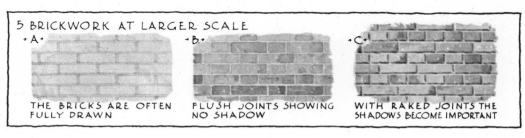

5 BRICKWORK AT LARGER SCALE

·A·

·B·

·C·

THE BRICKS ARE OFTEN FULLY DRAWN

FLUSH JOINTS SHOWING NO SHADOW

WITH RAKED JOINTS THE SHADOWS BECOME IMPORTANT

BRICKWORK *There are variations even on things as straightforward as bricks.*

Chapter 19

PAINTING
BUILDINGS

BUILDINGS HAVE ALWAYS been a favorite subject for watercolor painters. Buildings have personalities: cathedrals, run-down barns, covered bridges, castles, skyscrapers, lobster shacks each convey a different character. Buildings require skill and practice: take your sketchbook with you and use it whenever you find opportunities.

LARGE BUILDINGS

Many amateur painters shun large buildings because they think large buildings are difficult to paint. Actually, large buildings are often easier than other types. The mere fact that they have to be reduced to drawing paper size forces you to eliminate or simplify a vast amount of detail. The masses of most large buildings today are simple and block-like. And their surroundings are customarily so small in scale that they require little accurate representation.

Not that these buildings don't require patience, for they do. But they are easier in relation to other structures than many believe. Possibly the thing requiring the most skill is choosing a station point. Too frequently this is taken so close that upper stories are thrown into extremely acute perspective, the effect being unnatural. Small scale preliminaries should be made to determine the best station point, angle of view, height of eye, etc., ample distance being allowed from spectator to subject. The same prelim-

inaries, rendered a bit, can help you decide on such things as the proper direction of lighting, general composition, and color scheme.

BUILDING DETAILS

In this chapter we briefly discuss the handling, in transparent watercolor pigments, of such materials as stone, brick, stucco, etc., along with such portions of buildings as chimneys, roofs, and windows. Subjects of this nature afford a splendid starting point: it would be an excellent plan to experiment with them before attempting to paint complete structures. I sincerely advise you to concentrate for a while on indicating all the common building materials and details as they appear in different structures under varying lighting conditions.

STONEWORK

Stonework varies to such an extent in kind, finish, manner of laying, etc., that we shall not attempt to cover the field thoroughly. *A* and *B*, Sketch 1, of our color reproduction on page 180, are self-explanatory. At *C* a pale tint was run over the penciling, after which the stones were rendered individually, light edges being left toward the sun. The joints in shadow were strengthened in pencil. The light joints in Sketch 2 (*B*) were ruled with the pen, over pencil lines, in Chinese white slightly tinted with yellow. The same pigment was used for the highlights at *C*. The pencil was employed for the dark rulings at *A* and *B*, while at *C* the shadows were ruled with gray-violet watercolor before the white was applied. At 3 (*B*) the tiny darks of the joints were done with a sharp, hard pencil after the whites were ruled with the pen. Sketch 4 explains itself, while Sketch 5 is included mainly to show that you should experiment with many effects in order to realize fully how diversified such appearances can be.

A problem often encountered, especially when dealing with interiors, is the treatment of marble or other stonework having a veined or mottled character. The customary solution is to mingle either transparent or opaque pigments, or both, on moist paper. The veining is done with pencil, pen, or brush. When such stonework is highly polished, strong reflections are often mirrored in its surface. Observe actual materials like these to acquire hints on their treatment.

BRICKWORK

Like stonework, brickwork varies greatly in effect according to the size, shape, color, and texture of the bricks, the manner of laying, the angle from

FIRST STAGE
PENCILLED AND TINTED

SECOND STAGE
SHADOWS AND DETAIL ADDED

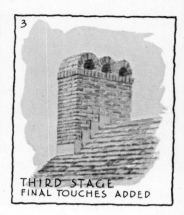

THIRD STAGE
FINAL TOUCHES ADDED

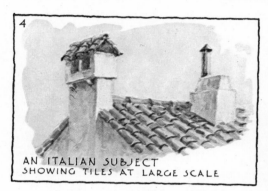

AN ITALIAN SUBJECT
SHOWING TILES AT LARGE SCALE

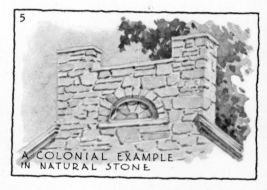

A COLONIAL EXAMPLE
IN NATURAL STONE

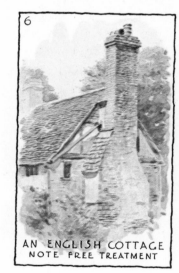

AN ENGLISH COTTAGE
NOTE FREE TREATMENT

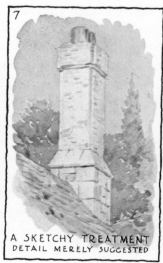

A SKETCHY TREATMENT
DETAIL MERELY SUGGESTED

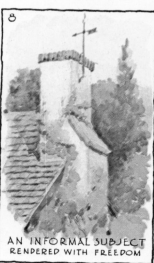

AN INFORMAL SUBJECT
RENDERED WITH FREEDOM

CHIMNEYS *Have you noticed how many different kinds of chimneys there are? Notice also the way the skies and trees have been treated differently to harmonize with each scheme.*

184

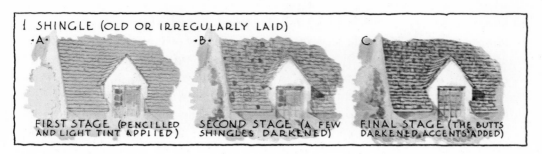

1 SHINGLE (OLD OR IRREGULARLY LAID)

·A· FIRST STAGE (PENCILLED AND LIGHT TINT APPLIED)

·B· SECOND STAGE (A FEW SHINGLES DARKENED)

·C· FINAL STAGE (THE BUTTS DARKENED, ACCENTS ADDED)

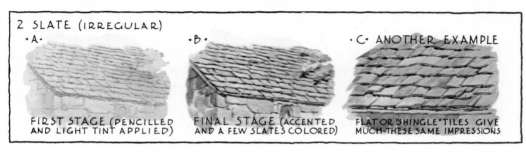

2 SLATE (IRREGULAR)

·A· FIRST STAGE (PENCILLED AND LIGHT TINT APPLIED)

·B· FINAL STAGE (ACCENTED AND A FEW SLATES COLORED)

·C· ANOTHER EXAMPLE
FLAT OR "SHINGLE" TILES GIVE MUCH THESE SAME IMPRESSIONS

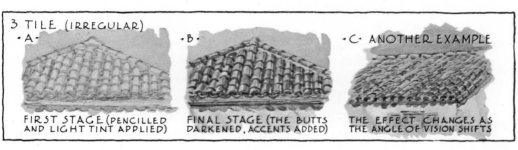

3 TILE (IRREGULAR)

·A· FIRST STAGE (PENCILLED AND LIGHT TINT APPLIED)

·B· FINAL STAGE (THE BUTTS DARKENED, ACCENTS ADDED)

·C· ANOTHER EXAMPLE
THE EFFECT CHANGES AS THE ANGLE OF VISION SHIFTS

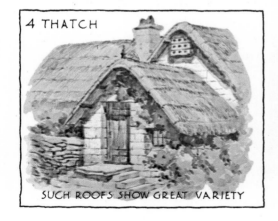

4 THATCH

SUCH ROOFS SHOW GREAT VARIETY

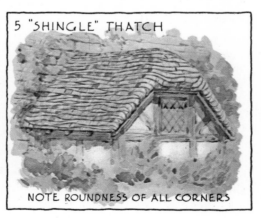

5 "SHINGLE" THATCH

NOTE ROUNDNESS OF ALL CORNERS

ROOFS *Roofing materials take time but present no great difficulties.*

which viewed, the direction of light, etc. The kind of joint and mortar also makes a decided difference. Actual brickwork is perhaps the best teacher of appearances. The scale of your drawing has much to do with the method of rendering. Customarily it would not be possible, even if desirable, to represent all the brick courses of a building at correct scale, so it is the common practice to indicate brickwork in a somewhat suggestive manner, trying to give an impression of the whole rather than exact courses or separate bricks. Yet there are no rules. In Sketch 1 of the color reproduction on page 181, we have a typical small scale indication of brickwork of somewhat rough texture. It is generally a mistake to make the mortar joints in brickwork indications too light; they will attract too much attention. On the other hand, if you pencil in brickwork, don't make the marks too dark (especially if the bricks are meant to be light), or it may gray and muddy the effect. Colored pencils are sometimes substituted for the black as a preventative.

At 2, we have instrumental penciling instead of the freehand: on large paper areas this is usually more rapid and is often better, too, where brick surfaces are smooth and uniform.

Sketch 3 pictures a method quite popular, the ruling pen having replaced the brush. At C, a colored pencil was dragged over the surface to kill the mechanical effect; also a few shadows were penciled. Ruled indications are less practical where there is sharp perspective convergence.

Often wash alone (generally of deposing type) is sufficient for the brickwork. Again, free suggestions like those at 4, on page 181, are the best. Numbers 6 and 7, on page 184, show similar suggestions.

You may work at large scale and find these suggestive treatments insufficient. It may even prove necessary to draw individual bricks as at 5, page 181, and 3, page 184. In still another method, almost too mechanical and conspicuous, the whole surface is washed with a bricky hue and the joints are ruled in opaque white.

CONCRETE AND STUCCO

Concrete and stucco, when plain, are comparatively easy to represent. You only catch the correct value and hue for each area and give a bit of suggestion of its granular surface. When large areas seem too uniform they can be developed texturally (perhaps with sandpaper, or some of the sediment washes), or broken with tree or cloud shadows, etc.

CLAPBOARDS AND SHINGLES (WALLS)

Walls are also quite simple. When light, their treatment is much like that of stucco, with the addition of lines to represent the butts or shadows of

the courses. These lines may be freehand or instrumental, and in pencil, paint, or ink. If correctly spaced and converged, they will go a long way in themselves toward producing a satisfactory effect. When walls are shingled, it is seldom advisable to emphasize the vertical joint lines. We shall speak of shingled roofs in a moment.

OTHER BUILDING MATERIALS

Since the building details we discuss next involve representations of slate, window, glass, etc., we shall give such things no further attention just now except to advise the reader to experiment with them for himself.

CHIMNEYS

Sketches 1, 2, and 3, on the color reproduction, page 184, demonstrate in progressive stages a method of representing brick (and roof shingles) at comparatively large scale. Let us point out again that although occasionally you may want to render each individual brick, it is not as pleasing. A sketchy treatment, as pictured in 7, is generally more pleasing. A brick treatment, such as we picture at 6, in which the freehand pencil line plays quite a part, is also pleasing when the subject will permit it. Free treatments are often advisable in the case of stone chimneys, too. Sketches 4 and 8, page 184, present plaster chimneys, the former very rough. Note the tile.

Not the least interesting thing about the sketches on page 184 is the variation of hue in the skies and trees.

ROOFS

The color reproduction on page 185 shows plainly that roofs do not all look alike. The sketches are mainly self-explanatory. For shingle and slate (unless the latter is very rough) one general treatment will ordinarily do, though slate usually is laid in wider courses.

Most manufactured shingles, especially if thin, have so little esthetic character that the painter often tricks them up a bit, destroying their offensive mechanical regularity.

WINDOWS

There is no one common detail which requires so much care in delineation as the window. Certainly there is no other detail which offers equal variety in appearance. The best way in which the student can come to a full realization of this is by studying actual windows as he sees them all about him.

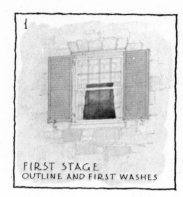

FIRST STAGE
OUTLINE AND FIRST WASHES

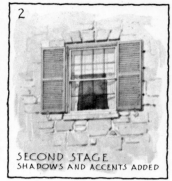

SECOND STAGE
SHADOWS AND ACCENTS ADDED

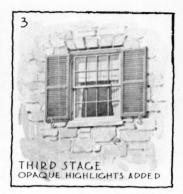

THIRD STAGE
OPAQUE HIGHLIGHTS ADDED

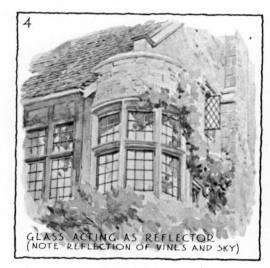

GLASS ACTING AS REFLECTOR
(NOTE REFLECTION OF VINES AND SKY)

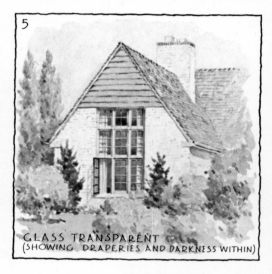

GLASS TRANSPARENT
(SHOWING DRAPERIES AND DARKNESS WITHIN)

AN OPEN WINDOW
IS OFTEN INTERESTING

VINES AND FLOWERS
MAY BE EMPLOYED

AWNINGS OFFER A
CHANCE FOR COLOR

WINDOWS *Sometimes glass seems transparent, other times glass acts as a mirror. Avoid painting windows as though they were holes in the building.*

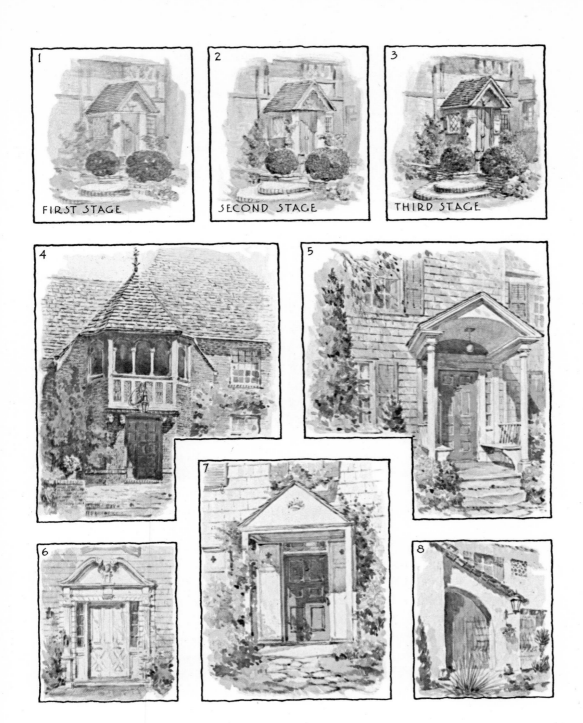

FIRST STAGE

SECOND STAGE

THIRD STAGE

DOORWAYS *When you paint doorways you follow the same principles you have been using all along.*

189

Not only do they differ in form and character, but the glass is responsible for an astonishing diversity of effects. Sometimes it is invisible, or practically so, and the window could be indicated as though the sashes were unglazed, the shades, draperies, and the like showing plainly. Again, the glass catches the light in such a way that it is impossible to see through it; instead it acts as a mirror, reflecting the sky, buildings, people, etc. These two conditions we see illustrated in Sketches 3 and 4, page 188. The former was painted as though there were no glass: the latter exhibits a reflection of the sky, vines, and roof overhang.

Frequently the qualities of transparency and reflecting capacity are combined, even in a single window, and in the case of a vertical range of windows, as in a tall building. Windows near the top of a tall building, especially if on the shade side, frequently reflect the sky and so can be painted blue, the detail within being invisible. Yet they must not be rendered to look like holes through the building, as they may if they exactly match the sky. Windows nearer the street often reflect buildings opposite, and so appear warmer. Or they lose their reflective quality and permit clear view of whatever is behind them. Window reveals should not be drawn too deep; it is easy to forget their correct scale. Remember that in many modern buildings the glass is scarcely back of the plane of the outside wall. Much depends on direction of light and the angle from which the glass is viewed.

The sketches on page 188 require little explanation. Those at 1, 2, and 3 demonstrate progressively one kind of method to use. Note the careful penciling at 1, the darks added at 2 with both brush and ruling pen, and the final ruling at 3 of opaque white (slightly yellowed) for the sash bars. Shadows are highly important in such work. Here the light was from the left, above. Note the sash shadows on the shades and curtains. In Sketches 3 and 6 the tone within the room contains some dull orange: this gives a feeling of depth and transparency. The open casements in the latter sketch reveal a bluish glass hue, yet we can see through the glass.

It is not wise to finish one window (or any similar detail) completely, then to go to the next. Rather, it is better to perform a single operation on every window in turn, then another operation, and so on—thus saving time and securing uniformity of effect. The ruling pen highlights can be added last—a fair amount of pigment must be mixed to a creamy consistency: the pen will require frequent wiping.

DOORWAYS

Though doors and doorways are always prominent features when you paint buildings, often forming centers of interest, they involve the same principles already discussed. Study the color page, 189.

SHADOWS

We spoke of the importance of correct shadow representation. Perhaps there is no single thing more subject to dispute than methods of treating shadows, particularly in relation to hue. When painting shadows, some artists use dark values of the normal hues of the surfaces on which the shadows fall, maintaining that this is logical, because shadow is merely absence of light. If, for instance, you want to paint a shadow on a brick and timber wall, as at 4, page 192, you would paint it like the wall in light, only darker. This was the method actually followed here. Other artists make their shadows more blue or violet, arguing that areas of a given surface in shadow often appear to an extent complementary to areas in light, due mainly to simultaneous contrast. This is also logical, for it is certainly true that where blue or violet are used in shadows, adjacent areas in light generally appear all the brighter because of the complementary contrast. We see indications of cool color in the shadows of Sketches 6, 7, 8, and 9, page 192, illustrating this point. Regardless of color, the sharper the shadow against the light, even when exaggerated by sudden gradation as at 5, the brighter that light will appear.

SHADOW VALUES AND SHAPES

It is not only the hues of shadows that are important: their values must be right. Read the notes on Sketches 2 and 3.

In earlier chapters we spoke of the way shadows reveal the form on which they fall and also reveal the form which casts them. Sketch 1 gives us examples of this. The shadow on the door helps us to judge not only the angle at which the door is open, but the relief of the panels. From the triangular shadow beneath the shutter we know it is not parallel with the wall. The shadows of the steps emphasize their shape and projection.

REFLECTED LIGHT

Practically all shadows are affected more or less by light (or color) reflected into them. This shows plainly in 6, 7, and 8, page 192, with their light soffits, made so by the light thrown from below. Often such reflection is strong enough to cast reversed shadows: see those of the mutules, 5 and 8.

Exercise 51: Representing Buildings
Practice sketching the buildings around you or paint buildings from photographs. Try to render the details—stonework, windows, chimneys, roof—in the manner proposed in this book. If you can master the technique of painting these details, you will have come a long way!

191

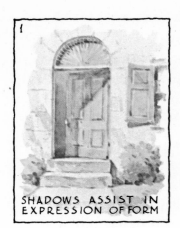

SHADOWS ASSIST IN EXPRESSION OF FORM

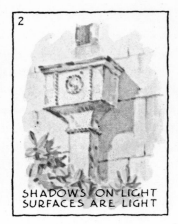

SHADOWS ON LIGHT SURFACES ARE LIGHT

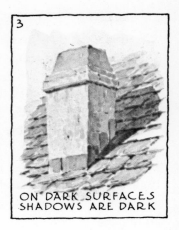

ON DARK SURFACES SHADOWS ARE DARK

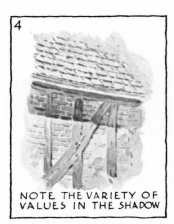

NOTE THE VARIETY OF VALUES IN THE SHADOW

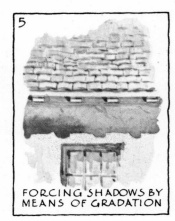

FORCING SHADOWS BY MEANS OF GRADATION

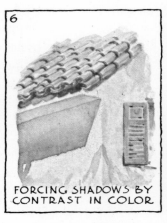

FORCING SHADOWS BY CONTRAST IN COLOR

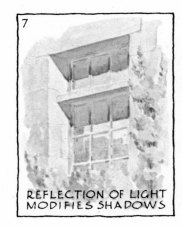

REFLECTION OF LIGHT MODIFIES SHADOWS

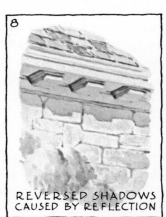

REVERSED SHADOWS CAUSED BY REFLECTION

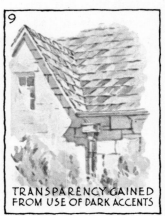

TRANSPARENCY GAINED FROM USE OF DARK ACCENTS

SHADOWS *Shadows are highly important regardless of whether you are doing small or large work. Not only do they suggest sunlight, but they express form.*

192

Chapter 20

SKIES AND
CLOUDS

WE HAVE OFTEN SPOKEN of the fact that the artist can represent at best only inadequately and incompletely many of the things which nature shows him. The artist is constantly forced to suggest or interpret. This is particularly true of skies. It is impossible to paint them as we see them. Even the clear, cloudless sky has qualities which baffle us. Not only is it often brilliant and luminous and, to a degree, fairly dazzling, but it has a vague, indeterminate character, great depth and transparency, and an indescribable quality of scintillation. Cloudy skies add to our problems, for there are clouds of many types, exhibiting all sorts of shapes, values, hues, and kinds of edge. And none of these are constant: clouds form, move, re-form, and perhaps disappear before our very eyes, and often with bewildering rapidity. And then come sunrises and sunsets and moonlight! Try these if you want to understand the limitations of the artist!

Paradoxically, this needn't worry the beginner much, for the human eye seems quite well satisfied with the interpretations the artist offers. If you have learned to run flat and graded washes with a fair degree of skill, you can produce reasonably good effects of cloudless skies right at the start. Your greatest fault, perhaps, is that your washes often show conspicuous blemishes. Again, your skies appear to be solid, vertical objects, like backdrops for a stage. A sky is far from solid, and if we think of it having definite form at all, it is domical rather than flat, giving the impression of starting way below the horizon, curving upward to the zenith and from

there out of sight. The beginner soon learns which of his pigments and papers are best suited to obtaining this effect.

It is undoubtedly better, at first, to paint simple skies, rather than to paint terrible clouds which so often ruin the beginner's early work. Some of these appear to be cut from paper or made from wads of cotton; others look like huge balls or eggs. Some seem solid and heavy, like stones. Obviously, even the darkest cloud, to be successful, should be represented in such a way that the spectator feels that a solid object, such as an airplane, could easily pass through it.

Skies, especially towards the horizon, are seldom as blue as the beginner believes. Not only are they comparatively light but they vary decidedly in color; sometimes they are greenish, yellowish, or pinkish; again they lean toward violet or red. Approaching the zenith they show somewhat less diversity because of the relatively purer atmosphere, yet even here one finds great differences.

If only the portion of a sky toward the horizon is shown, it need by no means be graded. If one includes larger areas of sky, however, it is almost invariably better to attempt to express, through grades, a dome-like form. Occasionally one imitates a somewhat less common aspect of nature, making the sky light towards the zenith and darker below. So varied are nature's effects, in fact, that you will soon learn to select the one best suited to your particular purpose.

TEXTURE

Artists have long sought means of interpreting something of the atmospheric scintillation or vibration of skies, which a perfectly plain wash, no matter how clear and smooth, fails to suggest.

Although sediment washes, stippling, and similar methods are successful, not only in catching something of the atmospheric spirit desired, but also in leading interest into otherwise barren portions of compositions, it is extremely easy to develop over-conspicuous textures which make skies seem painty things near at hand, the intended purpose being defeated.

Exercise 52: Sky Textures
To clinch some of these points, make a number of little sky studies showing various textures. Try making a sky by stippling, using a sediment wash, even using opaque pigment, to see how many effects you can obtain.

Exercise 53: Cloudy Skies

The best way to gain mastery over cloudy skies is by painting them over and over directly from nature. You can advantageously scrutinize paintings by other artists, too, perhaps copying particularly effective bits here and there. Possibly the easiest type, contrary to general belief, is that suggested at 1, of our color reproduction on page 196, for this is nothing but a mingling of colors dropped onto moist paper and allowed to spread. This was done with French blue and rose madder over a foundation wash of yellow ochre. Try some of these.

MINGLINGS ON MINGLINGS

We should perhaps make clear that when the desired effect is not obtained in a single mingling, it is sometimes best to allow it to dry, later superposing one mingling on another. Often in the second mingling nothing is attempted but the modeling of the clouds. Occasionally the foundation mingling is scrubbed a bit before the other is added.

GLYCERINE AND ALCOHOL

When washes tend to dry too rapidly, as in large skies, ten or fifteen drops of glycerine to each cupful of mixing water will serve as a preventative. Contrarily, if drying is annoyingly slow, it can be somewhat accelerated by adding a small quantity of alcohol to the water.

Exercise 54: Erased Clouds

At 2, page 196, we have clouds created by erasure. The background grade was run with a mixture of Antwerp blue and alizarin crimson, a bit of aureolin yellow being added towards the horizon. When dry, an ordinary red eraser was employed. No shield was used. Smoke, rays of light, and similar hazy effects can be indicated by this means. Experiment with it.

DIRECT HANDLING

Somewhat more difficult to manage are clouds of a clean-cut nature such as those suggested by Sketch 3, page 196. It is usually best to sketch their shapes very delicately in pencil. Then a pale wash, perhaps of yellow, is applied over the entire sky, clouds and all, for clouds are seldom pure white. When dry, the main sky washes are run, the cloud areas being left plain. Eventually they are modeled through washing or mingling, the direction

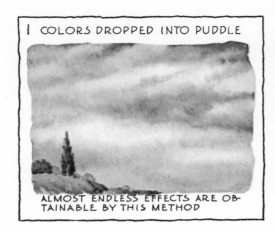

1 COLORS DROPPED INTO PUDDLE

ALMOST ENDLESS EFFECTS ARE OBTAINABLE BY THIS METHOD

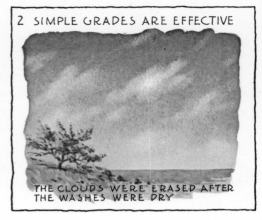

2 SIMPLE GRADES ARE EFFECTIVE

THE CLOUDS WERE ERASED AFTER THE WASHES WERE DRY

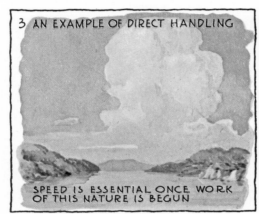

3 AN EXAMPLE OF DIRECT HANDLING

SPEED IS ESSENTIAL ONCE WORK OF THIS NATURE IS BEGUN

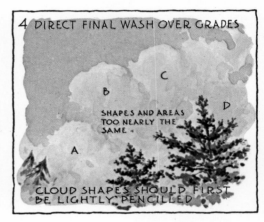

4 DIRECT FINAL WASH OVER GRADES

C
B
D
SHAPES AND AREAS TOO NEARLY THE SAME
A

CLOUD SHAPES SHOULD FIRST BE LIGHTLY PENCILLED

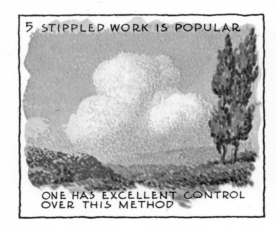

5 STIPPLED WORK IS POPULAR

ONE HAS EXCELLENT CONTROL OVER THIS METHOD

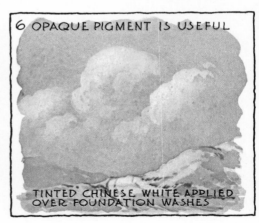

6 OPAQUE PIGMENT IS USEFUL

TINTED CHINESE WHITE APPLIED OVER FOUNDATION WASHES

CLOUD TREATMENTS *Here are six ways of handling sky and clouds. You will find it valuable to practice each method so that you can convey a variety of effects. Notice that the textures and hues of the sky and clouds vary with each treatment.*

196

of light being kept in mind. Sometimes sky and clouds are carried to completion together; this takes practice.

In working from clouds in nature, you will find that they fall into definite classes. It would pay to learn, from books on the subject, their names and characteristics. Clouds as a whole are not as round as the beginner thinks them to be: some can be bounded with lines which are practically straight. Even when of one class, they often show, at a single moment, astonishing divergence of form. No two areas seem alike. A common fault of the artist is failure to observe this point. See Sketch 4, on the facing page, where the several shapes, *A, B, C,* and *D* are too nearly the same. In seeking greater variety, one should strive to avoid shapes suggestive of the human face, animals' heads, etc.

There is a type of direct handling in which the cloud forms are not particularly definite. These representations are really a combination of wash work and mingling, and are done very freely.

Exercise 55: Direct Handling
Try all sorts of experiments in direct handling, turning preferably to nature.

Exercise 56: Stipple
In Exercise 52, we spoke of using stipple in cloudless skies. Now we advise you to build up cloud effects in stipple, somewhat on the order of that at 5, on the facing page. Use both transparent and opaque colors. In this instance, transparent pigments were opaqued by mixture with Chinese white.

Exercise 57: Opaque Effects
Sketch 6 shows another use of opaque color for cloud indication. The sky was first applied as a pair of superposed washes of transparent pigment, one of soft blue and the other of pale red-orange. When dry, the clouds were painted with Chinese white, tinted with Naples yellow. This mixture was gradually diluted as it advanced down the paper, permitting more and more of the undertone to show through. Try this scheme.

COMPOSITION

The artist, realizing the great variety of effects the sky presents, and knowing that exactly the same ones are seldom visible twice, takes advantage of this condition, especially in original compositions, by using the type of sky which best serves his purpose.

If you paint a building as a dark mass, you may want a contrast

Figure 112
SKY COMPOSITION *Light clouds form effective backgrounds for dark buildings.*

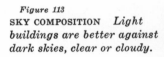

Figure 113
SKY COMPOSITION *Light buildings are better against dark skies, clear or cloudy.*

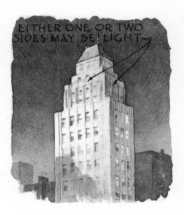

created by a light sky or clouds. Figure 112 was designed to illustrate this point. Figure 113 illustrates the opposite condition. When a building grades in tone, its upper portions dark and its lower parts light, as in Figure 114, the sky is often rendered in reverse gradation. By such methods, the sky is made to emphasize the building through contrast. Sometimes the opposition is more subtle: see Figure 115. Again, skies offer no great contrast with the rest of the subject but, in a measure, serve as an extension of it. You can make the sky, in color, texture, and pattern, a natural continuation of the all-over design formed by the subject matter beneath it.

On the other hand, you can do the opposite by bringing the sky very dark behind the light building (by means of one large wash with a settling mixture) but leaving it light behind the trees.

Figure 114
SKY COMPOSITION *Skies may be graded to give contrasts wherever desired.*

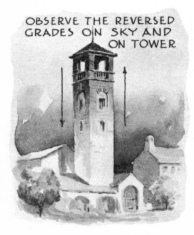

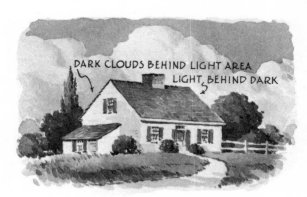

Figure 115
SKY COMPOSITION *There are endless applications of clouds as a means of obtaining contrast or increased interest.*

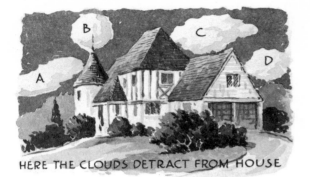

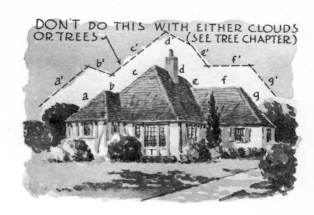

Figure 116
SKY COMPOSITION *Clouds should not be too round or placed as if they are rolling or sliding from roof tops.*

HERE THE CLOUDS DETRACT FROM HOUSE

DON'T DO THIS WITH EITHER CLOUDS OR TREES (SEE TREE CHAPTER)

Figure 117
SKY COMPOSITION *Be careful not to "parallel" roof lines with cloud edges in an obvious way.*

In Figure 116, we exaggerate common faults of the beginner, for here the clouds are too prominent and poorly related to the architecture. Figure 117 is self-explanatory; compare it with Figure 107.

Clouds and cloud shadows are sometimes useful in adding interest to barren subjects as exemplified by Figure 118.

The direction of cloud movement is a thing sometimes utilized by the artist. If the perspective lines of a subject converge too rapidly in one direction, for instance, he can arrange the cloud lines (or direction of movement) to take an opposite slant. In short, clouds can help or harm a drawing to a surprising extent according to the manner of employment.

SUNSETS AND SUNRISES

It is hard to write much of value about sunrises and sunsets: your success will depend largely on your powers of observation and retention. It is very difficult, in any medium, to obtain even a passable representation of the brilliancy of these dazzling effects, especially when one works directly from

Figure 118
SKY COMPOSITION *Now and then, even cloud shadows are valuable for breaking up large or uninteresting surfaces.*

199

the subject where astonishing changes take place momentarily. Watercolor is less amenable to this purpose than oil or pastel. The best watercolor method, perhaps (we are thinking particularly of sketching), is to make many small color notes, fresh and direct, selecting the most effective of these for final development. Even the final will probably possess more of the spirit of the subject if done swiftly, thus suggesting by its very handling the transitory character of the effect.

Not infrequently the artist turns his back to the setting sun, and pictures a subject flooded with its vivid rays.

Another method is painting only the upper portions of the structures lighted by sunset, the lower portions rendered in shadow. Sometimes it may be wise to avoid trying to catch the full brilliancy of a sunrise or sunset, waiting for the quieter mood of morning or evening to set in. The *afterglow* of light from a sunset may be more effective than the flaming sunset.

Chapter 21

STIPPLE, SPATTER, AND SPRAY

SKIES AND OTHER LARGE AREAS are so frequently rendered in stipple, spray, and spatter that it seems appropriate at this time to supplement our scattered remarks in earlier chapters with a few definite instructions on methods. These methods are not recommended as a conventional means of painting. However, it never hurts to experiment with unorthodox procedures. Who knows when you may need them?

STIPPLE

As to stipple, we have already had so much to say that we can now dispose of it with a word. We have seen that it consists of many tiny brush marks of either transparent or opaque pigment placed in juxtaposition. Though particularly popular for skies, entire drawings are often rendered by this means.

The beginner sometimes makes his first contact with stipple through trying to hide faults. A poor rendering in transparent color is often saved through this pointillistic work, done in opaque color, naturally a painstaking process.

Through stipple, one can combine a number of colors in a given area, which the eye will merge from a sufficient distance, or a single hue can be used. Quite a common method is to evenly distribute two or three analogous hues of about the same value.

Exercise 58: Stipple

Extend the stipple practice of Exercise 56 to all sorts of subjects. Stipple still life objects, outdoor objects, even abstract design to get a feeling for the method.

SPRAY

Spraying is more often done by the commercial artist than the painter, but it is a technique worth trying. If nothing else, it might save a painting you had given up for lost. Though far less easily controlled than stipple, and a bit less harmonious texturally, spray (brought into contrast with brush work) can usually be applied more rapidly, particularly where areas are large. It varies greatly in character according to the pigments chosen and the method of application. Generally, concentrated liquid watercolor is used for spraying. We have the extremely fine spray of the air brush, which shows almost no individual dots, and heavy sprays, commonly blown with some crude form of atomizer. Both transparent and opaque pigments are frequently employed.

Undoubtedly there is some justification for the objection, on the part of certain artists, to the use of spray, the customary claim being that it is too mechanical in appearance. Yet when the spray is fine, it can do a good job of suggesting such impressions as the vibration of atmosphere. And by its use, extremely brilliant and beautiful effects are obtainable.

Figure 119
AIR BRUSH *This model can be adjusted to spray both large and small areas.*

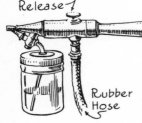

Release

Rubber Hose

THE AIR BRUSH

The air brush is the mechanical sprayer mainly used by the commercial artist. You might enjoy practicing with it. It works on the principle of the atomizer, the pigment being forced from a container through a spraying instrument by means of compressed air or gas. Such instruments vary greatly in size and character. For sky work, etc., a brush like that in Figure 119 is satisfactory, as it holds sufficient pigment to cover a fair sized sky and yet can be adjusted to produce a fine enough spray to be practical for much more limited areas. Some prefer a smaller brush more like that in Figure 120. My favorite brush is shown in Figure 121.

Figure 120
AIR BRUSH *This is one type of air brush, best suited to detail.*

Figure 121
AIR BRUSH *This is my favorite brush.*

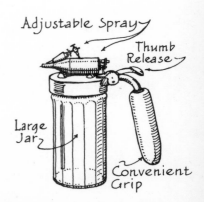

Adjustable Spray

Thumb Release

Large Jar

Convenient Grip

In addition to a brush or two, you need an air compressor and storage tank, or a drum of gas. Commercial art studios frequently have an electric compressor providing sufficient pressure to operate a number of brushes at a time. There are also portable outfits which are pumped by hand. In the cities it is common to substitute carbonic gas for the compressed air. You do not need a compressor since the gas is available in drums similar to those used in soda fountains, a single drum often lasting for months; when empty, it is replaced with a full one. The brush is connected to the tank by a small hose. The pressure can be easily controlled.

ATOMIZER

As an air brush outfit is relatively expensive, students usually seek substitutes. The mouth atomizer used for fixatif is sometimes employed (see Figure 122); with patience it produces fair results. Medical and perfume atomizers with bulb attachments, paint and insecticide sprayers, etc., often do very well. Though some of these throw a coarser spray than the air brush, this is not always a disadvantage: coarse sprays of two or more colors, blown separately, can be extremely effective.

MASK OR STENCIL

Whatever sprayer is selected, a way must be found to shield portions of a drawing from the spray. Usually one or more paper masks are made.

In describing these, perhaps it is wise to explain the entire spraying procedure. Let us take that of the architectural renderer working with an air brush as typical. His drawing is commonly laid out instrumentally in pencil with the greatest accuracy, even the shadows being cast. The paper must be absolutely clean before any spraying is undertaken. Not only is the eraser called into service for this cleaning, but the renderer follows it with a wash of water, perhaps slightly tinted (a bit of yellow is common), over the entire paper. This tends to restore the surface and "fixes" the pencil lines. If there are any areas where this water does not "take," they are suspected as danger spots, possibly a bit oily from the hands, and receive extra scrubbing. It is claimed that shiny papers can be advantageously rubbed, when dry, with whiting or powdered chalk, which insures adhesion of the spray. Next he lays his board flat, or nearly so, and covers it with a sheet of heavy tracing paper pulled tight and thumbtacked around the edges. The more impervious the tracing paper is to moisture the better, the oily or waxy types being good. (Art supply dealers offer a special paper for masking drawings, called *frisket paper*, and they can explain its use.) With

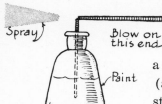

Spray

Blow on
this end

Paint

Figure 122
ATOMIZER *This
gives a coarse spray
which can be effec-
tive. The result
looks very much like
spatter.*

a razor blade, the renderer cuts the paper along the profile of the building (and perhaps the trees) and around the margins bounding the sky, next stripping off the tracing paper from the sky, leaving it exposed. He then surrounds this area with strips of stencil board three or four inches wide as additional protection to the tracing paper covered drawing, bringing them as close to the opening as possible. Newspapers are now brought up to overlap these strips.

In other words, every reasonable precaution is taken to protect all but the exposed sky from the spray. It is even necessary to weigh down these papers and strips to keep the spray from penetrating beneath them. Sheet lead, cut into various shapes, is useful here. If parts of the tracing paper mask are so small that they curl, stick them down with rubber cement; no cement should be left where spray is to be used.

RUBBER CEMENT

If the profile of a building shows intricate details—finials, tracery, flag-poles, etc.—it is often easier to paint them with a couple coats of rubber cement than to protect them with paper masks. The cement can readily be rolled away with the finger when the spraying is completed.

While on this point, we should perhaps mention that even in free water-color sketching some artists use cement in much this same manner, perhaps painting birch trunks, flagpoles, masts, or things of that sort. The washes are then carried over the whole, cement and all: when dry, the cement is rolled away, revealing the white paper. This method is somewhat crudely illustrated by Figure 123 where the words were painted in cement, a gray wash superposed, and the cement rubbed off with the finger. Rubber cement can be thinned with naphtha or benzol to the proper consistency for brush application.

THE PIGMENT

Though colors especially made for the air brush are available, ordinary watercolors, mixed the same way as they are mixed for washes, do very well. Sometimes they are thickened with opaque pigment to increase their covering capacity: if too thick, they may clog the brush.

Figure 123
RUBBER CEMENT *Rather than using a mask,
you might try this method: with the cement,
cover the area you want to protect from
your wash; then carry your wash over the
whole, including the cemented area. Roll
away the protective cement later.*

This is advanced according to the printed directions accompanying the brush. With a bit of practice, the artist learns the best air pressure, needle adjustment, distance, and angle. The artist generally works standing, because this enables him to swing the brush back and forth steadily, so as to build a uniform tone: if it is held still, even for a moment, a spot darker than the rest may be formed.

If you blow too coarse a spray, hold the brush too close to the paper, or spray the same area too long, the minute drops of pigment on the paper may unite to produce an unpleasant mottled effect. It is advisable to interrupt the spraying frequently to permit drying.

You can blow a dark tone from comparatively light pigment (though there is little point in doing so) : it is all a matter of patience. And if your first color is not quite to your liking, you can blow another over it, blending the two. Brilliant effects of great beauty can be obtained in this manner. Grades can be blown as easily as flat tones. In a sky such as we have been considering, it is common practice to use very little pigment at the horizon, deepening the tone gradually towards the zenith. Antwerp blue makes a good sky for the typical problem, modified, perhaps, with French blue or cobalt above and a bit of aureolin yellow below.

In order to judge the hue of any area during the spraying process, it is advisable to hold a piece of white paper against it now and then for comparison. Unless this is done, the final tone, when the protection is removed, is almost certain to be surprisingly dark.

When your sky is finished, the protective materials are removed, care being taken not to touch any of them to the sky as they may be wet underneath with spray. Air brush work is easily damaged and hard to repair.

CLOUDS

A simple means of producing clouds in air brush skies is by using the eraser, picking out a few light ones here and there in a flat or graded sky as at 2, page 196. These can then be modeled, if desired, by means of the fine air brush.

There is another, rather tricky method to air brush skies. Here, as soon as the building is masked, the entire sky is sprayed with a light blue, very faint towards the horizon. The board is kept flat. When dry, fine sand is carefully sprinkled where the clouds are wanted: it takes a bit of practice to learn to do this advantageously, as effects must be judged in reverse. For the lightest clouds the sand must be piled so thick that no spray can

penetrate: for vaporous ones a scattering will do. I apply my sand by means of an ordinary envelope, tearing a small hole in one corner through which it is sifted. It is best not to change the location of the sand once it is on the paper, with your finger or brush, as any attempts to do so are quite certain to be evident after the sky is blown. Therefore, if it is not well distributed the first time, brush it off and try again.

Next spray the sand lightly with water to dampen it and so hold it in position, then advance your coloring much as though the sand were not there. Be careful not to blow it off, however. The work must be interrupted several times to permit drying: if not, pigment may puddle under grains of sand, causing unsightly spots which only careful hand stippling can overcome.

With the sky dark enough, and dry, the sand is brushed off and preserved for another time. A small air brush is next used, as a rule, for modeling the clouds a bit, though sometimes careful highlighting with the eraser here and there through the original blue spray completes the work with absolute satisfaction.

When the protective masks, etc., have been removed, and the rest of his rendering has been completed in the customary way, the artist commonly turns to his air brush again in order to bring some of the portions not in air brush into closer harmony, texturally, with the sky. Sometimes a cardboard reversed silhouette, cut to the shape of building or tree shadows, is laid over the lower portion of the drawing and the foreground blown with shadowy hues. The cutout can be held above the paper a half inch or so, making a soft edge possible.

Rarely are entire paintings done with the air brush because so many masks are required.

There are numerous other uses of spray which you will gradually discover. Sometimes an entire drawing, if too dark, is given an extremely fine spray of some light pigment, generally opaque. Foggy effects can be

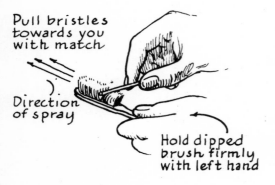

Pull bristles towards you with match

Direction of spray

Hold dipped brush firmly with left hand

Figure 124
SPATTER *Using a match and brush is one way to spatter paint.*

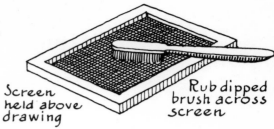

SPATTER *Screen and brush
give a greater control of the
spatter.*

Screen
held above
drawing

Rub dipped
brush across
screen

obtained in the same manner. Coarser sprays, or spatter, are splendid for snow effects. An ordinary fixatif blower will be quite suitable for this sort of thing.

SPATTER

If you have no instrument at hand suitable for spraying, or if you prefer a somewhat coarser result, spatter may serve your purpose. As in spraying, you commonly protect at least a part of your paper. The board is usually kept flat or nearly so. An easy way of applying the spatter is illustrated in Figure 124. The biggest objection to this method is that the brush must be dipped repeatedly. Again, over-large drops may be thrown on the paper. Better control can be obtained by means of a screen, see Figure 125. We have already pointed to Figure 122, which shows the mouth atomizer: much of the spraying done with this resembles spatter work.

Occasionally, you can use spray or spatter to overcome poor washes. Sometimes, as on skies, black ink is selected for this.

Exercise 59: Spatter and Spray
Try some spatter and spray to see what effects you can obtain with these devices.

Chapter 22

THE TREATMENT
OF REFLECTIONS

WHEN YOU PAINT OUTDOORS—and even indoors—you will constantly en-
counter the problem of reflections. They can be very perplexing problems
to the beginner and so, we hope, this chapter may help overcome some
major obstacles.

HORIZONTAL PLANES

First let us consider reflections in horizontal planes—reflections we see in
wet streets, shiny floors, glass table tops, etc. Our immediate concern is
with the correct construction of these. Not only are their shapes fully as
important as their values or hues, but they are more subject to rule. We
shall concentrate mainly on simple geometric solids: the principles involved
apply to many objects.

At *A,* Figure 126, is a cube seen below the eye, supported by a shiny
horizontal plane. As normally viewed, such an object reflects its own image,
inverted. In other words, if we drew a second cube below the first, properly
constructed according to the laws of perspective, it would serve as the
reflection of the first. Line 1' would be equal in length to line 1, 2' to 2, and
3' to 3. By connecting the lower ends of lines 1' and 2', we could complete
plane x', the reflection of x.

At *B,* the cube has been raised by a distance equal to line 2. In this
case line 1, the front corner, still reflects its own length at 1', but this re-
flection appears as far below the horizontal reflecting plane as the line

208

itself is above it, line 2′ equaling line 2. In other words, if we lifted the cube an inch above the plane, its reflection would drop to an inch below it. Plane *P* shows the original position of the cube. In laying out this diagram, this was the first thing drawn, perspectively equal lines then being measured off above and below. It is interesting to observe that the top of the solid does not reflect in either Sketch *A* or Sketch *B,* but in the latter the bottom does, and, since it is in shadow, its reflection is very dark.

At *C* we illustrate an extension of the truth expressed at *A,* for here we simulate a building by means of a triangular prism resting on a square prism in turn supported by a flat reflecting plane. As in the previous examples, every vertical line, including the gable lines, 1 and 4, reflects its own length, by actual measurement. As a result of the position of these objects below the eye, however, line *d* automatically (through perspective foreshortening) reflects at *d′* as a shorter line, line *f* following the same law; line *e,* contrarily, reflects at *e′* as a longer line. The entire plane *a* shows a comparatively narrow reflection *b.* As in the case of the first cube, the reflection of the building is drawn exactly as the building would appear if inverted, with its base occupying its original position.

In Sketch *D* the building is raised as was the cube at *B.* Again, as the object was brought above the reflecting plane, its reflection dropped an equal distance below it. Plane *c* is even narrower than was *b* in the previous example, because further below the eye.

Exercise 60: Laws of Reflection
You can learn much about such reflections through experimenting with actual objects placed on, or held above, a horizontal glass mirror. Better yet, use as a reflector a flat piece of plated metal, or other highly polished material, for the ordinary mirror sometimes shows double reflections which prove confusing, one caused by the surface of the glass and the other by the silvered coating on the back.

Figures 127 and 128 illustrate pictorially the application of the laws of reflection. Here the water is calm. The values of the reflection have been shown slightly darker than the surfaces reflected, this representing normal

Figure 126
LAWS OF REFLECTION
Carefully study this illustration and the text to learn these fundamental laws.

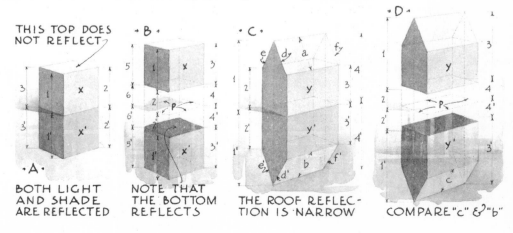

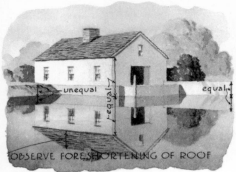

Figure 127
APPLYING THE LAWS *Compare this drawing with A and C in Figure 126. Notice that the water is calm and also that the values in the reflection are darker than those in the object casting the reflection.*

Figure 128
APPLYING THE LAWS *Compare this drawing with B and D in Figure 126. The water is slightly agitated.*

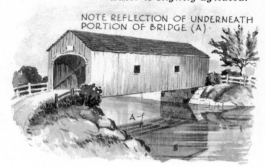

appearances. The horizontal brush marks in the reflection in Figure 128 help to suggest the slightly restless water. Observe here that the bridge is so viewed that its roof barely reflects; however, the floor framing, invisible in the bridge itself, reflects at *A*.

REFLECTIVE SURFACES, NOT PLANE

Figure 129 shows us some truths about the reflection of vertical cylinders, at the same time demonstrating that the shape, size, and character of a reflection depend in no small measure on the reflecting surface. In other words, reflections vary with changes in the reflecting surface. At *A*, this surface is level and smooth, and, as in our previous examples, the metal buoy exhibits a reflection practically like the object itself inverted. At *B* the water is in motion enough to make its surface somewhat like a slightly corrugated mirror, the reflection now becoming not only deformed and elongated, but broken here and there where areas are so turned that they fail to mirror the object. Furthermore, the reflection is constantly changing

Figure 129
REFLECTING SURFACES *Here a cylindrical form is being reflected. Notice that reflections vary with changes in the reflecting surface.*

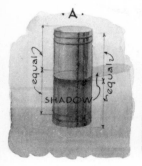
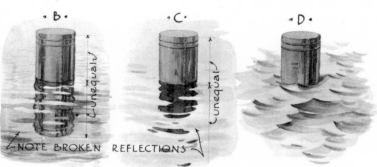

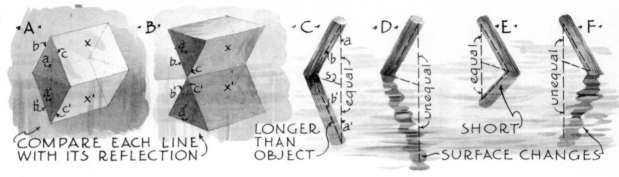

Figure 130

SLANTED REFLECTIONS *Reflections of slanting lines vary with the slant.*

in effect because of the restlessness of the water. At *C* still rougher water has made these interruptions much more evident, and the total length of the reflection has further increased. One can judge at a glance that here the water is more disturbed than before. At *D* the definite reflection is lost, because of the actual waves which have formed, though these waves might still be somewhat affected by the object in value and hue.

Exercise 61: Reflective Surfaces
Experiment with cylindrical, conical, and other rounded objects, reflecting them in your horizontal mirror. Sketch some of them, with their reflections. Try to understand why each object reflects as it does. Also observe and sketch the reflections of objects, regardless of shape, as seen in actual water, both calm and rough.

The next illustrations make a few additional points. Figure 130 once more exemplifies the fact demonstrated on the previous plate—that reflections of slanted lines vary according to their slant, and the angle from which they are viewed. *A* and *B* need no new explanation: line *a'* in each is exactly equal to line *a*. Note that *x'* is narrow in Sketch *A* and wide in *B*. The four following sketches picture another application of the same principle. In Sketch *C*, where the water is calm, line *a* represents the distance from the end of the sloping line *b* to the water. Line *a'* is equal to *a*. Despite this, reflection *b'*, like those of the roof lines in the former plate, looks longer than line *b*. In Sketch *D*, the ruffled water further lengthens this reflection, at the same time distorting it. At *E* we are viewing the pile from the opposite direction. The reflection in the calm water at *E* seems short compared with the object; at *F* the disturbed water lengthens it.

SPHERICAL REFLECTIONS

It is not so easy to construct correct reflections for spheres, ovoids, etc., yet we can get in mind their general appearance with little trouble. In Figure 131, for instance, we see that a hemisphere, in the position shown, plus its

Figure 131
SPHERICAL REFLEC-TIONS *The hemisphere and its reflection make a complete sphere. However, when the object is below eye level, such as is the case here, the area of the object casting the reflection seems greater than that of the reflection.*

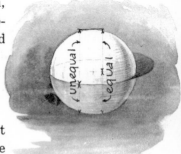

Figure 132
SPHERICAL REFLECTIONS
Rocks can often be treated as
spheres or hemispheres.

Figure 133
SPHERICAL REFLECTIONS
Hills are also similar to
hemispheres.

reflection, makes a complete sphere, though when below the eye like this a much greater area of the hemispherical surface is visible than is reflected. Figures 132 and 133 suggest ways of applying this principle.

Exercise 62: Varied Surfaces
Using your mirror or similar reflector, placed horizontally, experiment with solids like these. Model some little hills and rocks—in short any typical forms—with clay or wax, and study and perhaps sketch their reflections. Sketch real places outdoors where there are rounded hills, etc., reflected in both calm and ruffled water.

INTERIORS

Because we have reflections wherever there are reflective surfaces—and there are many such in furniture, polished floors, and the like—we must give these interior details some attention. Figure 134 points to their importance. Perhaps the most significant thing about this is the floor treatment, in which a merging of reflection and surface texture is suggested. Reflections, as we have seen, are always modified by the character of the reflecting surface.

Many times interior reflections are so complicated that it proves best not to attract too much attention to them. Hence in the present example the desk reflection in the floor was soon allowed to die out. Often, shadows are likewise suppressed.

THE WET STREET

On wet days we get a great variety of reflections outdoors which otherwise are non-existent, for almost any wet surface is more or less mirror-like.

Figure 134
INTERIOR REFLECTIONS *Reflections in indoor paintings can be quite distracting unless you subordinate and simplify them.*

Figure 135
WET STREETS *These reflect very definite images. They also reflect the light of the sky.*

Wet streets and sidewalks reflect not only the light of the sky, but definite images of nearby things. See, for example, in Figure 135 the clean-cut inverted images of the hydrant, street-lamp, barrel, store front, etc. The awning catches something of the brilliancy of the sky, as does a portion of the window glass.

VERTICAL PLANES

In the next few illustrations, we picture reflections on surfaces which are not all horizontal. The first four of these diagrams are our immediate consideration. In Figure 136 we see a cube placed at the angle of intersection of vertical and horizontal reflecting surfaces. Not only does this cube reflect in the horizontal plane, as it did at *A,* Figure 126 (though we have suppressed this reflection here), but in the vertical plane as well. This latter reflection, seen in this instance in angular perspective as it is, would be perspectively equal, but not actually equal, to the cube. It would look exactly like a second cube beyond the first and in contact with it. A simple method of constructing a reflection of this type is demonstrated by the diagonals which, running from the extremities of line *c* through the center of the upright line of contact of the cube and vertical plane, cut lines *a* and *b,* produced, to establish the extremities of *c',* the correct reflection of *c.*

Figure 136
VERTICAL PLANE RE-FLECTIONS *Four cubes seem to be lined up in this two-way reflection. The object is in contact with the reflecting surface.*

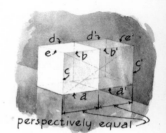

perspectively equal

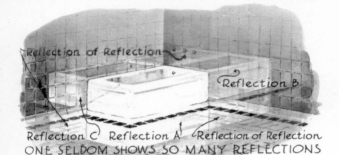

Reflection of Reflection → Reflection B
Reflection C Reflection A Reflection of Reflection
ONE SELDOM SHOWS SO MANY REFLECTIONS

Figure 137
VERTICAL AND HORIZONTAL
PLANE REFLECTIONS *Here
seven bathtubs seem to be
lined up in a three-way
reflection. This is quite
a trick!*

Exercise 63: Two-way Reflectors
Place horizontal and vertical reflectors as at 1, with a cube or like
object at their intersection, and study and sketch the reflections. You will
discover what amounts to four cubes including the original, its reflections,
and the reflections of the reflections.

THREE REFLECTORS

In Figure 137 we picture a practical, if not beautiful, demonstration of
the reflections of a bathtub in a floor and two adjacent walls, all of glazed
tile. The tub reflects invertedly at *A, B,* and *C,* and in addition we have
reflections of reflections, as marked, the total effect being that of four
tubs with three visible inverted reflections.

Exercise 64: Three-way Reflectors
Arrange three reflectors in this way, with a rectangular prism—a card-
board box is good—at the intersection. Study and sketch the effect from
several angles.

MOVE THE VERTICAL PLANE

Now we turn to Figure 138 where the cube pictured in Figure 136 has been
moved away from the wall. At *P* we show the original area of contact. The
reflection is perspectively as far behind *P* as the cube is before it. See how
diagonals have been drawn through the center of the near edge of *P*
as an aid in the construction of the reflection. Note that the shadow cast
behind the cube, barely visible in the drawing of the cube itself, shows
plainly in the reflection, as does the shade on the back.

Figure 138
VERTICAL PLANE REFLECTIONS
*The object is no longer in
contact with the reflecting
surface. Compare this with
Figure 136.*

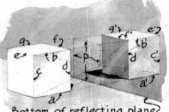

Bottom of reflecting plane

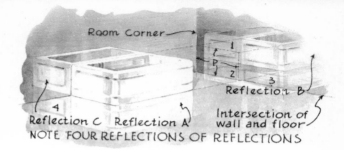

Reflection C Reflection A Reflection B

Intersection of wall and floor

NOTE FOUR REFLECTIONS OF REFLECTIONS

Figure 139

THREE-WAY REFLECTORS *By moving the vertical plane we now have eight bathtubs. Compare this with Figure 137.*

Exercise 65: Vertical Planes

Experiment with and sketch from objects placed at various distances from a vertical reflector, as here, and turned at different angles. Base similar experiments on the conditions exemplified in Figure 139 where a tub much like that above has been moved from the corner; note that in addition to the normal reflections *A, B,* and *C* there are now four visible reflections of reflections, 1, 2, 3, and 4.

TIPPED PLANES

When we come to reflections in tipped planes, such complications arise that we have space here only to call attention, by means of Figure 140, to the basic truth that reflections in slanting surfaces vary according to the slant, as well as to the angle from which they are seen. If you want to work out such problems, you must be familiar with the laws of instrumental perspective. For all practical purposes, you can manage well enough through experimentation with mirrors and the like. And remember that reflections are usually subordinated anyway, and often omitted.

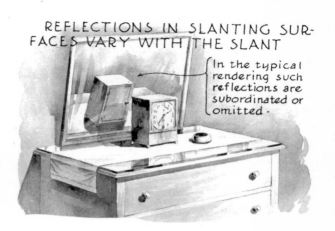

REFLECTIONS IN SLANTING SUR- FACES VARY WITH THE SLANT

In the typical rendering such reflections are subordinated or omitted.

Figure 140

TIPPED PLANES *The angle and surface of the slanting surface determines the reflection produced. By experimenting with mirrors, you can learn much about reflections in polished plane surfaces.*

Brass watering pot

Figure 141
CURVED REFLECTORS
*Polished, curved
surfaces reflect dis-
torted shapes. The
smoothness of the
surface determines
the distinctness of
the reflection. The
brass watering pot
pictured here will
mirror sharper re-
flections than the
clay flower pot.*

CURVED OR IRREGULAR REFLECTORS

We have seen that in ruffled water, reflections are distorted and broken. Similarly, we can recall the curved amusement park mirrors that do such absurd things to us. There are many smaller reflecting surfaces all about us which in their power to distort are similar to these: polished lighting fixtures, dishes, chrome trimmings of automobiles, etc. The smoother the surfaces are, the more distinct the reflections. The watering pot of polished brass in Figure 141 looks shiny because of the sudden changes in its tones. It is reflecting a number of things. It is impossible to construct this type of reflection by rule; still life painting is the best means of learning about it. You can never practice this too much.

COLOR

Reflective surfaces reflect color just as they do light and shade. Clear reflectors reflect the natural colors of the things reflected. Your image in the mirror reveals your own hues; your brown suit reflects as brown. Colors reflected in colored reflectors are often modified thereby. If a yellow bowl is reflected in a blue tray, the two colors may blend to produce a greenish reflection. On the contrary, where the light is strong we often find reflections on smooth shiny objects so bright that they have annihilated entirely the local color. In painting still life, for example, the artist discovers highlights (reflections) on objects which are diminutive images of windows or other sources of illumination, and so brilliant that in them no hint of the local color of the reflecting surface can be detected.

The color of a reflection may be altered in hue by the simultaneous reflection of some other color from a different source. Shiny objects, curved in form, frequently exhibit a merging of colors borrowed, by reflection, from other objects. (If objects are transparent or translucent, like glass bottles, their colors are further modified by the colors that may be seen through them.)

Exercise 66: Colors in Reflection
If you have not already done so, make some still life studies in color with this matter of reflections uppermost in your mind.

We find similar complexities and modifications outdoors, where water is our most conspicuous reflecting surface. We have already seen that, when it is in motion, reflections are broken or distorted. Reflections in water of objects in it, or nearby, are usually modified, too, by simultaneous reflections of the sky. In fact, a main reason why water so often looks blue is that it is reflecting the sky. And we all have seen sunsets brilliantly inverted upon water; a mere film of it is enough. Trees, buildings, and other nearby objects are other tempering factors; even when they fail to mirror their own images, they influence the general effect. Furthermore, water often has color of its own, being dyed by mineral and vegetable pigments, etc. And it is more or less transparent, so the colors of things below sometimes show through.

All this we introduce merely to make clear that no rules can be given for the proper representation of water. You must turn to nature for your lessons. If the water is smooth, or practically so, you are usually safe in handling it much as you would a horizontal mirror.

Chapter 23

SOME TIPS ON COMPOSITION

ALTHOUGH WE CAN GIVE the reader no foolproof rules for composition, un-fortunately, we shall briefly discuss some of its qualities, such as unity, emphasis, and balance. We can at least offer some practical tips which may help you compose your pictures better. Buildings are used as the central motif in this chapter, but you can apply the suggestions to what-ever subject matter you prefer to paint.

COMPOSING WITH CONTRASTS

At 1, Figure 142, we show diagrammatically a simple building. Let us assume, to make the problem more real, that this diagram stands for such a complete outline drawing of a building (doors, windows, and all) as the delineator commonly prepares in pencil on his white paper as a layout for a typical sketch. Though such an outline study often gives, as it stands, a fairly adequate interpretation of the structure, it has little force to attract or hold the eye (no carrying power), offers but meagre suggestion of space and substance, and tells us nothing of the color scheme. One of the artist's problems is to learn to make his buildings—or any other subject he is focusing on—stand out from his paper to make it seen and under-stood at a glance, a thing which he can do by means of well-arranged con-trasts of light and dark or of color. For the moment we shall neglect color

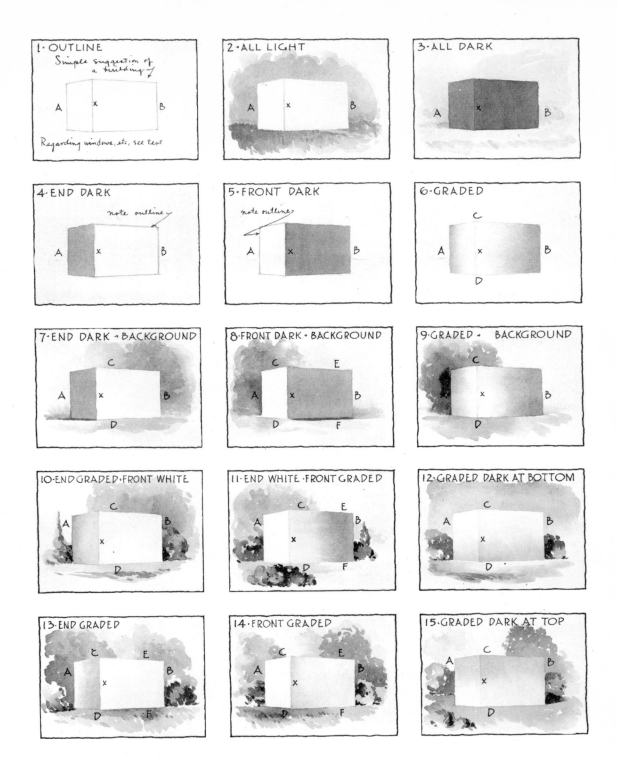

Figure 142

COMPOSING WITH CONTRASTS *Learn to make values help you; build contrasts where they will best serve your needs. Tones—graded or flat—can give life to your painting when they are properly used.*

in order to concentrate on value contrasts. Let us see how the artist sizes up his outline and plans the contrasts which will give it this desired life.

If the proposed building is to be made of light materials, as a majority of buildings are, the obvious thing to do is to leave it quite light (the later treatment of its details would be sure to darken it somewhat) against a dark background: this general scheme of composition we illustrate at 2. A building of dark materials, contrarily, is often contrasted with a relatively light background (3). Again, the renderer takes advantage of natural contrasts of sunshine, shade, and shadow. At 4, for example, the end of the building, assumed to be in shade, was rendered dark, and at once stands out plainly against the light surroundings. But the front here has no prominence, depending wholly on its outline. If we reverse the light and shade, as at 5, the front gains strength but the end loses. Schemes 4 and 5, then, are not satisfactory as they stand. At 6 the near corner (x) is left light, and both end and front are graded darker at A and B. This scheme has possibilities, but gives no contrast at C and D. Schemes 4 and 6, or 5 and 6, might be combined to advantage.

But perhaps the best way to overcome the faults of 4 is illustrated at 7, where sky, foliage, and ground tones, plus the end tone, throw the front into contrast. Here we have a good scheme, which, with variations, has been used hundreds of times. At 8 the faults of 5 are similarly corrected, while at 9 we see what foreground and background tones, developing contrasts at C and D, will do to Scheme 6. Note that at 7, 8, and 9 the building is everywhere dark against light or light against dark, an arrangement which is customarily desirable.

The remaining diagrams on page 219 picture further uses of graded tones for creating contrasts where wanted.

We can summarize this lesson by saying that the artist learns to take advantage of natural contrasts, whether due to local tones of materials or to light and shade, manipulating them in a way that will bring out his central object. The beginner often fails to realize that such contrasts are deliberately composed. Study the aqueduct drawings, Figures 51 to 56, as a reminder of how much control the artist can exercise over value arrangement.

Figure 143 redemonstrates much of this. With the roof tone applied to the outline (1), as at 2, the roof gained prominence: the shade and shadow tones at 3 strengthened the end: the bush at A, Sketch 4, brought out the front: the foreground, distant trees, etc., at 5, completed the whole. In this way, a very common scheme is developed, subject to numerous adaptations. At 6 and 7, we see softer contrasts arrived at through gradation. At 8, the attention is focused at the left: at 13, it has

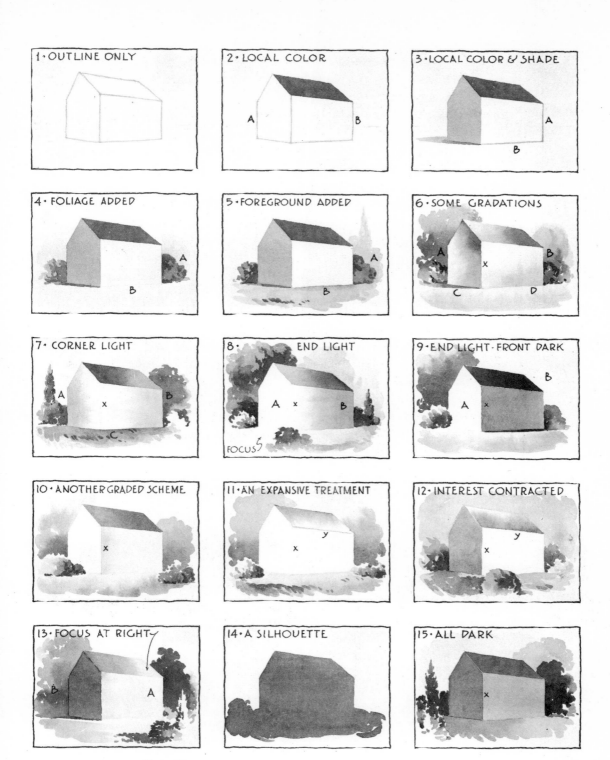

Figure 143

COMPOSING WITH CONTRASTS *Both local values and light and shade tones are utilized. Any area in your painting can be emphasized or thrown into subordination.*

been shifted to the right. The foreground bushes in 8 and 13 help to set the building back. We can expand the interest—as was done in 11—by avoiding strong contrasts of tone as at *x* and *y:* we can also contract the interest as at 12. This sheet suggests only a few of hundreds of possibilities for the treatment of even the simplest structure. Complex structures offer still greater opportunities for variety.

Exercise 67: Value Representation
Make many little sketches, such as the ones illustrated here. With practice, you will begin to feel comfortable switching values around until they please you. This device will help you immensely in composing your pictures.

TRACING PAPER

Another helpful exercise is to lay tracing paper over photographs of existing buildings, making groups of quick sketches—charcoal or soft pencil will do—trying the stunts we have suggested here. Forget the detail. We are trying to make plain that important as color and technique are, value composition is extremely vital. It can be learned only by experimentation.

One of the best possible types of sketches to make at the beginning of this practice is exemplified by Figures 144 to 151. Subjects of greater architectural significance could of course be substituted, but the general handling should be approximately the same as here, black (it can be

Figure 144
COMPOSING WITH CONTRASTS *Here the roof tops are light and the side walls are light.*

Figure 145
COMPOSING WITH CONTRASTS *Here the roof tops are light and the side walls are dark.*

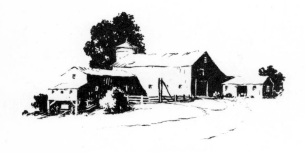

Figure 146
COMPOSING WITH CONTRASTS *Here the roof tops are dark and all the walls are light.*

Figure 147
COMPOSING WITH CONTRASTS *Based on the same scheme as that of Figure 145, gray roof tops and grass have been added.*

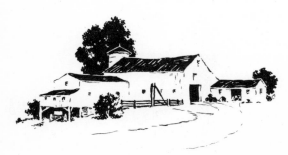

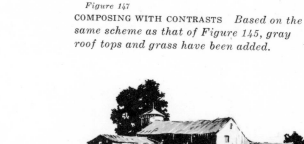

brushed on) being used for all the dark values and white for all the light. If you can learn to spot these strong blacks so they compose well (form a pleasing and expressive pattern or design) you will have learned an important lesson. The sketches can be done on tracing paper placed over the photograph, or, better, from actual buildings. The right-hand sketches—those showing the gray—are somewhat more realistic modifications of the left-hand sketches. It would be helpful to do some of these, also. In such work you should express as much as possible with a few tones. This teaches simplicity: the beginner's renderings are nearly always too complex.

CONTRASTS OF HUE

If one hue is brought against another, even if they are similar in value, there is contrast. The more unlike these hues are—the farther apart on the color wheel—the greater the contrast. Analogous colors are less useful to us, therefore, when we are trying to build contrasts as a means of emphasizing a building or some feature of it, than are complementary ones. If we wish to force a red building into prominence, we surround it with green trees: similarly, we throw an orange or yellow structure against a blue sky or contrast it with violet shadows. We remind the reader that the strongest contrasts at the artist's command involve not only value and

Figure 148
COMPOSING WITH CONTRASTS *Gray has been added here to modify the general scheme portrayed in Figure 146.*

Figure 149
COMPOSING WITH CONTRASTS *All the values have been reduced here, but the scheme is still the same as the one in Figure 144.*

Figure 150
COMPOSING WITH CONTRASTS *Large gray areas constitute this scheme.*

Figure 151
COMPOSING WITH CONTRASTS *A dark, silhouette effect is produced by this use of values.*

hue but also that other quality of color, intensity; even textural contrasts are frequently brought into play.

Although this chapter is not dealing with the theory of pictorial composition, we should perhaps offer a word on the meaning of some of the common terms.

"Unity" explains itself. A work of art should be a homogeneous whole. It should contain only related parts, and these should be merged to form a complete unit, giving a harmonious effect. The eye should not be irritated by irrelevant, meaningless or over-insistent details. If a painting has such details or lacks harmonious adjustment of any of its constituent elements we say it lacks unity. If even a single element is incongruous or not properly subordinated to the whole, unity is impaired. A composition is particularly unfortunate, as we have several times said, when it has two or more conflicting centers of interest.

"Balance" is another word frequently used in referring to works of art; again the meaning is largely self-evident, for if a drawing is to have balance it must be in equilibrium or equipoise. If we place a mass which is dark or of some given color on one side of a drawing, we must counteract it with some compensating mass or masses of similar attentive value on the other. These need not be the same in size, color, or placement, but must play their part in maintaining the equilibrium of the whole. If a single detail attracts too much attention, it forces the entire drawing out of balance. Either the offending detail must be toned down or the rest of the drawing strengthened. It takes very little to destroy the balance of a sketch or painting—a conspicuous tree or automobile, an airplane against the sky, a person in an unusual place or doing an unusual thing. An excellent way to judge balance is to reflect the finished picture in a mirror; thus viewed in reverse the eye, too familiar with its normal appearance, is more likely to detect any lack of equilibrium.

Another attribute of a good composition is "emphasis." Much more will be said about emphasis in the following chapter.

Regardless of how much the artist may know of the theory of composition, it is only through trial sketches that he can obtain schemes productive of best results. This is especially true in the case of the beginner, though even the professional often makes several before starting his final painting.

These are usually done on tracing paper placed over the pencil layout. Therefore, you waste no time blocking in proportions. With a soft pencil or charcoal or, if color is wanted, with pastels or other colored crayons all the leading elements are decided upon. This is a critical period, and you must work thoughtfully, disposing all values (including such contrasting ones as we have stressed), planning the color scheme, determining the direction of the light, proper treatment of surroundings, etc. If your first trial sketch seems disappointing, a second should be made, and perhaps a third. Then, select the best sketch, spray it with fixatif, hang it in plain sight as a guide for your final painting. Though this final should show far greater finish, it should retain, so far as possible, the vitality and spontaneity of your sketch.

The beginner does not seem to realize that he will save hours if he takes the trouble to make even a single reasonably accurate preliminary study for each painting he undertakes, yet this is true, for he can advance his final work with greater certainty. Some artists prefer to make their preliminary studies at small scale—sort of thumbnail sketches or marginal notes. The purpose is of course the same.

COMPOSING BY "ADDITION"

We now introduce a little stunt which has proved so useful in my classes, and even in my own work, that it seems worth passing on.

If you are painting a landscape indoors, or if you are adjusting the position of landscape elements you see before you, you may find yourself composing by "addition." You may put the building near the center of the paper. Then you discover a fine big empty space, and in goes a tree. That is addition. This makes another area seem bare and in goes another tree. Then finally you fill all the remaining smaller areas with bushes, tree shadows, etc. Finally the sky looks vacant and clouds are shoved in, and a couple of drooping branches bearing banana-shaped leaves to fill the corners. With a happy smile you gaze at your finished product. Rendered by addition!

Far better for you to compose a unified setting by the means we just discussed. Or you can extend this method of addition as follows.

Let us suppose that a large foreground tree is wanted. On a sheet of very transparent tracing paper placed over the layout you can sketch a tree in full values, and perhaps in color (pastel or colored crayon). Then you can shove this paper around, trying the effect of the tree in various positions until it relates well to the architecture and contributes to the esthetic appearance of the whole instead of merely occupying some con-

veniently vacant spot. When this tree has been well placed, you can simi-larly sketch, on another sheet of tracing paper laid over the first, other trees or similar features of different type or scale, shifting them until they, too, look just right. Sometimes even third and fourth sheets are added, or new sheets are substituted for some of the old. Small details like bushes may be on individual small sheets. Composition by lamination! With such sketches well located, a final study, incorporating all their most desirable features and adjusting their forms, values, and hues, can be made on still another sheet. This can be pushed far enough to become a practical guide for the final sketch. Some painters save the best of these sheets and utilize them later when doing other similar renderings.

COMPOSING WITH CUTOUTS

Cutouts are merely a further development of this idea. In leisure time make renderings on ordinary watercolor paper (fairly heavy but not mounted board) of a variety of trees, bushes, and the like. Cut these out (around the edges) and save them for future use. Later, when the initial light tones have been applied to the layout for a sketch, some of these cutouts are shoved around the paper until a pleasing and logical composi-tion is discovered. Then they are lightly outlined on the drawing, with any necessary modifications in form to meet existing conditions. The painting is then carried forward with the cutouts in view as a guide, such changes in value, hue, or detail being made as seem desirable. If your cutouts curl, weight them down with a sheet of glass.

Cutouts of entire foregrounds are sometimes convenient, showing hedges or fences, walks or streets; they will not jibe perspectively with all subjects but nevertheless can help you to obtain good compositions. Cut-outs are also useful for large structures, foreground shadows, masses of people and automobiles, or silhouettes of typical buildings to place at left and right.

Cutouts are not intended to take the place of studies but rather to help in their making.

Chapter 24

EMPHASIS,
DISTANCE,
DETACHMENT

WE HAVE REPEATEDLY SPOKEN of emphasis and subordination, the center of interest, distance, detachment, etc. Our present aim is to amplify and clarify a number of these matters.

EMPHASIS THROUGH VALUE CONTRASTS

We mentioned some time ago the danger of developing two competing centers of interest in a sketch, destroying its unity. In the subjects in the next few illustrations it might have been extremely easy to do so. Trouble was avoided by emphasizing one center in each sketch, while subordinating the other.

In these examples, this emphasis was obtained wholly through contrasts of value. Study Figures 152 and 153 and you will see that each has exactly the same elements, yet in Figure 152 the eye goes immediately to the upper portions while at Figure 153 it turns to the lower, the attraction in each case being the strong opposition of lights and darks. In the sketches in Figures 154 and 155 emphasis and subordination were again obtained through value control.

It is not only in directing the proper attention to a center of interest that value opposition is used; on the contrary, contrasts of light and dark are utilized wherever a bit of strength seems needed anywhere in a drawing.

Figure 153

EMPHASIS THROUGH VALUE CONTRAST *By increasing the opposition of light and darks —without changing any elements in the composition—the focal point now falls on the lower portion of the picture.*

Figure 152

EMPHASIS THROUGH VALUE CONTRAST *In this sketch, your eye is directed to the upper arch in the picture. More sky is needed to improve the composition.*

EMPHASIS THROUGH COLOR CONTRASTS

Another trick on which the artist relies when he desires to emphasize a given area is the use of color contrasts. They demand attention according to their size, strength, position, etc. Especially conspicuous are large areas of opposing (complementary) colors.

EMPHASIS THROUGH DETAIL

If the artist details one portion of a painting more fully than another, this, too, draws the eye. Paradoxically, a plain area, surrounded by detailed areas, sometimes appears more conspicuous because of its contrasting simplicity.

Quite naturally, large things attract more attention than small, though small things of odd shape are sometimes more conspicuous than larger things of ordinary shape. A curve like the letter S normally proves more striking than a straight line of similar length, and a triangle, especially if inverted, has more compelling force than a square or rectangle. A star-shaped mass is particularly emphatic.

Texture often has force, also. Of two objects nearly alike, one plain and one textured, the latter will usually catch and hold the eye more readily than the former, though much depends on environment. Often the artist deliberately develops pattern in uninteresting areas, perhaps through tricks of technique, and gains emphasis in this way.

EMPHASIS THROUGH LOCATION AND MOTION

A tiny spot in a plain area will attract attention to a degree wholly disproportionate with its size. A small airplane painted in a clear sky, for in-

Figure 154
EMPHASIS THROUGH VALUE CONTRAST *The strong contrasts rendered in the rocky formation on the left draws attention to that portion of the sketch. Notice how subdued the right-hand portion is.*

FOCUS AT LEFT

Figure 155
EMPHASIS THROUGH VALUE CONTRAST *Here the left-hand portion has been subdued, and contrast given to the foliage on the right. Notice how your eye now is directed to the right.*

FOCUS AT RIGHT

stance, will be seen almost immediately. In an area filled with heterogeneous pattern elements, on the contrary, a spot of equal size and strength might be lost.

Objects in motion attract more attention than objects at rest.

THE SURPRISE ELEMENT

Anything unusual attracts attention, too, such as a man standing on his head or walking on stilts.

This is enough to show that the artist, especially if he does original compositions, must learn through experience how to make the spectator look at the things which seem to him essential.

DISTANCE

It is a general rule that objects vary not only in size, but in definiteness or distinctness, in proportion to their distance from the eye, and can safely be represented with this in mind.

There are exceptions to this rule so far as distinctness is concerned, for much depends on where the eye is focused. Though it is usually possible to see things more clearly if you are nearby than if at some distance, it is nevertheless true that if the eye is focused on something distant it may, for the moment, seem more distinct than something very close but out of focus. In expressing distance, therefore, a good way, many times, is to make the objects in focus fairly distinct, and objects out of focus indistinct. The most common treatment, however, is to show things in the foreground quite strong in value and color and definite in detail, things in the middle distance softer (with somewhat blurred edges) and flatter, and things in the distance extremely inconspicuous. Figure 156 demonstrates this; the eye is led back gradually from A to B to C, and a sense of space is created. In Figure 157 we get a more dramatic composition, the eye taking a sudden leap from the dark foreground to the far softer middle distance. Though Figure 158 offers somewhat the same contrast, the tendency is for this composition to lead the eye away by easier degrees. This is partly because of the value arrangement, though the converging lines of the buildings are a contributing factor.

Values also become less distinct as they are more distant, for cooler and cooler colors are employed as distance increases. You can show depth in your painting by perspective: *linear* perspective, in which the converging lines of the architecture lead the eye into space; depth is also created by what is known as *aerial* perspective—perspective of air or atmosphere.

Often, as in a landscape or marine view, we have the aerial type but not the linear. Most architectural subjects, street scenes, etc., exhibit both kinds of perspective.

To sum up, the artist gains distance in various ways, not only by making things smaller but through color and value contrasts or gradations, simplification, softer edges, linear construction, and perspective.

DETACHMENT

When two objects are in almost the same plane, and it is desired to make one seem behind the other, the artist is sometimes required to "force" the feeling of separation. This is illustrated in Figure 159. In order to set the chimney back of the ridge, it was graded lighter below (*B*) until it disappeared behind the sharp ridge line at *A*. This thought is illustrated again at *A* and *B*, Figure 160, where the stone parapet (*B*) was graded to light behind ridge *A*.

GRADED TONES

In innumerable effects of distance and detachment, graded tones play a part, as here. See how grades have been deliberately utilized in many portions of Figure 160. The roof, dark at ridge *A*, grades to light at the eaves, permitting the graded shadow at *F* to count, bringing the eaves forward through contrast. The parapet shadow on this roof takes the opposite grade, as does the parapet wall, which, though light at *B*, has become dark and sharp at *C*. Soft foliage has been graded against this wall at *D* and elsewhere, though below, at *E*, we discover the opposite gradation, the wall being darker than the foliage. This all proves how the artist can play around with his values, according to need, relying many times on gradation.

In Figure 161 further uses of grades are shown. The overhanging branches grade to black at *A*; the shrubs, light at *B*, and so taking their place behind the branches at *A*, grade to dark behind the fence below, bringing it into sharp relief; the fence rails grade to dark at the left in order to throw them into contrast with the light background; the fore-

Figure 159
DETACHMENT *Grading the tone of the chimney helps give the effect of separation. The position of the chimney has been clarified.*

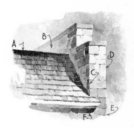

Figure 160
DETACHMENT *There is no doubt that the stone parapet is connected to the other side of the ridge. If the tones had not been graded, the parapet would look as if it were sitting on top of the ridge. Notice the many deliberately arranged contrasts.*

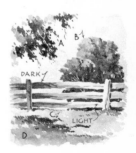

Figure 161
GRADED TONES *Study the way the tones have been graded in the tree, shrubs, fence, background, and foreground.*

231

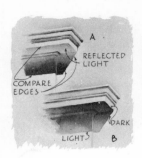

Figure 162
GRADED TONES *Shadows may be graded to advantage in many cases. The manner in which you handle the shadows will tell much about the quality of light in your painting.*

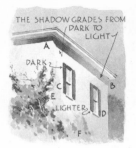

Figure 163
GRADED TONES *Here graded shadow is used to produce a sense of depth.*

ground tone grades from light at *D* to sharp and dark at *C*. Thus is a brilliant effect secured: the things which are near seem near.

Figure 162 pictures some other typical grades such as nature constantly offers. At *A* the shadow tone grows sharp and strong at its lower edge but is light above, due to reflection from somewhere below. This gives a feeling of brilliant light and transparent shadow. At *B*, where there was little or no reflection, the grade is reversed. Figure 163 demonstrates how another type of graded shadow can be utilized to give depth, or distance, the tone being deep at *A* and light at *B*. Corresponding lightening of the shutters from *C* to *D*, and of the vine from *E* to *F*, contribute to the effect.

In very realistic painting, impressions of gradation are often obtained by means of a succession of stepped flat tones, as at *A*, *B*, and *C*, Figure 164. The moldings, between these areas, have been made higher in value, giving a feeling of light reflected from below. Note the reversed shadows of the mutules, caused by the reflection. Nature often shows us these shadows within shadows.

I hope that these suggestions will not only call attention again to how frequently graded washes can be put to definite use by the artist, but I also hope these suggestions will make you more observant of the phenomena as you sketch from nature, whether indoors or out. As a matter of fact, grades are particularly common indoors, due to the diffusion of light.

Figure 164
GRADED TONES *You can obtain an effect of gradation by means of graduated flat tones. Note the reflected light in this sketch.*

Chapter 25

UNUSUAL METHODS
AND MATERIALS

THOUGH THE BULK OF OUR INSTRUCTION to this point has had to do with the use of watercolor commonly known as transparent, we have broadened our scope here and there in order to touch briefly on other colored media, especially when they combine well with transparent pigments. I would like to round out Part One of this volume by dealing a bit more fully with these paints, particularly opaque watercolor and watercolor used on colored papers or in conjunction with other media. It would be impossible to discuss the opaque media at length so if you are interested I strongly advise you to study about gouache, tempera, casein, and water soluble acrylic paints. Much has been written about these media in other books.

OPAQUE WATERCOLORS

In Chapter 1 we pointed out that there are several types of opaque watercolor pigments. In use, however, they may be considered as one. They are capable of completely hiding the paper surface but can be diluted with water to any reasonable degree. Ordinary transparent colors are often made opaque through the addition of Chinese or other opaque white.

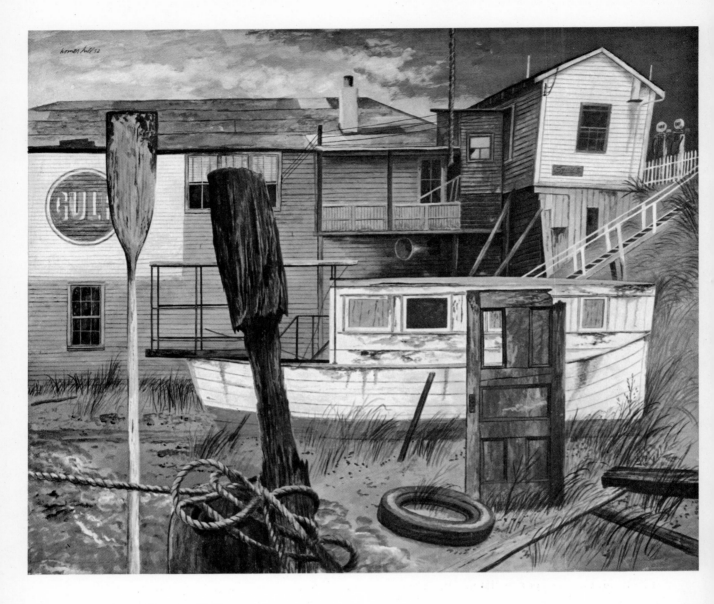

Homer Hill

BLUE DOOR *Opaque watercolor allows the artist to work
more slowly and deliberately; he can build up his passages
by applying one opaque tone over another* and *he can cor-
rect his mistakes. For this reason, opaque colors (gouache,
casein, tempera, and acrylic) are favored by illustrators,
architectural renderers, and other artists whose work de-
mands great precision of detail. The textures of the oar
and the rotting pile in the foreground, for example, are
far easier to render in opaque color than they would be in
transparent watercolor.*

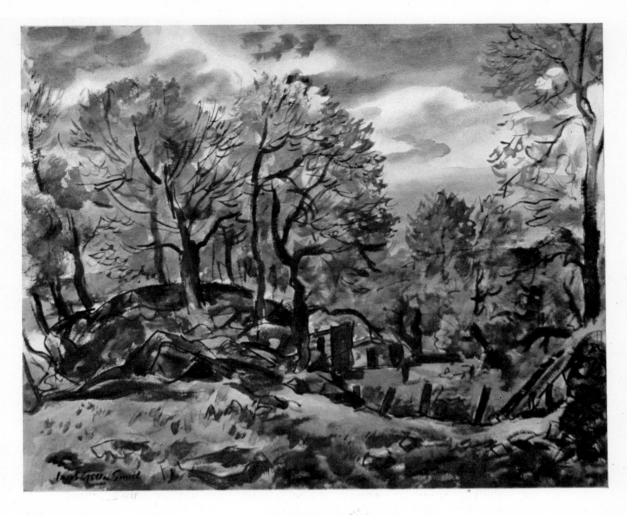

Jacob Getlar Smith

MAY *Transparent watercolor can be particularly effective when combined with a linear medium like pen and ink, as in this lively landscape. The artist has delineated the basic forms of the trees, rocks, and architectural elements with a fountain pen and black India ink. The colors are then washed freely over the lines, which do not blur or soften because India ink is waterproof. Notice the subtle, shifting colors achieved by the wet-in-wet method in the sky. Collection, Mrs. Jacob Getlar Smith*

As a typical opaque palette we offer the palette of H. Raymond Bishop. He says, of the way this palette is used:

"First the drawing is given a flat wash of transparent watercolor, generally Antwerp blue and rose madder. The body color is applied over that to obtain the highlights and shadows. Twelve colors—a standard range in students' sets—give as satisfactory and permanent results as any. The names of these are as follows: blue, violet-blue, violet, red-violet, red, orange-red, orange, orange-yellow, yellow, yellow-green, green, and blue-green.

"Pleasing atmospheric effects can be obtained by using the color rather dry and dragging the brush lightly over the tooth of the paper. Since the opaque colors dry out much lighter, allowance has to be made for the change in value."

In opaque color work, all the other materials, including brushes, can be the same as for transparent color.

METHOD

What Bishop has just said is enough to show that the common method of using opaque color is quite different from that employed for the transparent type. In many respects the former is more like oil paint, demanding a similar technique. Unless diluted, it obscures, or nearly obscures, everything beneath it—paper, pencil lines, and other pigment. No longer is it possible to flow clear washes grading without blemish from hue to hue, or to build up effects by the superposition of wash on wash.

Yet there are compensations. The artist can, for instance, more readily repair faults; he can add lights; he can accomplish much with stippling; he can utilize tinted paper to great advantage; he can produce soft, velvety tones not possible with any other medium.

Instead of starting with light tones and gradually adding darker ones, it is probably more customary to begin with the middle tones, adding both lights and darks. A bush, for example, could be rendered in middle green, the shade added with dark green, and the highlights with light green.

Since such colors are deceptive when wet, it is important to mix plenty of pigment if large areas are to be covered, as it is not always easy to match it again. A color cannot be correctly judged until a sample of it is dry.

When opaque colors are greatly diluted, they are handled more like transparent ones. It is also common practice to combine opaque and transparent pigments, getting the advantages of each medium.

These are only a few general hints. It is only through experience that you can learn what opaque pigments can and cannot do.

WATERCOLOR AND CHARCOAL

Charcoal is frequently employed in conjunction with both transparent and opaque watercolor. When used with the former, the drawing is customarily blocked out in charcoal in a sketchy way, though sometimes quite a complete value study is made. This is then sprayed with regular charcoal fixatif, and, when dry, superposed with watercolor washes, the charcoal showing through to quite an extent.

OPAQUE COLOR ON COLORED PAPER

Much opaque watercolor work is done on colored paper, the hue of the paper chosen depending on the subject. For a building with brown roofs, for example, a paper the color of the roofs might be selected, little or no pigment being used on the roof areas. Such a combination is particularly practical for quick sketching.

COLORED PENCILS

Colored pencils are very useful, especially in layout work. They help the artist to feel his way into his subject, and they merge successfully with the colored pigment later added.

WATERCOLOR AND INK

Black ink can be used effectively with watercolor. As a rule, waterproof ink is selected; it can be applied with either pen or brush. Some drawings are fully completed in ink and merely tinted with watercolor; again, the ink is used sparingly as a means of reinforcing the watercolor work.

COLORED INK WORK

As black ink sometimes seems a bit too harsh and persistent when employed in combination with the more delicate tones of watercolor, many artists prefer to dilute it or to substitute colored ink. Artists have long been troubled by foundation washes of watercolor softening under subsequent washes, resulting in unsightly defects. Waterproof inks in color, such as

are made by Higgins, obviate this difficulty. They are available in many hues and can be mixed freely or diluted to suit. Once dry they are waterproof and durable.

Many drawings are done entirely in colored ink. Sometimes it is applied with the pen, sometimes with the brush, and often with the two combined. Or it can be blown on or spattered. Dry-brush effects are possible. In short, there is no end to the interesting opportunities. Paintings surprisingly similar to watercolors can be made. The chief difference between ink and watercolor is that the former, being waterproof, dyes the paper. This may be an advantage, as in foundation washes or, a disadvantage, as when mistakes are made. Often when working with watercolor the artist feels that he would like the key of his entire drawing better if it were cooler or warmer or of some other hue. Frequently he can do nothing about this unless he resorts to spray (and here the results are problematical), for if he carries washes over the existing work, the pigment previously in place may streak. When painting with colored inks, on the contrary, there is never a time when a superposing wash cannot be laid with perfect safety, even over the darkest accents.

An interesting method of working is to lay foundation washes of waterproof inks, after which watercolor, mixed with a little glycerine, is applied over the whole. The glycerine prevents rapid drying of watercolor and makes it possible to wipe out the highlights or other areas with a stiff brush, permitting the ink to show through.

Part Two

DEMONSTRATIONS BY
PROFESSIONALS

HOW TO STRETCH
WATERCOLOR PAPER:
JOHN ROGERS

ONE OF THE FIRST THINGS a student watercolorist should know is how to stretch watercolor paper. Many artists and students—though well aware of the difficulties involved in painting watercolors—don't seem to realize how often these difficulties are multiplied because the painting is done on unstretched paper. It is true that some artists do well without stretching their paper by using a very dry technique or by working on heavy paper; but for those who work on lightweight paper using average methods, stretching is imperative. The method suggested here turns out a nicely stretched paper. Any sheet, if properly handled, will adhere all around and remain absolutely flat, and it will work with the pleasant tightness of a well-stretched canvas. This method of shrinking (for that's what it really is) will give less trouble and produce more successfully stretched paper than the paste paper method or any other.

Our first picture shows the materials needed: a sheet of clean wrapping paper about the size of the board being used; a pack of white blotters; a jar of drawing board paste and a few paste brushes; a sheet of any good handmade watercolor paper, 72 lb. rough; a five-ply plywood board about 26″ x 34″ for a full sheet or 17″ x 26″ for a half. It is a good idea to have at least two of each size. The plywood board is placed on the drawing table with the wrapping paper on top of it—the blotters, paste and brushes are placed conveniently.

Wet the watercolor paper (step one) by slipping it loosely half folded under cold water which you have run in the bathtub. It is important that

MATERIALS *For stretching paper you need wrapping paper, white blotters, paste, brushes, watercolor paper, and plywood board.*

STEP ONE *Wet the watercolor paper under cold water.*

it be completely submerged and remain submerged during the few minutes required to become thoroughly wet.

Grasp the wet paper by the corners and lift it carefully out of the water. Flop it onto the wrapping paper (step two), quickly taking a blotter to soak up any large amount of water that might run off.

In our fourth picture (step three) the edge of the paper is being dried —it must be blotted all around to a width of about three-quarters of an inch. Since the paper dries very rapidly this should be done quickly.

Apply paste around the edge of the paper (step four) to a width of about one-half inch. Use a spare piece of mat board as an aid in keeping

STEP TWO *Place the water-color paper onto the wrapping paper and let the blotting paper absorb excess water.*

STEP THREE *Blot the edge of the watercolor paper.*

STEP FOUR *Paste the edge of the watercolor paper. Work rapidly!*

STEP FIVE *After removing the wrapping paper, place the watercolor paper on the plywood board, leaving an even border of board around the paper.*

STEP SIX *Paste down the edge of the paper onto the board and gently blot up excess moisture.*

STEP SEVEN *After you have completed your painting, cut the paper off the board with a razor blade.*

neatly within the one-half inch width. The drawing board paste is put on just as it comes from the jar. It must be brushed on smoothly and thoroughly. Here again speed is most important.

The wrapping paper is lifted and placed on some other table so that the watercolor paper may be lifted over and lowered onto the plywood board. The paper should be placed so that an even border of wood is left all around (step five). Run your thumb lightly around the edge to be sure it has firmly adhered.

All excess moisture is again blotted from the entire border. The gentle pulling operation shown (step six) is done sparingly and with considerable care, since wet watercolor paper is easily torn. Generally, just a little pressure is enough to flatten any slight unevenness that may exist. Allow the paper to dry completely before starting to paint.

When the watercolor is finished it can be cut off the board with a razor blade (step seven). The pasted border should be left on, for it is to this that the next sheet will be attached. Assuming that the first sheet is bonded to the board firmly, one can stretch quite a few papers, each adhering to the previous border. When the border builds up too high, the whole thing can then be pried off. Portions that can't be pried off must be soaked with lukewarm water and scraped until the board is clean.

The ease with which work can be done on this taut surface is ample payment for the trouble involved in stretching. At least the basic element in a watercolor—the paper—will not stand in the way of a successful painting if you follow this procedure.

PAINTING A LANDSCAPE: NORMAN KENT

THE FORM AND PATTERN of willow trees have been a delight to landscapists for centuries. The color of the foliage is attractive in all seasons and under all conditions of lighting. The lost-and-found presence of the sturdy trunks and branches detected through the screen of feathery leaf compels the painter to careful study.

After several days of sketching and painting in the neighborhood of Seeley Creek, Pennsylvania, I came to the subject of *Willow Bank.* It was a late afternoon at the end of August. I had formed a strong attachment for the willow trees I had drawn during the morning. First I made a quick pencil drawing similar to the one reproduced. Next I set up my easel and painted a 15″ x 20″ watercolor in about an hour. But even before taking it home to look at it in indoor light, I knew it did not represent my first impression of this peaceful place.

Determined to make amends for my failure, I went back the following day after a critical appraisal of my first picture. But now the light was very different. An overcast sky threatened rain, and where before I had been confronted with a pattern of strong light and shade, now I found more subtle tone and simplified form. In a way it was a more challenging thing to paint. Even as I began blocking in the main lines of composition I felt grateful for the previous day's labor. It had provided me with a familiarity of the meandering creek, the form of the bank, and the bulk of the willow trees.

My paper was a sheet of 300 lb. rough-surfaced stock. For my prelimi-

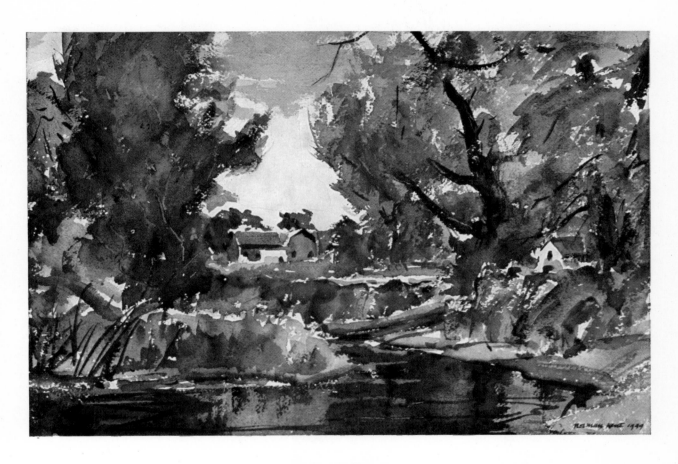

Norman Kent

WILLOW BANK *After laying out the preliminary drawing of his subject, the artist proceeded to paint the landscape. He advanced the total painting as he worked, establishing first the green foliage, then the foreground earth color. As he worked, the artist retained the accents of white paper, an effect which adds vitality to the over-all painting. Collection, Roy M. Mason.*

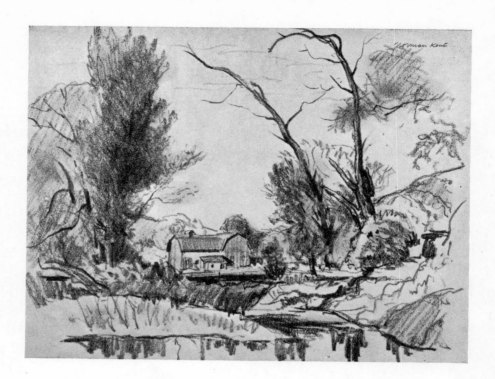

PRELIMINARY DRAW-
ING *This quick
pencil sketch, mea-
suring 9 x 12 inches,
was made with a
carbon pencil.*

nary lines I used a nubbin of charcoal. I find charcoal excellent for this purpose since its lines can be changed so quickly and it does not invite a detailed rendering—especially on rough paper.

I have often witnessed a watercolorist spending the better part of an hour carefully plotting a hard pencil drawing on his paper only to find when he was ready to paint that the light effects which had attracted him to the subject in the first place had vanished. It's much better to set down rapidly the major space divisions and general forms and then begin to paint.

It's always difficult for an artist to reconstruct the various steps he has gone through in producing a particular painting. But several things I remember quite clearly about *Willow Bank*. The first thing I did was to mix a generous wash of dark green to establish the color density of that mass of trees to the left on the far bank. This was applied and smaller patches of the same wash were repeated on the right side. While these washes were wet, I dried my brush and softened edges here and there.

Now the foreground needed an underwash of warm earth color to establish its relation to the general tone. Then the barn in the middle distance was painted with a thin wash with the end of my large sable brush. Next I dealt with the water plane. A neutral gray wash was applied and allowed to dry before the reflections were added.

In all the process already described I had been careful not to lose the little accents of white paper, for without them the close-valued patterns would have been merged together and form destroyed. One such patch of white paper provided the inspiration for the little red-roofed house to be seen on the right side. It became a compositional device which assists the eye in moving *through* the entire design.

At this point in the painting about forty minutes had elapsed. The paper was fairly well covered. After a few minutes rest, I began pulling the whole picture together, closing up unwanted exits and adding the strong dark accents of tree trunks and branches. Certain passages, now dry, were dampened with a cloth and the color "lifted." This may be seen in the foliage and in the reflections to the right.

The outdoor painting was now complete. Later, after studying the result in a trial mat and under glass, a few minor changes were effected by additions and some modifications of color and tone.

For tools, I use a large red sable brush and usually paint on a water-color easel. My paint box is a heavy metal affair with six generous mixing trays and eighteen wells for pigment. When open it measures 11″ x 12″. While I am presently using sheets of 300 lb. imported stock, rough textured, I have also used 140 lb. paper in pads, both hot pressed and cold pressed varieties.

While I prefer to paint out-of-doors directly from the subject, I find that I am able to do an equal amount of watercolor painting in my studio from sketches. Under these conditions I try to select sketches with marked contrasts of light and shade, avoiding close-valued subjects like *Willow Bank* which require intimate association to do well.

PAINTING A
WATERCOLOR:
TED KAUTZKY

TED KAUTZKY (1896-1953) was not only one of our top watercolor painters, but for many years he also majored in pencil rendering. In the latter medium, he developed a personal and powerful style which can aptly be called pencil painting. In 1952 we asked Ted to write about his watercolor work and what follows immediately are his own words.

"For years I have been studying trees, sketching and painting them in all seasons and all weather.

"The willow, seen in the watercolor reproduced here, is one of my favorite trees. And the most intimately familiar because of the old willow road that winds its way to my summer studio on the rocky ledges of Land's End, Cape Ann, on the Massachusetts coast.

"Of course I had admired—yes, and sketched there—old willows many times, but they had not been the subject of a watercolor until one misty summer's day when, trudging along in the rain, I was wholly captivated by the mood of the wet country road, glistening with puddles which reflected the dark foreground trees. The hazy atmosphere translated the receding trees and the background into a perfect sequence of simplified values. The road had never before revealed itself in quite that mood and I had to hurry home to paint it.

"As is my custom when painting indoors, I made several 7" x 10"

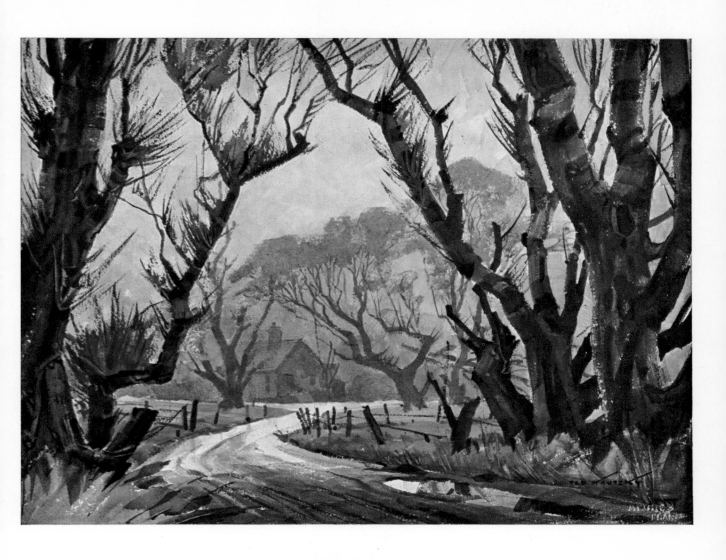

Ted Kautzky

OLD WILLOW ROAD *In this final painting, notice how the artist has remained true to his preliminary drawing. Translated into color, the values are the same as the artist had established in his drawing. The triangular compositional structure is also very close to the pencil sketch.*

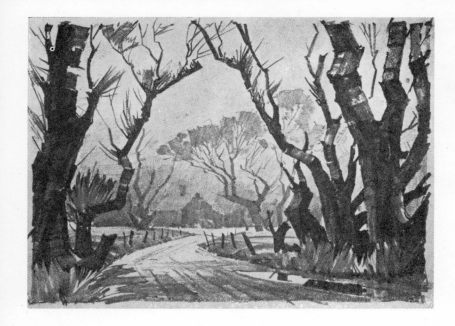

PRELIMINARY DRAWING *All important decisions about composition and values are made in this sketch.*

COMPOSITIONAL STRUCTURE
The two heavy lines form a triangle off center. The dotted line indicates the importance of the direction of the corner of background trees. The perspective lines of the road accentuate the sense of depth.

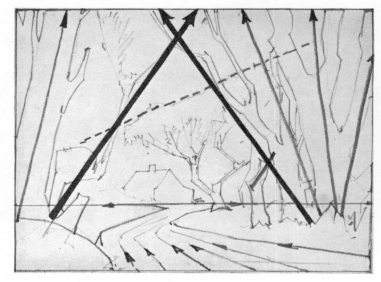

VALUE ORGANIZATION *1. The darkest tone for foreground trees; 2. the intermediate value for middle distant trees; 3. the lightest value for distant buildings and foliage. This is a very simple tonal plan.*

pencil sketches for studies for my composition. The final study in pencil is shown here with the watercolor. This, it will be seen, is more than a 'rough.' In my pencil studies I make all important decisions and definitely establish the picture's pattern and its values. When I take up my brush to paint, all of my creative thinking is concentrated on color and on technical considerations.

"In all my years of painting in all media, I have found that the success of the picture depends largely upon my study in preliminary sketches. I know that many painters make only the most casual of 'roughs'—but every one has his own way.

"Before starting to paint I give considerable thought to the order of painting, whether it is more practical to start with the lightest values or with the darkest. In painting *Old Willow Road* the foreground trees were laid in first with direct strokes, as dark as possible without losing the transparency of the color; then, in the following order, the middle ground willows, background, field, road and finally the sky. I left patches of paper for the very lightest values.

"This picture was painted with a very limited palette—burnt umber, raw sienna, French ultramarine blue and Hooker's green #2. The paper was a medium rough full sheet (22″ x 30″) with an off-white warm tint which seemed especially suited to this subject. While this subject required but few colors, I always have the following for use as needed: orange vermilion, cadmium orange, cadmium yellow, aureolin yellow, lemon yellow, cobalt blue, French ultramarine, Winsor blue, alizarin crimson, burnt sienna, burnt umber, raw sienna, raw umber, Hooker's green #2, Davy's gray and Payne's gray.

"I have four brushes: a small and a medium-size pointed sable; and a half-inch and a one-inch square flat ox hair."

Now for a word about the compositional drawing which was made by Kautzky as a study for the watercolor and is typical of the powerful pencil rendering by this talented and versatile artist. In his book, *Pencil Broadsides*, Kautzky recommends the use of two grades of graphite pencils, 2B and 3B, on a good quality of kid-finish bristol. He stresses the importance of experimenting with various surfaces of paper until the most compatible one is found. The kind of paper really determines the hardness of pencil used. On a very smooth surface the softer pencils will be needed; on a paper with considerable tooth, harder leads will produce quite dark tones.

Said Kautzky, "A sharp knife and a sandpaper block are important. The sandpaper block is as necessary as the pencil because it is the means of giving the lead exactly the right point for producing broad smooth

strokes. After the wood has been whittled away to expose about a quarter of an inch of the lead, the lead is rubbed at an angle on the sandpaper block to produce a flat wedge point. Broad strokes are made with the flat side of this wedge held evenly against the paper. The width of the strokes will depend upon the angle at which the point is sharpened. Note that the surface of the lead held against the paper will be oval-shaped since it is a section cut by a plane intersecting a cylinder. This oval shape allows great flexibility in producing a greater variety of strokes than could be had with a square lead."

Kautzky, however, frequently used square leads for bold broad areas—graphite sticks about one-quarter inch square which come in various degrees of hardness. These were employed freely on the sketch here reproduced, on the foreground tree trunk. The middle distance and the distance were done with the 2B and 3B leads.

Kautzky revealed a trick for securing a wash-like tone with these graphite sticks. After covering an area with direct strokes of the graphite, he rolled up a kneaded eraser into a cylindrical form and rolled it over the tone to pick up the graphite particles that ride on the paper's surface. This leaves only the graphite that has bitten into the paper. The result is a very smooth tone.

PAINTING A
STILL LIFE:
RALPH AVERY

A BOWL OF PEONIES has been selected for our still life subject. The large handsome flower forms seem to lend themselves to simple color masses that are challenging to the watercolor medium. This is mentioned because in choosing our subject and knowing that we are to paint in a rather broad way, we may as well select a sympathetic subject. Of course, any kind of flowers can be painted and we should experiment with all of them. For this purpose, however, we are avoiding flowers that are small or that do not form into masses easily or that depend upon tiny petals and details for their effect. Such a subject might better be drawn with a pen or pencil or made into an etching.

LOOKING AT THE SUBJECT

The creative part of any painting begins as soon as we start to observe the various possibilities as to composition. Such questions as looking with the light or against the light; high eye level or low eye level; the over-all shape—horizontal or vertical. These are all points to be considered early in our plans before selecting the best viewpoint with the aid of preliminary rough sketches. Selecting the best one of the roughs is often the deciding factor in the final success or failure of the painting. This being done, the procedure is not slavishly to enlarge the selected rough but rather to use

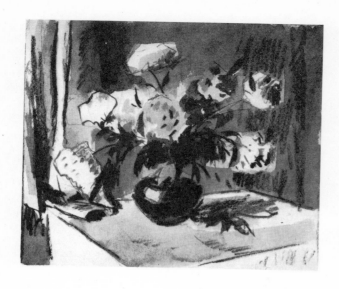

STEP ONE *This is one of several preliminary drawings made for the simple still life.*

it as a starting point in building the painting, reserving the right to change our thinking as we go along and to allow for the unexpected happenings that are characteristic of the watercolor medium.

GENERAL PROCEDURE IN WATERCOLOR PAINTING

Edges are so important in watercolor that we try to anticipate, well in advance of the finished effect, which edges are to be soft or blended and which are to be hard or sharp. Wherever soft edges are needed, the paper may be dampened with sponge or brush in those areas only, being careful to leave dry paper where sharp separations of color are needed. As the dampened areas begin to dry, and before completely dry, strokes of color can then be added for accents or emphasis, leaving a sort of semihard effect in their edges.

PAINTING STEP-BY-STEP

Starting on a piece of Whatman illustration board (no longer made), size 16″ x 20″, with a soft pencil or piece of medium charcoal, the main areas to be painted were sketched in. As rough as this step might appear to be and with little or no details indicated, important decisions were made at this time. The big areas were settled. If these areas do not satisfy, then it is better to get a fresh start rather than to regret later that we did not do so.

I would emphasize here that this drawing should not be carried into details or we might be tempted simply to make a colored drawing instead of a full-bodied painting. The underlying masses of color were now added to the outline composition. The darkest note was established by indicating the dark bowl. The middle values produced by the yellow and green background drapery were now brushed in, and with some of the flower sections left as white paper, we established the important patterns of the painting. If this much was well done, the effect might be something like a Japanese print.

The next logical step was to add modeling, to give a three-dimensional look to the flat masses, such as a general shadow tone on the drapery and flowers. How quickly the white flowers take on form merely from adding the warm gray wash of the shadow portions. Before additional touches were given to the red peonies, a little dampening of the portions to be worked on was used to insure softness of edges where we wanted them. It is well to remember that at this stage in our painting it was now a success or failure. The final darks were added that gave completeness to all the forms. At this stage we were drawing more carefully with the brush as the petals of the flowers were observed. In other words, no amount of finishing touches and details will redeem a faulty basic pattern with poorly rendered areas. Every stage of a painting should be interesting to look at. A miserable effect when the painting is half done hardly ever develops into a brilliant final performance.

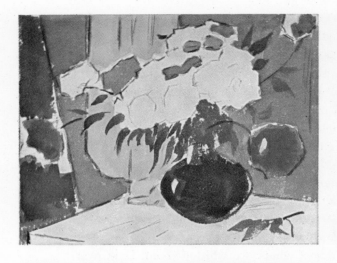

STEP TWO *The basic pattern was blocked in with flat color washes—essentially the abstract design.*

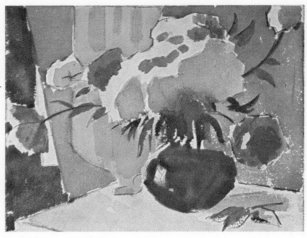

STEP THREE *In this stage, the shadow areas of the white peonies and the yellow drapery have been indicated, suggesting dimension but as yet undeveloped in tone or detail.*

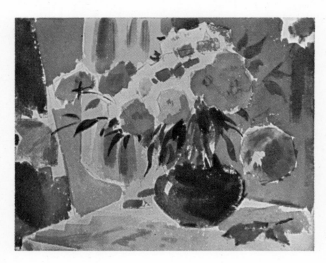

STEP FOUR *Further modeling of the flowers and bowl, without losing the desirable transparency of earlier washes, brought this stage to a point where the artist was able to effect minor value and color adjustments with confidence in the final result.*

258

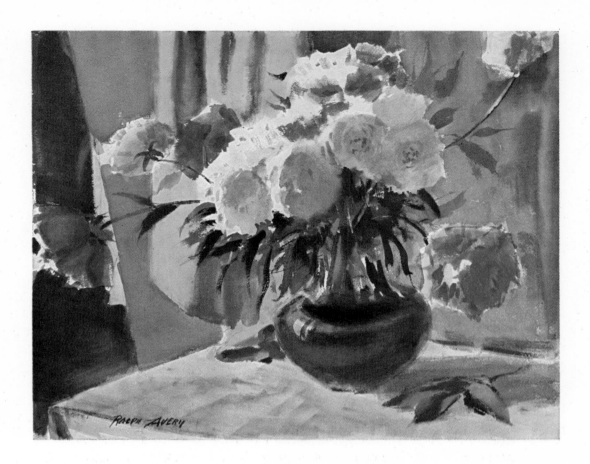

Ralph Avery

PEONIES *The artist advanced his painting to the final stage by making more refined adjustments of color and value, particularly in the drapery, vase, and tablecloth. If you compare this final stage with the first stage, you will notice that the artist had made his major decisions right from the start.*

PAINTING
OUTDOORS:
HERB OLSEN

THE SETTING FOR THIS PAINTING is purely imaginative. The composition resulted from seeing a group of people standing on a hill silhouetted against the sky. The grouping seemed to lend itself to a more dramatic situation. I could visualize such a group looking seaward, waiting expectantly for an ill-fated ship to bring home their loved ones.

In painting this picture, I used the small quiet puddle in the foreground as a contrast to the feeling of the vast ocean with its foreboding perils. The ominous sky, with the cone-shaped cloud, gives the picture an added feeling of unrest. The broken debris in the foreground suggests the title, *The Wreck*.

Before starting the painting I made a few abstractions in pencil. The composition then established in my mind, I drew the picture. With the drawing completed, the following steps were used in the execution of the painting:

STEP ONE I wet the sky area with a sponge and, while wet, using a 2-inch brush, painted lemon yellow over the entire sky area, then Payne's gray on the left top. The cloud was then painted with Payne's gray, mauve and yellow ochre, blended, and then allowed to dry. Lemon yellow and cobalt blue were used for the water. The puddle in the foreground has the same colors but, since it reflects the zenith, leans more toward the blue, or cooler tone.

STEP TWO The green area of the hill is Rembrandt green and Hooker's green. The lower section of the hill (clay bank) was painted with Indian red, cadmium orange, and yellow ochre all mixed on the paper. In this instance I used the paper for my palette. On the rock area at the right side of the painting, I used cobalt blue, Hooker's green, burnt umber and yellow ochre. The beach area is yellow ochre blended with Indian red and cobalt blue.

STEP THREE The darker effects in the green area were achieved by using sepia, Rembrandt green, and burnt sienna. For the darker effects in the clay area of the hill, sepia, Indian red and burnt sienna were used. A note of blue on the rock in the left foreground was washed on when dry. The reflection in the water is Payne's gray. The rocky bank on the right was painted with Payne's gray, burnt umber, and cobalt blue and then allowed to dry. The debris in the water was painted with sepia. Antwerp blue, and burnt sienna—the same was used for the posts in the upper left corner—retaining the lights. These can be scratched out with a razor blade.

STEP FOUR The figures were added last using yellow ochre, Indian red and burnt umber. The clay bank was softened by a wash of burnt sienna and cobalt blue. A touch of mauve and yellow ochre was added to the cloud.

STEP ONE *The top and fore-
ground areas were
washed on.*

STEP TWO *The colors were
mixed on the paper, a com-
mon procedure in watercolor
painting. The over-all color
scheme has been laid in.*

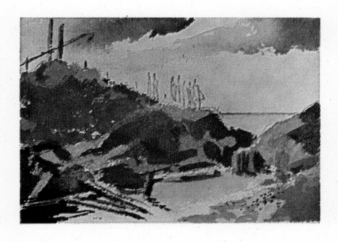

STEP THREE *The painting
has been advanced, greater
attention being given to the
modeling of the rocks and
background.*

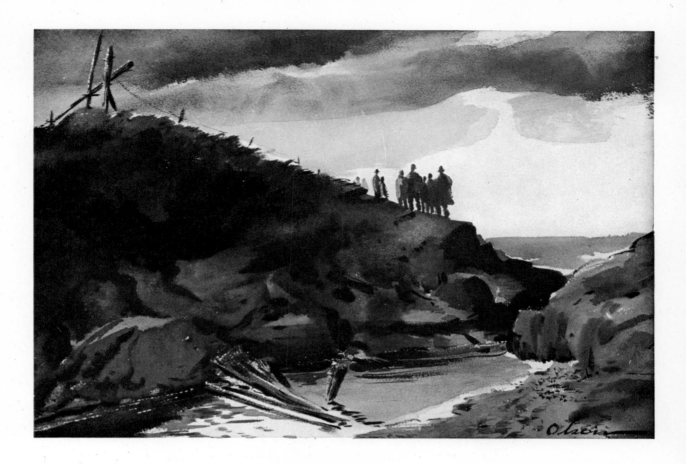

Herb Olsen

THE WRECK *In the final stage of his painting, the artist added the figures in yellow ochre, Indian red, and burnt umber. He softened the tones of the clay bank and strengthened the clouds by adding mauve and yellow ochre.*

CREATIVE METHODS:
SAMUEL KAMEN

LIKE OTHER ARTISTS, I am sensitive to the visual aspects of life. Some of these are more beautiful and moving than others. I try to analyze what it is that makes for this extra measure of beauty, then use my discoveries in the re-creation of the natural world on a still higher level of beauty. In this way I become increasingly free of the vagaries of chance beauty offered by nature. This process I call "design."

Almost all representational subject matter can be embodied in rich design. What an artist selects from nature as his material is a matter of individual preference determined by his personality and his understanding of life. If his predilections are shared by many others there is a strong bond of communication.

Representation and design are the two main compartments of the visual arts; they are the extremes encompassing the gamut of possibilities which run from pure representation to the abstract and the nonobjective. *Ocean's Edge,* the picture reproduced here in color, falls into the category of "designed representation." It is not a literal transcript of a single, whole seen experience; rather, it is the essence of many visual experiences carefully selected and heightened through the power of design. I attempted to extract from the natural world those aspects that have stirred my emotions: a storm passing swiftly through a sunny day, dramatizing the blue sea, green-covered dunes, shadowed cliffs and sunlight breaking through to illuminate olive-colored foliage.

264

All the parts are like, but not exactly like, the originals; some parts have been excluded, others retained, modified and added to, changed in position, shape and color for the purpose of creating a new visual synthesis of heightened emotion exceeding that of the original visual experience. No doubt a greater talent could have done more in this direction, as might I at a later stage in my development.

This painting, as usual, was done entirely from memory in my studio. Thus far I have rarely made a watercolor from life although I have painted a great deal in oil from both indoor and outdoor subjects. This watercolor required about three hours for completion. But, as often happens, I felt dissatisfied with the result without knowing just what the trouble was. So I put it aside and brought it out months later for the fresh look which revealed the faults. I am a believer in drawing and painting from memory. This way of working reveals the areas of my ignorance. Then I go back to nature, observe more closely and fill in the gaps.

I work on a tilting drawing board or on an outdoor tilting easel that makes it possible to control the washes. I soak rough-surfaced watercolor paper (114 lb.) in a tub of water. After the excess water has run off and the paper has been blotted, I fasten the paper to a somewhat larger drawing board with paper tape and allow it to dry stretched before painting on it.

My usual practice in "designed representation" is as follows: I start by making a composition in line and pattern embodying the subject matter; then I compose it in values, based on this line-pattern organization. After that I compose in color, integrating color with the already determined line, pattern and value design.

I like to experiment at each stage. For instance, after having determined a satisfying line, pattern and value design, I shift the values around but retain the line and pattern with only slight necessary modification. At times I begin with a pure design and then convert it into a still life or landscape, retaining the basic unchanged design organization. On the other hand I may complete a composition of designed representation, then convert it completely into a pure design devoid of any representational element.

As one's experience and mastery increase, it is possible to compose from the very beginning in line, pattern, value and color, integrating all simultaneously rather than by separate stages. I learn from the small to the large; I create from the large to the small.

It has been my practice to compose from imagination many hundreds of black and white compositions in wash—landscape, still life, figure and pure design themes. I usually do these in small size. Working small in the initial stages seems to eliminate barriers to the free flow of the creative process.

265

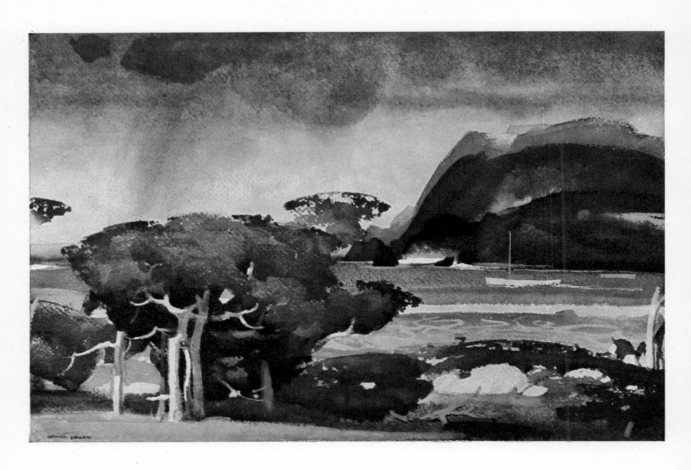

Samuel Kamen

OCEAN'S EDGE *Using what he calls "designed representation," the artist painted this landscape in the studio from memory. He first determined the line, pattern, and value design, then composed the painting in value, and finally composed the painting in color.*

INDEX

Accents, 104, 175, 238, 249, 256; of complementary colors, 95-96
Accidentals, 136
Acrylics, 233
Advancing colors, 88-90
Aerial perspective, 89, 231
After-images, 96, 138, 139
Air brush, 202-203; illus. of, 202
Alcohol, 151, 195
Alterations, 157-161; by addition, 159; by erasing, 158-159; by patching, 160; by sandpapering, 158; by scrubbing, 157-158; with knife or razor, 159; with opaque color, 160
Analogous colors, 81-82, 84, 88, 201; and composition, 223; defined, 78
Analogous color schemes, 94, 95; illus. of, 87
Antiquarian paper, 39
Atomizer, 203; illus. of, 204
Avery, Ralph, demonstration by, 255-259

Balance, defined, 224
Bark, 169, 170
Binary colors, *see* Secondary colors
Bishop, H. Raymond, 236
Blotter, 35, 53, 145, 241
Body colors, 17
Branches, 162-179 *passim;* trunks and, 169-170; *see also* Trees
Brickwork, 183-186; illus. of, 181
Brilliance, *see* Value
Bristle brushes, 31, 121, 136, 158; illus. of, 31
Brushes, 27, 30, 182, 245; bristle, 31, 121, 136, 158; camel's hair, 30; care of, 31; carrying, 143; molting, 31; pocket, 143; red sable, 30, 31, 152, 249, squirrel's hair, 30; using, 30, illus. of, 30-31
Buckling paper, 47, 49, 151
Buildings, 118, 180-192, 209; and dry-brush technique, 52; brickwork of, 183-186; chimneys of, 187; clapboards and shingles of, 186-187; composing, 218-226; concrete and stucco, 186; doorways of, 190; large, 182-183; masking, 204; roofs of, 187; shadows on, 172, 191; stonework of, 183; trees and, 173-174; windows of, 187-190; illus. of, 180, 181, 184, 185, 188, 189, 192
Burnishing, 160
Bushes, 162-179 *passim*

Buttons, *see* Pans

Cabinet, 33; illus. of, 34
Cakes, 18-19; size of, 21; illus. of, 19
Camel's hair brushes, 30
Canvas, 38, 42
Casein, 233; used for corrections, 160
Center of interest, 102, 150, 227, 228, 229; method of obtaining, 102
Charcoal, 26, 34, 48, 108, 178, 225, 256; combined with watercolor, 237
Cheesecloth, 36
Chimney, 30, 187, 231; illus. of, 184
Chroma, *see* Intensity
Clapboards, 186-187
Cleaning brushes, 31
Clothespins, 36
Clouds, 118, 193-200; created by spraying, 205-207; erased, 195; sky without, 194; using opaque watercolor, 197; using sand, 205-206; illus. of, 196, 198, 199
Cole, Rex Vicat, 162
Color box, 26, 27, 28, 143; illus. of, 27, 143; *see also* Painting sets
Color cups, 28-29; illus. of, 28
Color in Everyday Life, 89, 90
Color in Sketching and Rendering, 9-10
Color Manual for Artists, 89
Colors, activity of, 85-90; advancing, 88-90; analogous, 78, 81-82, 84, 88, 201, 223; areas of, 83, 84; arrangements of, 81-82, 83, 85-90; best for foundation washes, 64; brand of, 19; body, 17; books on, 89; characteristics of, 60-64; composing with, 218-222; contrasted for emphasis, 228; cool, 88, 89; description of, 24-25; distribution of, 24-25; experiments with, 60-98; fading, 64; fugitive, 21; illusions of, 85-90; judgment of, 29, 153; mat, 17; mixing and matching, 65-66, 72-84, 85-90, 117, 154-155; neutralized, 82-83; normal, 67, 69; number of, 21-22; opacity of, 64, 117; permanence of, 21; poster, 17; primary 22, 66, 73-74, 76, 77; retreating, 88-90; rules of, 86; schemes of, 81-82, 83, 87, 91-98, 117; secondary, 22, 74; show card, 17; spectrum, 22; students', 17; superposition of, 61; tertiary, 74; theories of, 66, 72; your approach to, 137-139; warm, 88, 89; illus. of, 61, 62;

see also After-images; Analogous colors; Complementary colors; Hue; Intensity; Near complements; Paints; Shade; Tone; Triads; Values

Color wheel, 28, 76, 80-82, 94, 97, 117, 223; making a, 76-77; illus. of, 77

Complementary colors, 81-82, 84, 138-139, 191; accents of, 95-96; and composition, 223; defined, 78; mixing, 78, 80; near and split, 96-97; illus. of, 79

Composition, 218-226; by addition, 225-226; in still life, 124-131; of foliage, 220, 226; terms of, 224; with contrasts of hue, 223-224; with contrasts of value, 218-22; with cutouts, 226; with tracing paper, 222-223; using preliminary sketches, 224-225; illus. of, 104-105, 106-107, 126, 132, 174, 198, 199, 219, 221, 222, 223

Concrete, 186

Containers for water, 29, 143; illus. of, 29, 143

Cool colors, 88, 89

Copying, 109-116

Corot, Jean-Baptiste-Camille, 81

Corrections, 31, 68, 155, 157-161; by erasing, 158-159; by patching, 160; by sandpapering, 158; by scrubbing, 157-158; with knife or razor, 159; with casein, 160; with opaque white, 160

Crayon, 26, 108

Cups, 28-29; illus. of, 28

Cutouts, 206; used for composition, 226

Dabs, exercises in, 52; illus. of, 52

Deposit washes, see Sediment washes

Detachment, 227-232; with graded tones, 231-232

Detail, for emphasis, 228

Diffraction, 171, 172, 173; see also Shadows

Direct method of painting, 134-135, 175; illus. of, 196

Distance, 227-232; illus. of, 230

Double-elephant paper, 39

Drawing board, 36, 118

Drawing table, 31-33; illus. of, 32, 33

Drawing Trees, 162

Dry-brush work, 39; and buildings, 52; and foliage, 52; exercises in, 51-52; illus. of, 52

Drying, 151; with alcohol, 151, 195; with fan, 36, 151; with hair dryer, 36, 151

Dust brush, 35; illus. of, 36

Easel, 31-33, 118, 265; outdoor, 144-145; illus. of, 32, 33

Edges, 256; quality of, 129; illus. of, 127, 128, 129, 130, 131

Eggshell board, 41

Emphasis, 224, 227-232, 256; through color contrast, 228; through detail, 228; through location and motion, 229-230; through value contrast, 227; with size, shape, texture, 229; with surprise, 231; illus. of, 228, 229

Equipment, 17-25, 26-27; for outdoor painting, 143-144; for still life painting, 118; see also Air brush; Brushes; Color box; Cups; Drawing table; Drawing board; Easel; Erasing knife; Erasing shield; Knife; Muffin tins; Paints; Palettes; Paper; Paper cutter; Pencil; Razor blade; Reducing glass; Rubber cement; Shadow box; Stool; Tracing paper; View finder; Water containers

Eraser, 34, 144, 145, 254

Erasing, 158-159; to make clouds, 195; to make highlights, 158; to represent texture, 140

Erasing knife, 34; illus. of, 34

Erasing shield, 34; illus. of, 34

Errors, correcting, 31, 68, 155, 157-161; illus. of, 173, 174

Eye level, 147, 255

Fading, 64

Fans, 101; repairing, 159

Ferrule, 31

Fixatif, 178, 225

Flat wash, 53-54, 167-168; 178, 193, 236; applying the, 54; stopping the, 55-56; illus. of, 54, 55

Flowers, 22, 162-179 passim, 255-259

Focal point, see Center of interest

Fog, 206-207

Foliage, 162-179, 231, 246; and dry-brush technique, 52; composing, 226; composing with, 220; holes through, 169; hue of, 167; values of, 167; illus. of, 164, 165, 166, 167, 168, 169, 170, 171, 172, 173, 174, 176, 177

Frame, stretching, 48; illus. of, 49

Freehand Drawing Self-Taught, 133

Frisket paper, 203

Gasser, Henry, his choice of pigments, 22-23

Glass, 186-190, 213

Glue, 43, 45, 47, 48

Glycerine, 195, 238

Godets, 28; illus. of, 28

Gouache, 17, 50, 137, 233; used for correction, 160

Graded wash, 53-54, 55-59, 178, 193; dark to light, 56; French method of, 57; light to dark, 56; overlapped, 57; stopping the, 55-56; superposed, 57-59; two stroke, 57; illus. of, 54

Graded tones, to show distance and detachment, 231-232

Granular washes, see Sediment washes

Grass, 162-179 passim; color of, 153, 178; shadows on, 173, 179

Hair dryer, 36, 151
Half-imperial, 45, 60, 144
Hawley, Hughson, 157
Hedges, 162-179 *passim;* illus. of, 176
Highlights, 31, 36, 68, 121, 136-137, 169, 182, 206, 236; and reflections, 216; erased, 158; made with opaque white, 136, 182, 183; reflected, 121; scrubbed, 158; illus. of, 127, 158
Hill, Adrian, 162
Hill, Homer, illus. by, 234
Horizon line, 147
Hue, 22; defined, 66-67; composing with, 223-224; contrasts of, 223-224; of trees, 167-168

Illustration boards, 41
Imperial paper, 39
Impressionists, 53, 84
Indirect method of painting, 135
Ink and watercolor, 237-238
Intensity, defined, 67
Intermediate colors, *see* Tertiary colors

Kamen, Samuel, 264-265; illus. by, 266
Kautzky, Ted, 162; demonstration by, 250-254
Kent, Norman, demonstration by, 246-249
Keuffel and Esser, 41
Kingman, Dong, his choice of pigments, 23; illus. by, 103
Knife, 35, 47, 253; illus. of, 35

Lamp, 119; daylight, 35; illus. of, 35
Landscape, 162-179; composition, 225-226; demonstrated, 246-249, 250-254, 260-263; *see also* Clouds; Flowers; Foliage; Outdoor Painting; Reflections; Sky; Trees
Lighting, 35; as it affects edges, 129; as it affects surface, 128; for still life, 118-119, 124-131; indoor, 140-141, 146; outdoor, 140-141; *see also* Reflected light; Shadows
Linear perspective, 231
Line work, exercises in, 51; illus. of, 52
Liquid watercolors, 18
Luckiesh, M., 89

Masks, 203-204, 205, 206
Mason, Roy M., illus. by, 20
Masters, learning from, 109-116, 117
Mat colors, 17
Memory work, 123
Mingling, 50, 53, 182; for sky, 195
Molting brushes, 31
Monochromatic color scheme, 93-94; illus. of, 87
Monochromatic painting, illus. of, 106-107
Morilla Board #1059, 42
Morilla Company, 42
Mounted paper, 151

Muffin tins, 29; illus. of, 29
Munsell color notation, 66

Near complements, 96-97, 138, 139; illus. of, 87
Normal colors, 69; defined, 67
Notes, 155

Object rest, *see* Shadow box
Oil painting, 22, 31, 38, 136, 151, 152, 200; vs. watercolor, 134
Olsen, Herb, demonstration by, 260-263
On Drawing and Painting Trees, 162
Opacity of color, 64, 117; illus. of, 63
Opaque watercolor, 14, 68, 233-238; on colored paper, 237; to make corrections, 160; to paint clouds, 197; illus. of, 196
Opaque white, used for corrections and alterations, 160; used for highlights, 136, 182, 183
Outdoor painting, 142-156, 162-179; center of interest in, 150; equipment for, 143-145; lighting in, 140-141, 146; selecting subject for, 145-148; *see also* Clouds; Flowers; Foliage; Landscape painting; Reflections; Sky; Trees

Paint cloth, 36
Painting sets, 18; illus. of, 13; *see also* Color box
Painting Trees and Landscapes in Watercolor, 162
Paints, 17-25; characteristics of, 60-64; opaque, 14, 68, 233-238; transparent, 17; *see also* Colors; Pigments
Palette, setting the, 29-30
Palettes, 21-22, 27, 28; illus. of, 28
Pan colors, 18-19, 27; size of, 21; illus. of, 18
Paper, 34, 38-42, 151, 241-245; antiquarian, 39; blocks, 42; buckling, 47; cold pressed, 39, 41, 249; cutting mounted, 35; double-elephant, 39; for painting outdoors, 144; for painting still life, 133; handmade, 38-41; hot pressed, 39, 249; how to mount, 43-49; how to stretch onto a board, 44-48; how to stretch onto a frame, 43-49; imperial, 39; imported, 38-39; machine-made, 41-42; mounted, 41; rough, 39; royal, 39; sizes of, 39; stretching demonstrated, 241-245; surfaces of, 39; weight of, 39; illus. of, 242, 243, 244, 245
Paper cutter, 35, 47; illus. of, 35
Paragon paper, 42-43
Paste, 43, 45, 241
Pastels, 26, 200, 225
Patching, 160
Pattern, 102-104
Pencil, 26, 34, 100, 108, 133, 145, 147, 154, 178, 182, 186, 203, 225, 237, 250, 253, 255, 256, 260; carrying the, 144; colored, 183, 237
Pencil Broadsides, 253

Pencil Drawing Step-by-Step, 133
Permanence, 117
Perspective, 147, 208, 215; aerial, 231; linear, 231
Photographs, advantages of, 99-100; painting from, 99-108, 116-117, 165; illus. of, 104-105
Pigments, characteristics of, 60-64; choosing, 17-25; *see also* Colors; Paints
Pike, John, illus. by, 40
Pitz, Henry C., 162
Pointillism, 53, 84, 175; *see also* Stipple
Point of view, 146
Poster colors, 17
Powdered colors, 18
Preliminary exercises, 50-59
Preliminary sketches, 34, 148-149, 180-182, 246, 252-253; for still life, 133-134; to aid in composition, 224-245; illus. of, 149, 248, 252; *see also* Thumbnail sketches
Primary colors, 22, 66, 76, 77; defined, 72-73; illus. of, 74
Progressive method of painting, 175
Proportion of picture, 132

Rag, 36, 53, 144, 145, 158
Razor blade, 46, 47, 204, 245; correcting with, 159; to represent textures, 140
Red sable brushes, 30, 31, 152, 249; illus. of, 30
Reducing glass, 145; illus. of, 145
Reflected light, 126-128, 130, 191; illus. of, 127, 128, 129
Reflections, 208-217, 248; color of, 216; in interiors, 213; laws of, 209-210; on curved surfaces, 216; on horizontal planes, 208-210; on tipped planes, 215; on vertical planes, 213-215; on water, 209-210, 217; on wet streets, 213-214; spherical, 211-212; illus. of, 209, 210, 211, 212, 213, 214, 215, 216
Reflectors, 126-127
Related colors, *see* Analogous colors
Retreating colors, 88-90
Rogers, John, 49; demonstration by, 241-245
Roof, 30, 187, 231; illus. of, 185
Royal paper, 39
Rubber cement, 204; for masking, 204; illus. of, 204
Run back, 59, 101, 151; repairing, 159

Sable brushes, 30
Sand, to create clouds, 205-206
Sandpapering, 135, 158, 160, 178, 183; to represent textures, 140
Sargent, John Singer, illus. by, 111
Sargent, Walter, 89, 90
Saturation, *see* Intensity
Screen, illus. of, 207
Secondary colors, 22, 76, 77; defined, 73; illus. of, 74

Sediment, 22, 24, 60
Sediment wash, 24, 178, 183, 194
Scrubbing, 31, 135-136, 157-158; to make highlights, 158; to represent textures, 140; with sponge brush, 35-36; illus. of, 158
Shade, 66, 68-71; defined, 67; method of obtaining, 68
Shadow box, 124-125; illus. of, 124, 125
Shadows, 128-131, 140, 146, 153-154; edges of, 154, 173; elliptical, 170-172; expressing form, 172-173; on buildings, 172, 191; on grass, 173, 179; shapes of, 154, 191; tree, 164, 170-173; values of, 191; illus. of, 170, 171, 172, 173
Shingles, 186-187
Show card colors, 17, 50-51
Simultaneous contrast, 80, 115, 137, 138-139, 153, 154, 191
Sketchbook, 144
Sketches, 34, 45, 83, 100, 129, 141, 155; matting, 155-156; *see also* Preliminary sketches; Thumbnail sketches
Sky, 193-200, 202, 203; cloudless, 194; cloudy, 195; composing the, 197-199; sunrise, 199-200; sunset, 199-200; texture of, 194; illus. of, 196, 198, 199
Slabs, 28-29; illus. of, 29
Smith, Jacob Getlar, 144; his choice of pigments, 23-24; illus. by, 235
Spatter, 50, 53, 140, 201-207 *passim*, 238; illus. of, 206, 207
Spectrum colors, 22
Split complements, 96-97; illus. of, 87
Sponge, 35-36, 43, 45, 50, 136, 158, 260; illus. of, 36
Spray, 50, 53, 140, 201-207 *passim*, 238; for sky, 202; to create clouds, 205-207
Squinting, 154
Squirrel's hair brush, 30
Station point, 180; *see also* Point of view
Stencil, 203-204
Still life, 117-141; choosing subjects for, 119-120; colored objects in, 131; composing, 124-131; composition and light in, 131; demonstrated, 255-259; in wash, 122; lighting, 124-131; outdoor subjects in, 130; painting step-by-step, 120-122; paper for, 133; rounded objects in, 130-131; single object, 117-123; value of, 117-118
Stipple, 50, 140, 160, 178, 194, 201-207 *passim*, 236; exercises in, 52-53; for painting foliage, 175, 177; for sky, 197, 202; illus. of, 52, 177, 196
Stonework, 183; illus. of, 180
Stool, 33, 145; illus. of, 34
Stretching paper, 45-49; board for, 45; demonstrated, 241-245; necessity of, 49; onto a board, 44-48; onto a frame, 43-44; pan method of, 45-46

Stucco, 186
Students' colors, 19, 118
Subject, analyzing, 100-101, 133; for outdoor painting, 145-148; for still life, 119-120
Sunglasses, 37, 145
Sunrise, 199-200
Sunsets, 22, 199-200
Superposition of color, 61; order of, 61; illus. of, 61, 62

Tape, 44
Tempera, 17, 50, 137, 233; used for corrections, 160
Tertiary colors, 77; defined, 73; illus. of, 75
Textures, 52, 61, 139-140; for emphasis, 229; represented by razor blade, 140; represented by sandpapering, 140; represented by scrubbing, 140
The Artistic Anatomy of Trees, 162
The Enjoyment and Use of Color, 89, 90
The Language of Color, 89-90
Thermos bottle, 29
Thumbnail sketches, 34
Tiles, 28-29; illus. of, 29
Tint, 66, 68-71; defined, 67; method of obtaining, 68
Tone, 66; defined, 68
Tracing paper, 108; for masking, 203-204; mounted, 42; used as aid in composition, 222-223, 225-226
Transparent painting, 50-51, 137
Trees, 118, 162-179; anatomy of, 163-165; books about, 162; created with masks, 206; holes through, 169, 170; hue of, 167-168; shadows, 170-173; silhouettes of, 165-166; trunk of, 204; values of, 166-167; illus. of, 164, 165, 166, 167, 168, 169, 170, 171, 172, 173, 174, 176, 177
Trees and Landscapes, 162
Triads, 78, 97; illus. of, 87
Tubes, 18-19, 26; and sticking caps, 36; size of,
21; studio, 21; illus. of, 19
Turner, J. M. W., illus. by, 110

Umbrella, 37, 145; illus. of, 37
Unity, 227; defined, 224

Values, 66, 150; contrasts used for composition, 218-222; contrasts used for emphasis, 227; defined, 67; exercises in comparing, 68-69; measuring, 69-71; scale of, 70-71; seeing with view finder, 128-129; illus. of, 70, 106-107
Value scales, 117; illus. of, 70
Vanishing point, 147
View finder, 125-126, 138, 144, 145, 147; seeing values with, 128-129
Vignetting, 102

Warm colors, 88, 89
Washes, 50; best colors for foundation, 64; comparative, 60-61; correct easel for, 31; exercises in, 53-59; flat, 53-54, 167-168, 178, 193, 236; graded, 53-54, 55-59, 178, 193; mingling, 195; mixing large, 29; sediment, 56, 178, 183, 194; simultaneous, 59; stopping the, 55-56; illus. of, 54, 55, 59
Water containers, 29, 143; illus. of, 29, 143
Water cups, 144
Watercolor, and charcoal, 237; and ink, 237-238; characteristics of, 60-64; liquid, 201; merits of, 11-13, 26; opaque, 50-51, 233-238; transparent, 50-51; vs. oil painting, 134; *see also*, Colors; Equipment; Paints
Watercolor Painting for the Beginner, 144
Watson, Ernest, 162
Weinberg, 89, 90
Whatman illustration board, 256
Windows, 187-190; illus. of, 188
Window shutter, 30
Wyeth, Andrew, illus. by, 58

Designed by Betty Binns
Composed in ten point century expanded by
Harry Sweetman Typesetting Corp.
Printed and bound in Japan by Toppan Printing Co., Ltd.